Movement
AT THE
Still Point

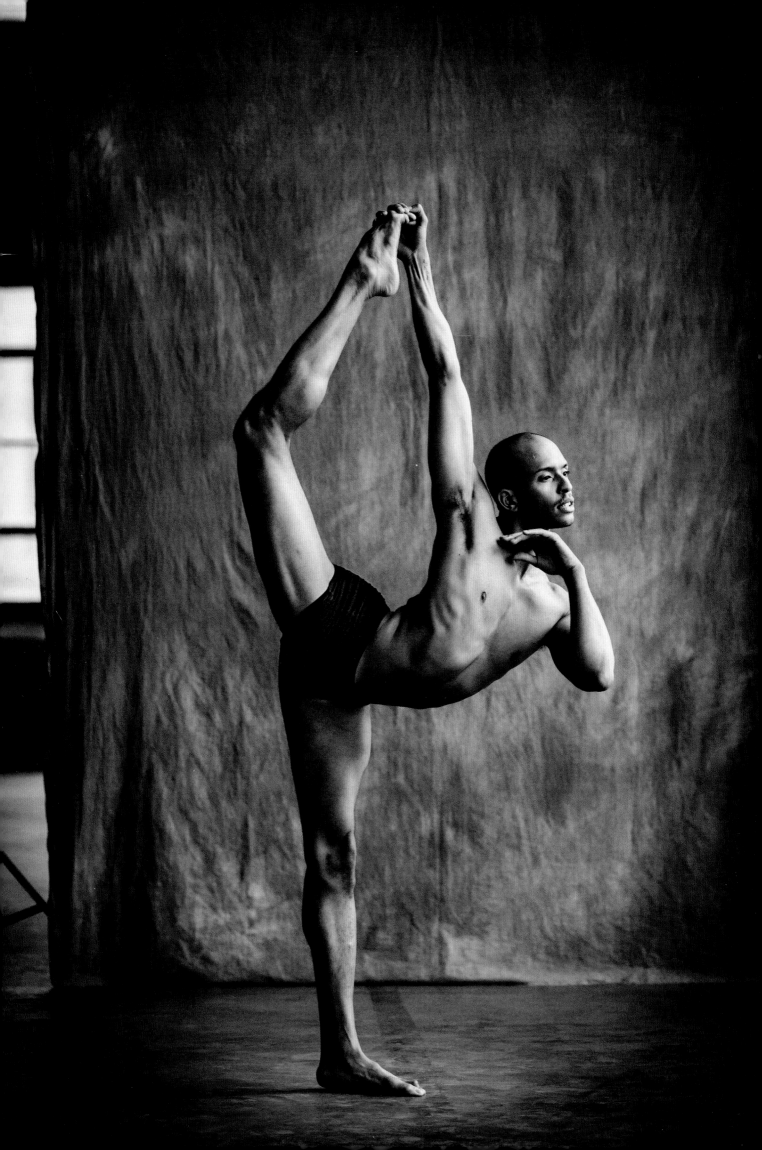

Movement
AT THE
Still Point
AN ODE TO DANCE

Photography by MARK MANN

Foreword by CHITA RIVERA Afterword by LONI LANDON

RIZZOLI
NEW YORK

New York · Paris · London · Milan

At the still point of the turning world. Neither flesh nor fleshless;
Neither from nor towards; at the still point, there the dance is,
But neither arrest nor movement. And do not call it fixity,
Where past and future are gathered. Neither movement from nor towards,
Neither ascent nor decline. Except for the point, the still point,
There would be no dance, and there is only the dance.
I can only say, there we have been: but I cannot say where.
And I cannot say, how long, for that is to place it in time.

T. S. Eliot
Excerpt from "Burnt Norton"
(No. 1 of *Four Quartets*)

This book is dedicated to Katie and Tenny.

CONTENTS

FOREWORD
by Chita Rivera

I DIDN'T KNOW WHAT TO EXPECT when I met Mark Mann at the studio on Manhattan's West Side—I've had the good fortune to work with some of the world's great photographers over my seventy-year career, and just like dancers, each one is a unique artist and a master of technique. I also know from experience that it isn't the photographer's expertise that makes a dance photo great; we're all seasoned pros, so we can always get the shot. But when the chemistry between the photographer and that dancer has that certain magic, it's like we're doing a dance of our own. And that is what makes a great picture.

The studio that Mark used for this body of work is vintage New York: the exposed brick walls, the weathered floors, the sunlight streaming through those industrial paned windows. The day was hot and bright, in that way only a New York City summer day can be, and I immediately felt at home. It felt like the old (and not air-conditioned!) studios where I rehearsed *West Side Story* with Jerry Robbins, or *Sweet Charity* and *Chicago* with Bob Fosse.

And Mark is one of a rare breed of photographers who understands dancers: how we move, the way we say things with our bodies that other people say in words, how much we love to perform for an audience—even an audience of one. So I put on my top hat, white tie and tails, and we did our own little dance, and it shows in the images he made of me, and of all the dancers in this beautiful collection.

It wasn't lost on either of us how special, and unexpected, this opportunity was after the pandemic closed down Broadway theaters, the dance world, and the entire city of New York—the whole world. It is thrilling to be back on Broadway, and back to collaborating with fellow artists, such as Mark.

Those of us who lived through the first years of AIDS don't take any of this for granted. I can't thank Broadway Cares / Equity Fights AIDS and The Actors Fund for all they did, and continue to do, in support of my beloved Broadway community. The photos in this book are not only beautiful in their own right, they're proof, plain to see in black and white, of the joy that dance brings to the world.

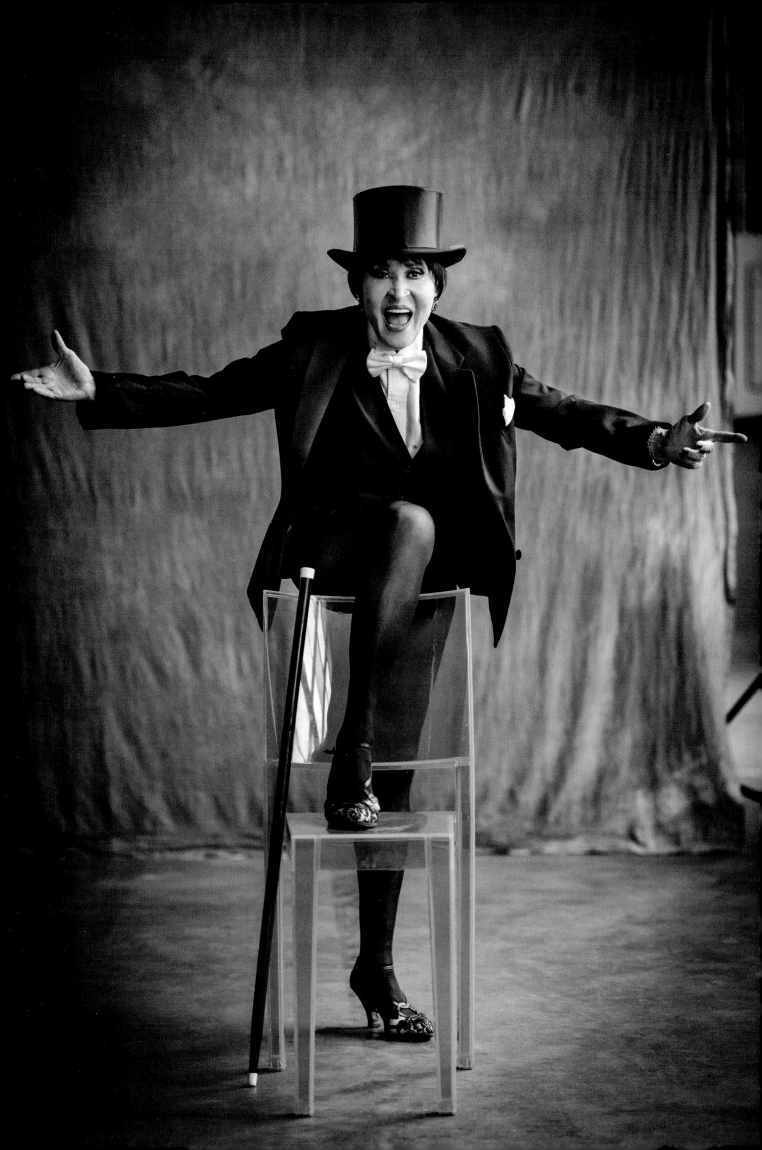

INTRODUCTION
by Mark Mann

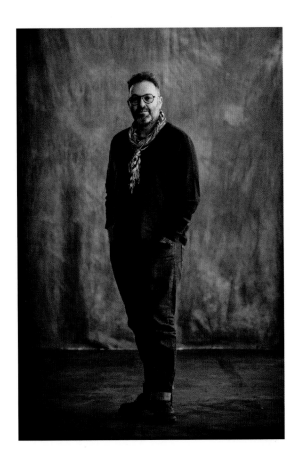

FOR ALMOST THIRTY YEARS, I've made a living from photographing portraits of people. Real people, professionals at the top of their game, gifted musical artists, charismatic celebrities, revered (and reviled) politicians . . . you name them, they've probably sat on my stool. It's been an honor and a privilege to talk and listen to every one of them; to make them laugh, set them at ease, find their vulnerability, identify a hidden quality in a glance. There's an immense physical demand on a portrait photographer in trying to capture a perfect moment of stillness. The skill is in being both the entertaining clown and the authoritative ringmaster.

When the pandemic hit, as it did for so many working artists, my work dried up overnight. And about six months in I was experiencing a heightened sense of fear and uncertainty. Worse, I was wrestling with a new unfamiliar but just as crippling feeling. Creative Block. I spent at least thirty minutes being a landscape photographer in the backyard of our family pandemic hideout. I tried still lifes around the house, skylines of the city. Nothing felt right. Until I realized that I wasn't creatively blocked at all. I was sad.

I was missing the people I photographed and the human connection between photographer and subject. I had no concept of how much I needed and craved that connection. Joni Mitchell knew it I guess—you don't know what you've got till it's gone.

Then one day, salvation arrived—albeit obscured by puffer jackets and misty exhalations during a wintertime outdoor visit—in the form of my sister-in-law Loni Landon. And that is how this book came to be.

Loni is a choreographer and an amazing human. We talked for hours about the damaging effects of Covid on the arts community—particularly dancers, many of whom she told me were suffering not only financially but also emotionally. They too were being stifled creatively and mourning the lack of human connection through collaboration and performance. Loni asked me if I had ever photographed a dancer. "Does Iggy Pop count?" I asked. (I joke when I'm uncomfortable.) The idea as it was expressed in that moment was simple: Find a venue for dancers to express themselves for an audience (me) and identify some people

(them) whom I could photograph. But like any act of creative self-expression that starts as an intangible and fantastical idea, it quickly became something bold and true thanks to a random and absurd moment.

While playing with a remote-controlled flying pigeon with my eight-year-old son in a warehouse space I rented on the West Side of Manhattan, I discovered an entire floor of the building I'd never stepped foot in. It was around ten in the morning when my son's pigeon flew through the rays of sunlight that pierced through overcast skies and bounced off the Hudson into the enormous studio. It was breathtaking. The ceilings were at least fifty feet high, and the echo of our voices made them sound otherworldly. The idea of photographing Loni's dancers in this space with their music playing was impossible to ignore—we had found the venue. Now all we needed were the dancers.

On February 15, 2021, at around eleven in the morning, my first dancer, Rena Butler, showed up. You would think with thirty years under my belt the nerves of meeting a new subject would subside almost instantly. I had Gretta with me—my medium format Leica S whom I love—and a background setup that I've used many times before. It's an Irving Penn–inspired backdrop designed and painted by Charles Broderson. But I had never taken photos like this before. I hoped Gretta and I knew what we were doing.

Given the distancing recommendations of the pandemic, I had decided to shoot with a 120mm lens that would give me the composition and the compression I wanted thirty

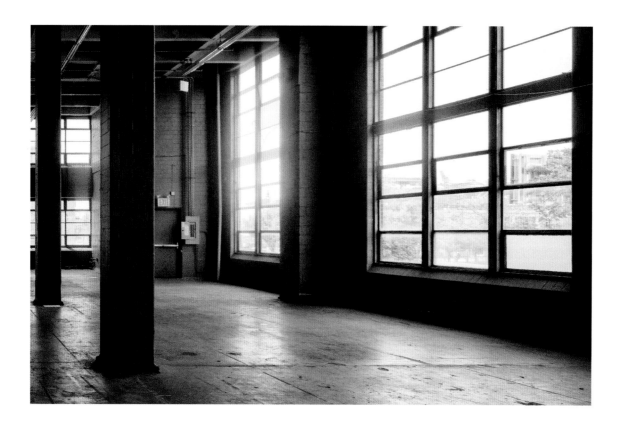

feet from my subject. But the challenge with the medium format camera would be its inability to take multiple frames quickly. The camera has great autofocus but again it's not built for speed. So I was better off with manual focus, but that was something that I'd not practiced for quite some time.

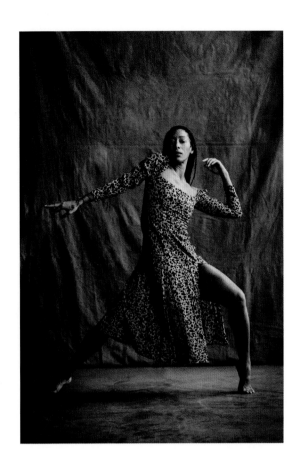

After chatting with Rena for a few moments, we turned on the music she had brought. As it played on a speaker she asked what I wanted her to do. I stared blankly at her for a few moments before saying, "Just move. Be you, and I'll try to capture it." I walked what seemed to be a very long way from my subject, and Rena started to move. Normally at this point I'd already be directing, engaging, chitchatting, laughing. But I was speechless. I realized I was watching a performance tailored exclusively for my camera. Rena had found her rhythm; as her body moved, it created astonishing shapes in the natural light that streamed in through the windows.

I would like the next line to read: I captured the performance perfectly from the very beginning. But that is far from the truth. For the first few minutes I was so captivated by the performance that I actually forgot I was supposed to be taking photos. Eventually, however, I focused literally and physically and I started to photograph the dance. It was in that precise moment that my whole life as a photographer was turned upside down. I was still. No longer the performing clown dictating the action but simply a voyeur of intense beauty and talent. I learned that day and in the subsequent nine months how to capture movement in single frames while letting the performer perform. I simply had to follow my intuition and press the shutter. It was absolute magic.

The privilege of dipping my own arhythmic toe into the vibrant and inclusive dance community will stay with me forever. I could not have done any of this without Loni's energy and commitment to booking dancers and getting more people involved. I'm also extremely grateful to my business partner and producer, Jacob Levy, who took care of all the logistics. But most of all I'm in eternal debt to the dancers in this book for teaching me through their grace, strength, and talent.

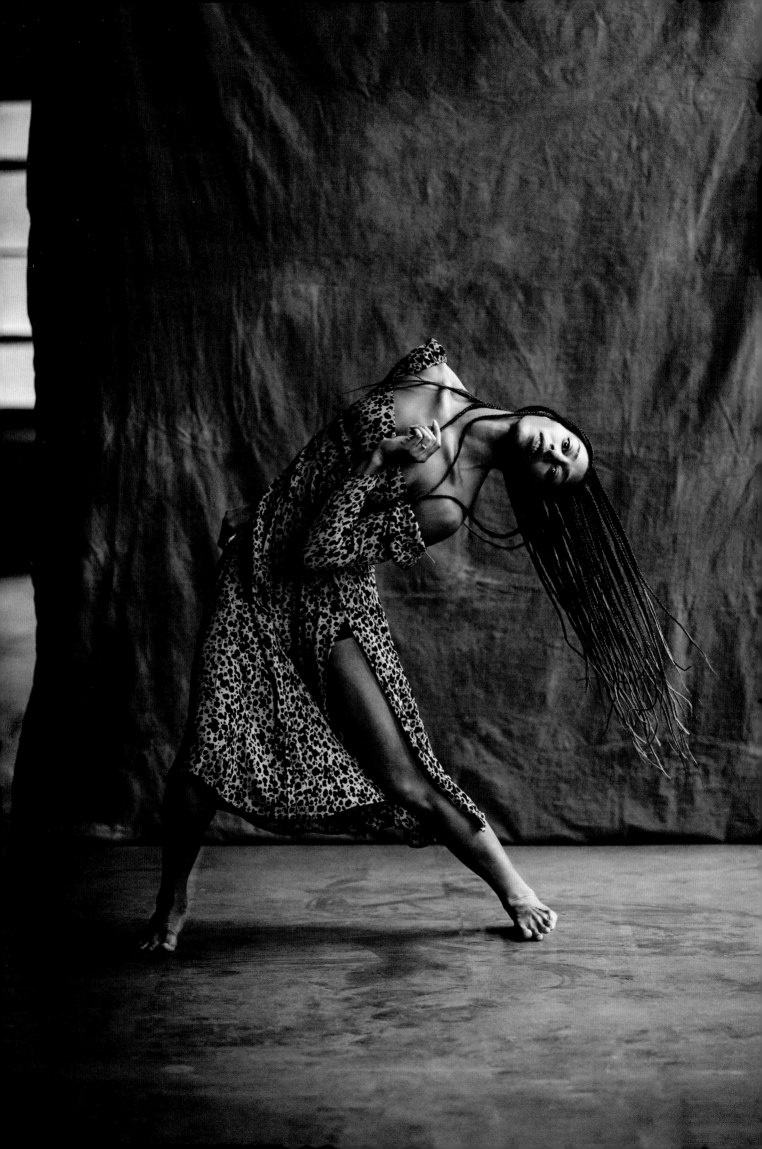

RENA BUTLER Contemporary and Ballet

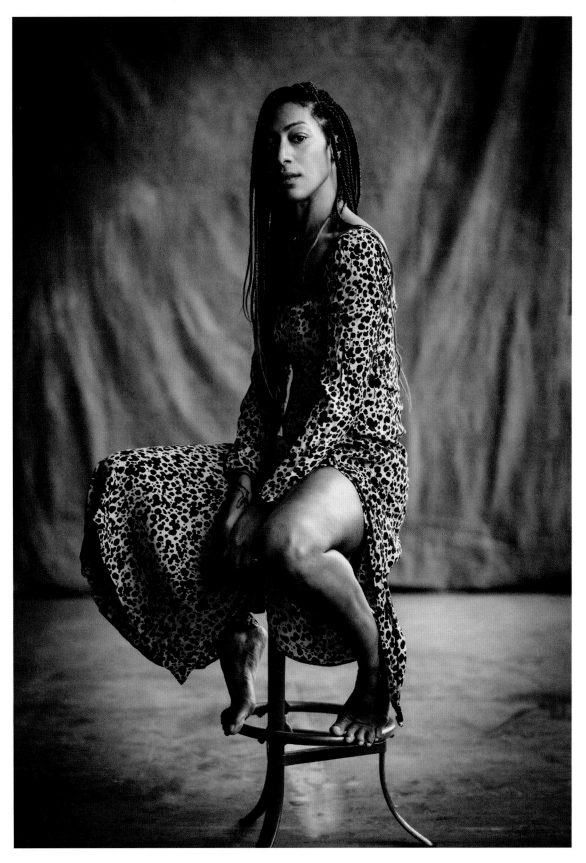

ANDY BLANKENBUEHLER Broadway

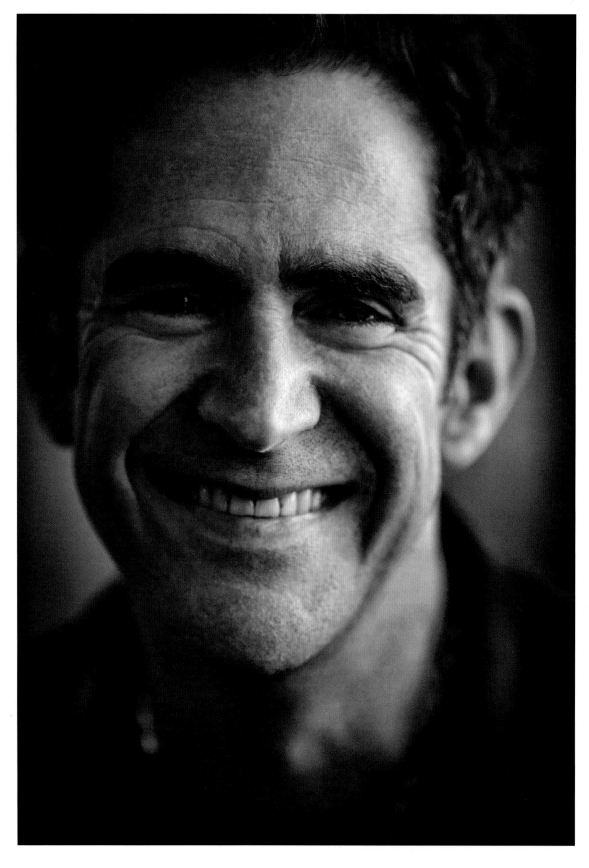

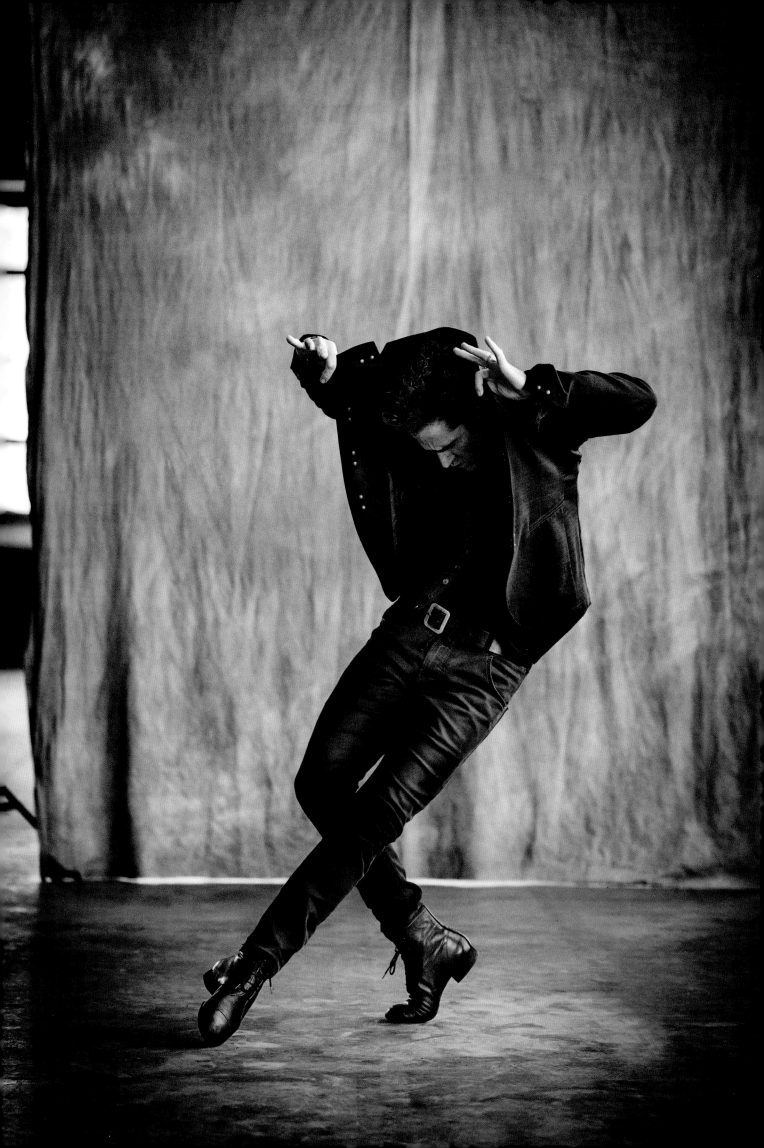

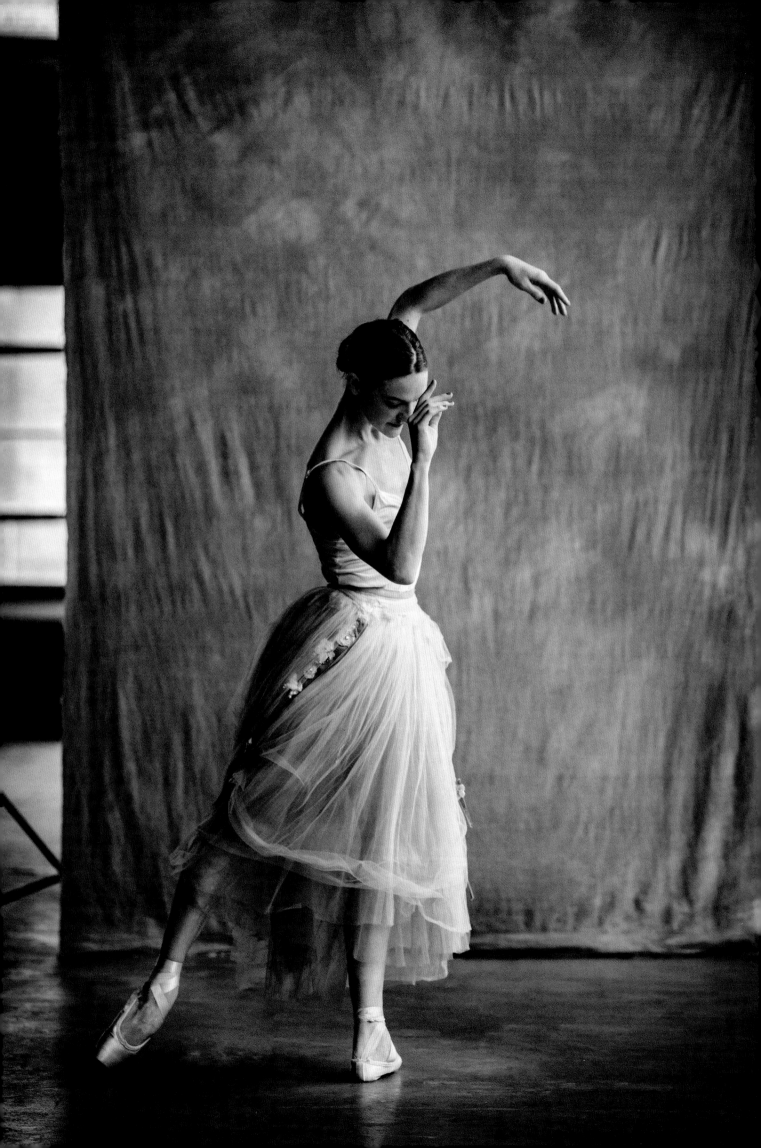

MEGAN LeCRONE Ballet

I don't think there is an emotional or physical sensation that I have not experienced! Dancers are—or at least I am—exceptionally sensitive and feel everything. We are so in tune with everything going on in our bodies, hearts, and minds all the time that it can get a little overwhelming. Exhaustion is pretty common … as are all of the normal sensations any athlete or person using their body generally feels. We feel elated at times, warm and dynamic and powerful, yet serene and still at the same time. It's a passion, so I certainly feel in love in a way. There is a sensuality and tenderness I think we experience at times as well.

Dancers relate, on one level, to one another through competition inherent in the art form. We compete for jobs, roles, and ranking, but we also compete with ourselves to be better than we were the day before, and maybe to understand ourselves more? This is an unspoken bond that we all have. We all know what it's like to get up each day, face ourselves and our bodies, be in front of a mirror for many hours in the day, perfecting and perfecting our steps and problem-solving, in a way. We try to accept ourselves on one level, define our limits or weaknesses, and then push beyond all that to get to a place where we are better or different or more informed or more open than we were the day before. Maintaining a healthy relationship with this comparison and competition is something that I think we all strive to do.

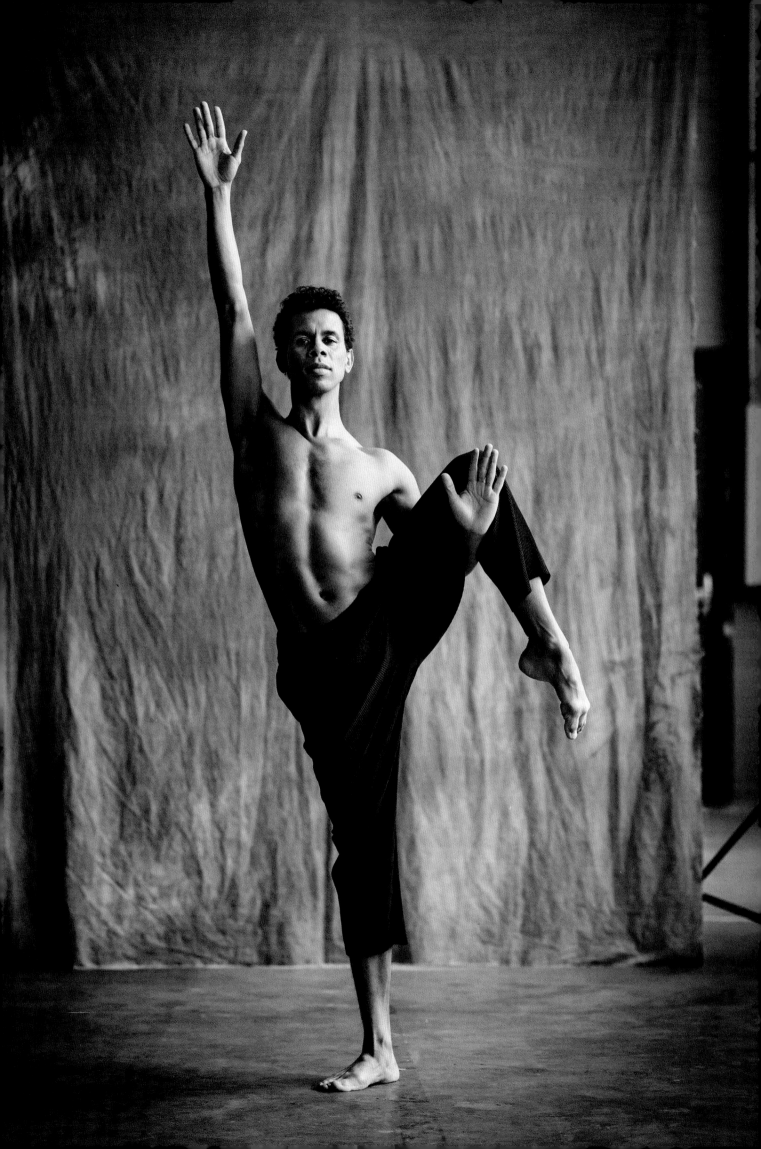

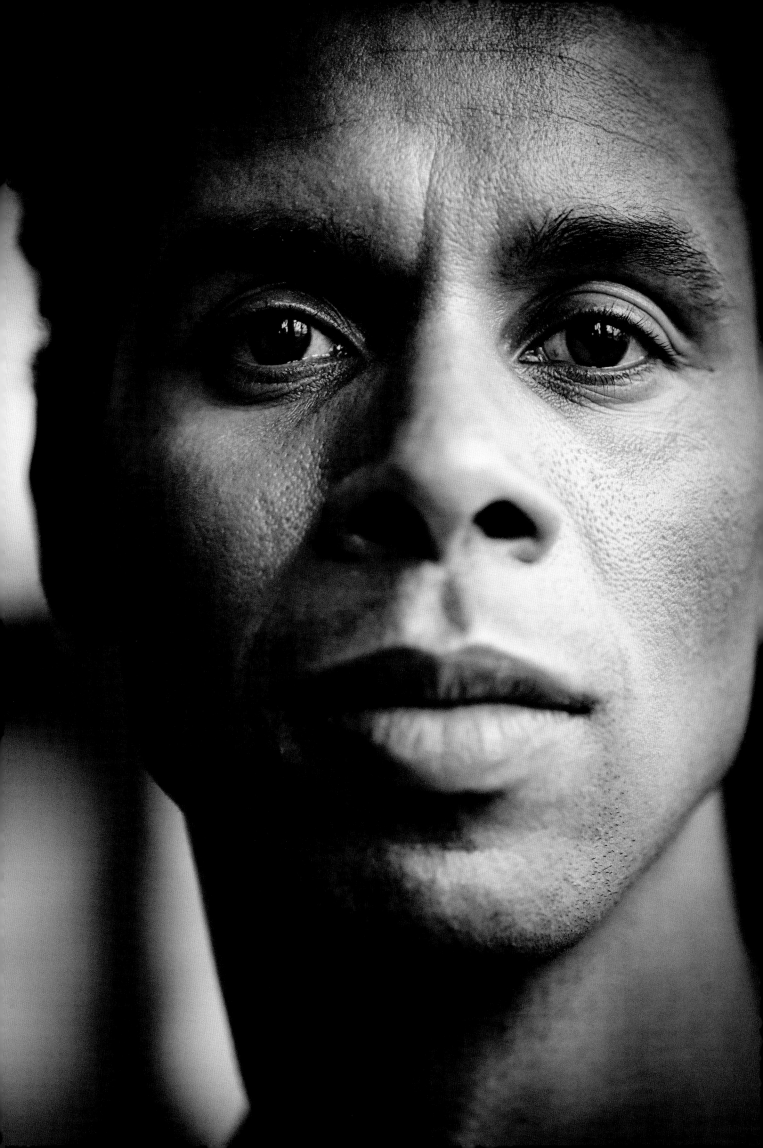

MARLA PHELAN Contemporary and Physical Theater

The dance field favors the young and earnest while it pushes maturing dancers (in their 30s!) toward retirement. The hard truth—young dancers are easier to overwork and underpay. There is very little advocacy for paying dancers a healthy living wage, and little consideration for longevity of the body and mind. The leaders of our field, who are placing inhuman demands on dancers, have too often never been dancers themselves or are repeating the same toxic leadership they experienced when they were young. At this point in my career, I have nothing to lose so I'm having these hard conversations with my colleagues and with the leaders of the field. It may not make me likable, but I hope it will change the norm.

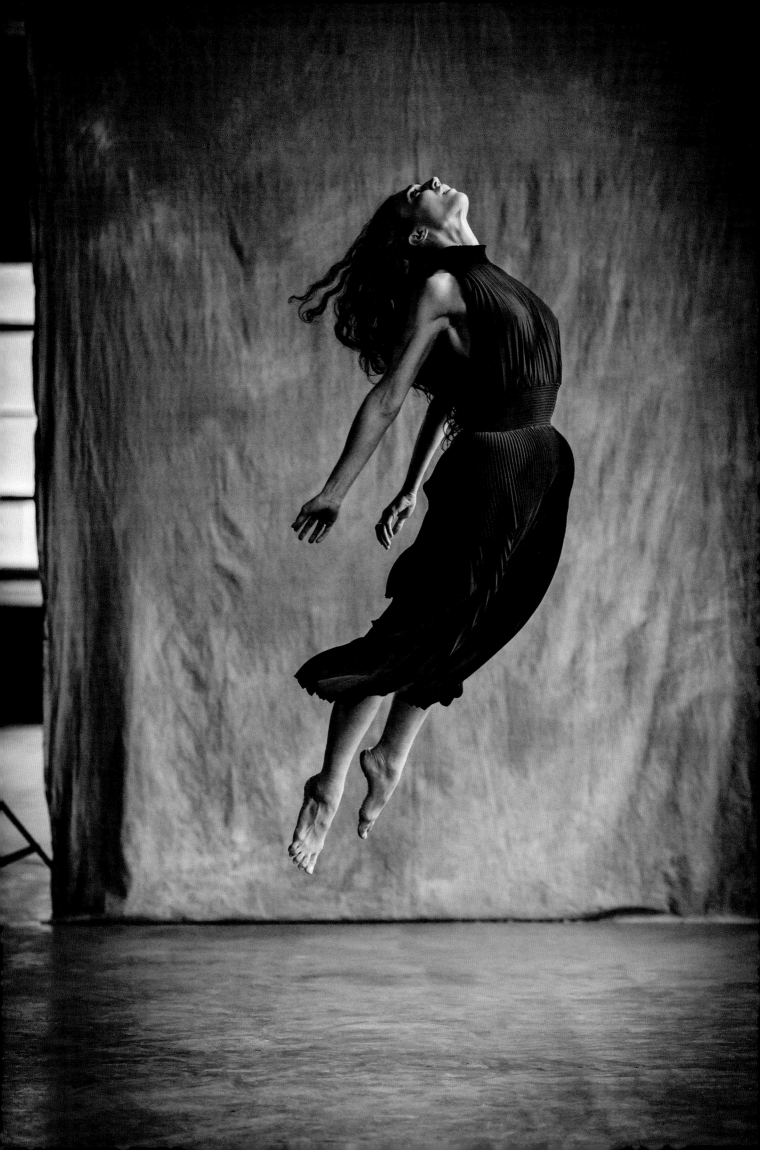

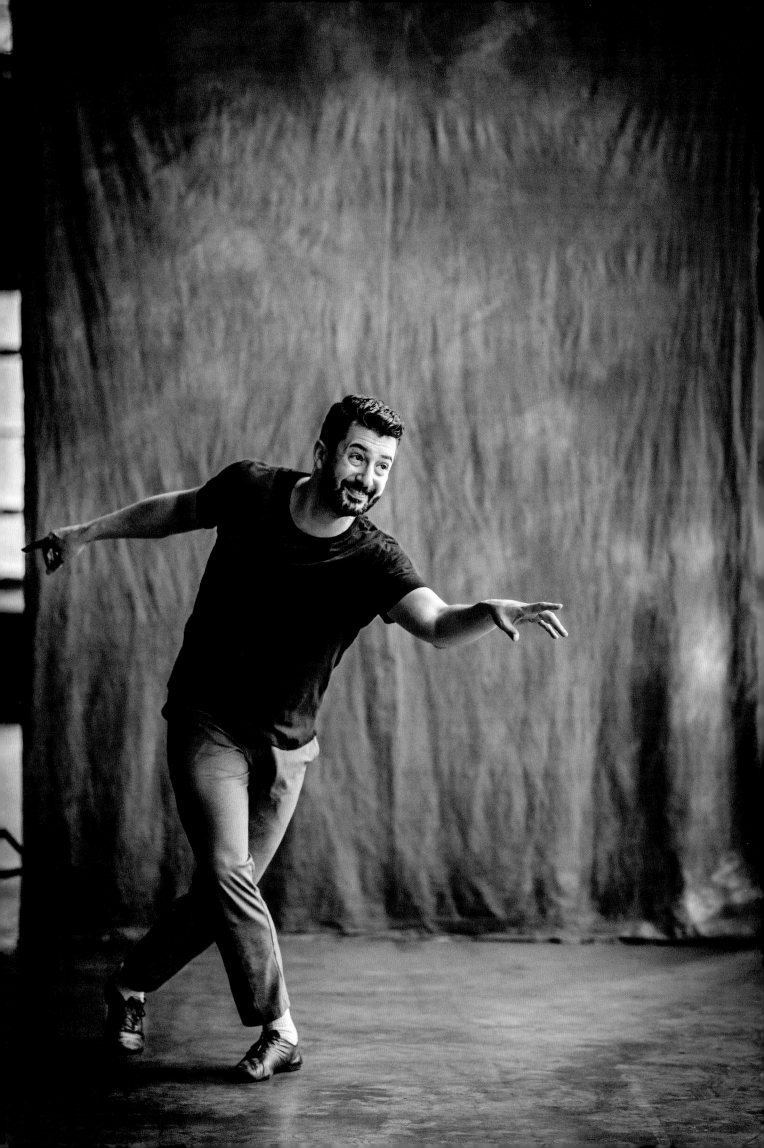

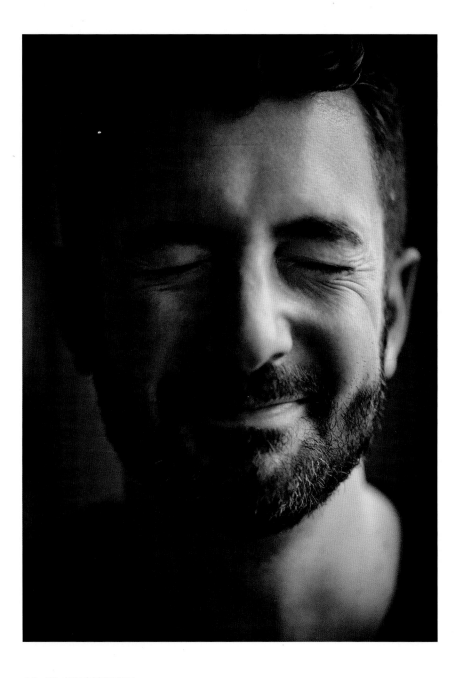

AL BLACKSTONE Broadway

Dance enables me to connect to the center of myself; the essence of who I am in this world. It connects me deeply to others and expands my capacity to love, to empathize, and to feel. I think that if you are lucky enough to discover something that powerful, you want to do it as much as possible. As a teenager I danced as much as I could, and when the chance came to make it a profession, I jumped at that possibility. I can imagine spending my time and energy in a different line of work, but I am so deeply grateful that I haven't had to. Sharing dance with others whether in a class or through choreography is more than a job; it's a calling.

Dancers, regardless of what kind of dance they do, share a unique bond. What we do is magical, but it is also incredibly difficult, particularly as a career. There can be jealousy, elitism, and the like…but at the end of the day we share a language that requires sensitivity, empathy, and lots of energy. This understanding makes for a community with strong roots and open hearts.

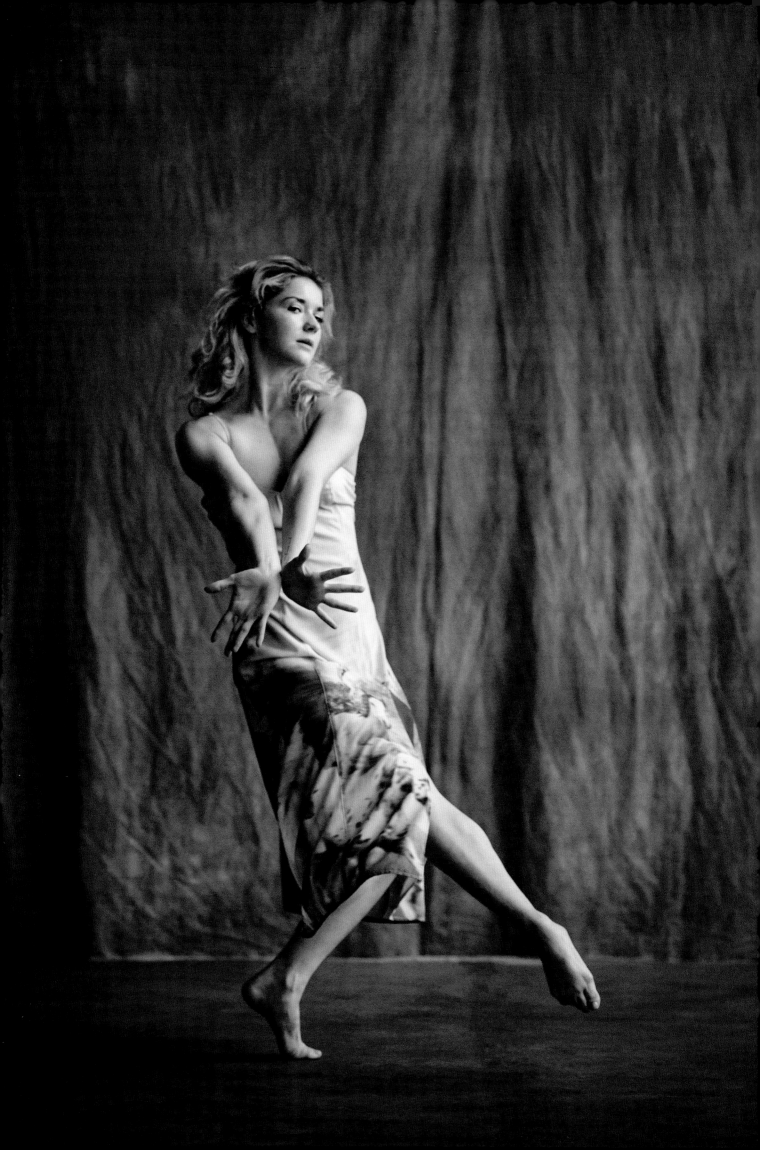

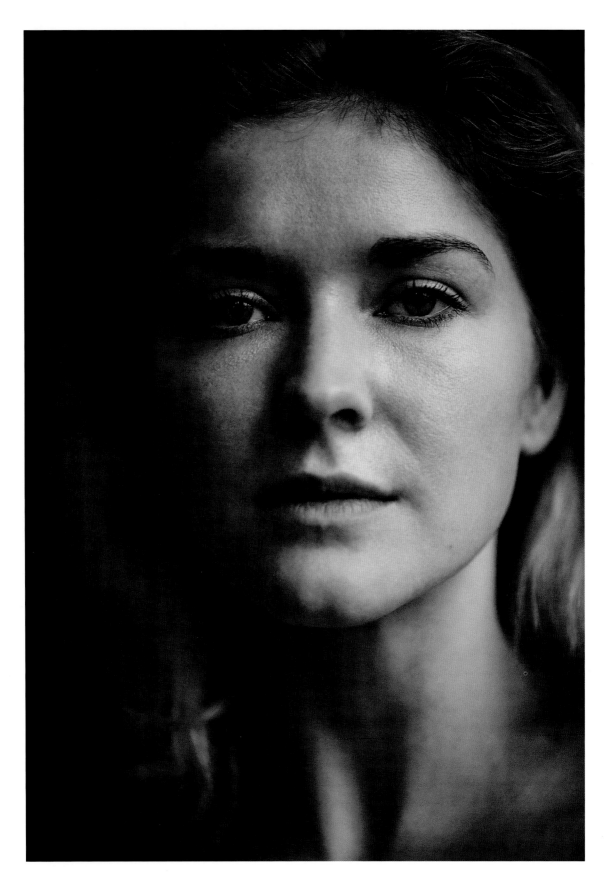

CASSANDRA TRENARY Ballet

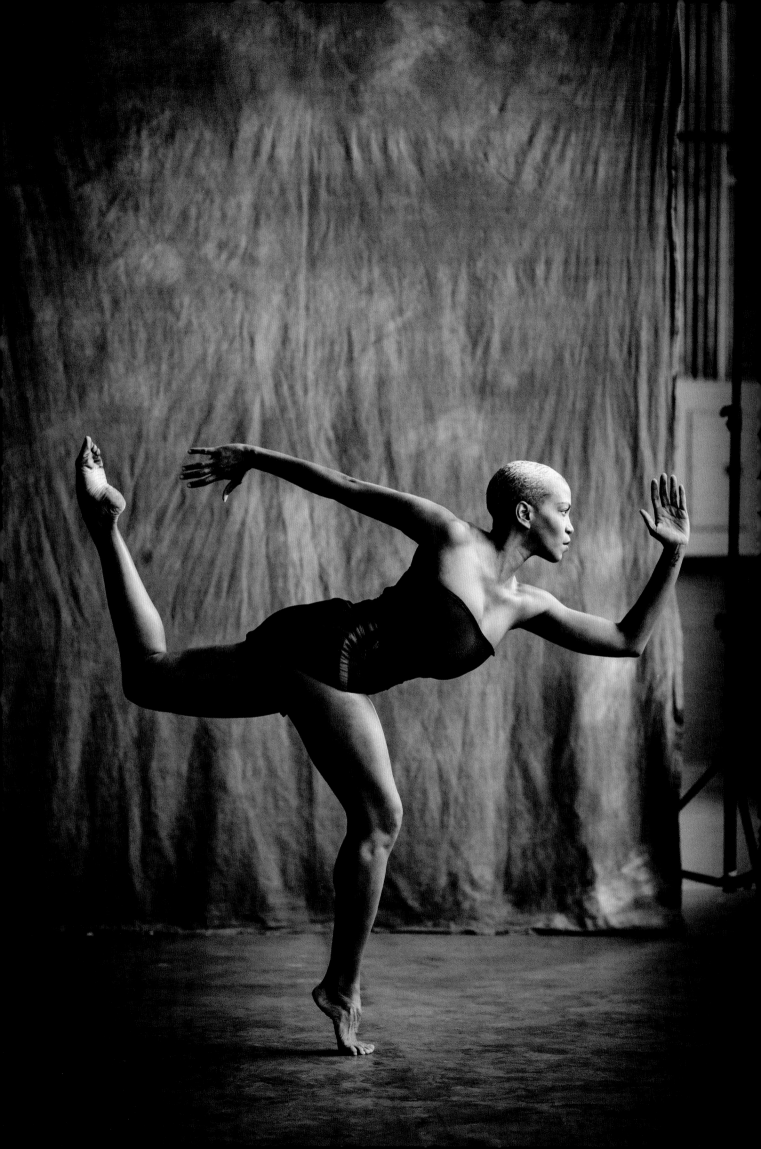

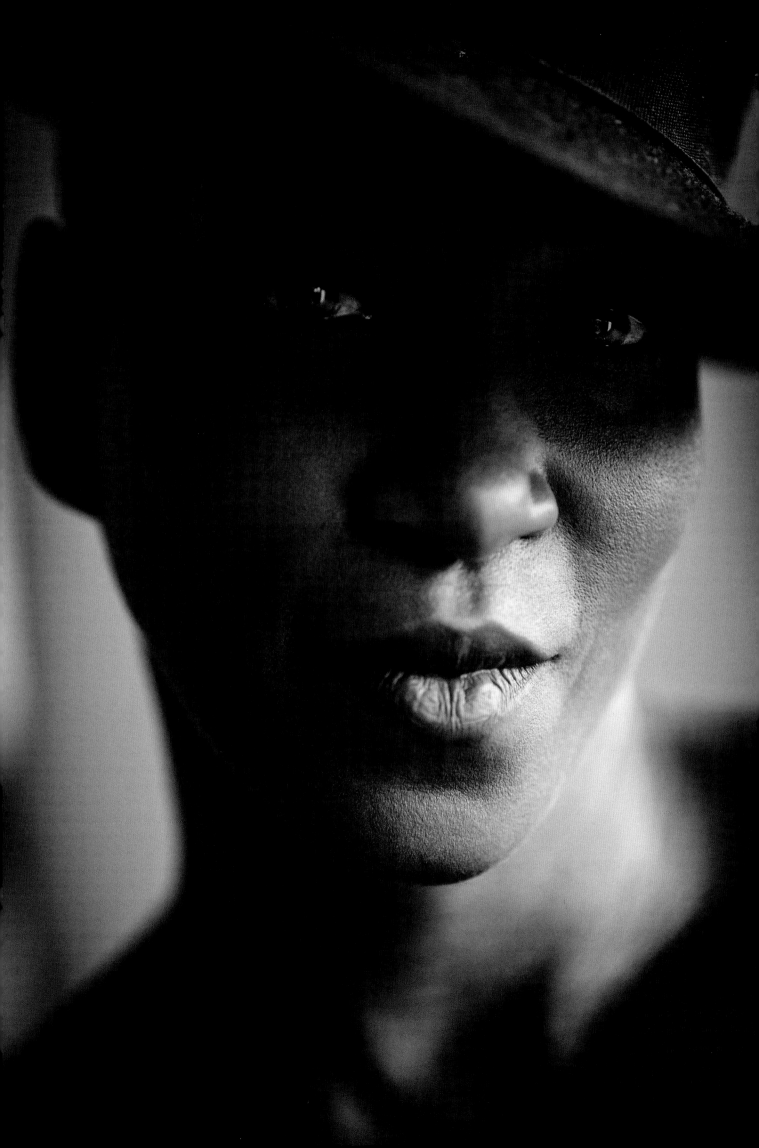

ALONSO GUZMAN and DARDO GALLETTO Argentine Tango

At show time, when the theater goes dark, right before the lights go on, I feel that my blood, my skin, my face, my feet, my beliefs and purpose to live—all of me changes. My imagination takes over, but the amalgam of things that I feel is often predetermined and rehearsed beforehand. In rehearsal, I catch myself rehearsing my imagination, not just my movement. Literally I'd be staring at nothing, feeling everything. I know people depend on my imagination to feel that which they cannot explain, so I take full responsibility to go crazy if I need to. Whatever the choreography demands, and my psyche can handle. My delirious interpretation of physical expression feeds purpose into my movement. The audience disappears, and I become something or someone else I can't fully explain or remember afterward. I'm left physically used and sore, but so happy that I got to live another life in the same body. After a show I smoke weed, drink bourbon, and recall my favorite moments just for the pleasure of it, just to see if I can remember who the heck I was back there on stage and what I can learn from that stranger I've created. *—AG*

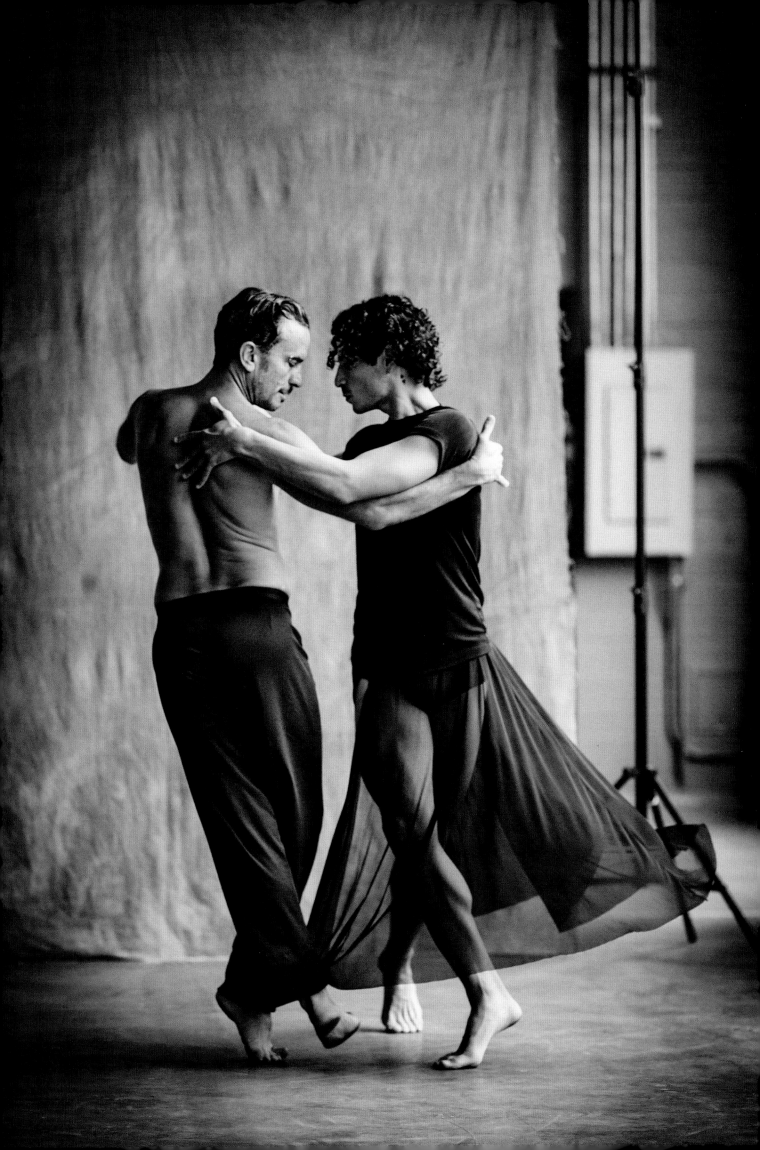

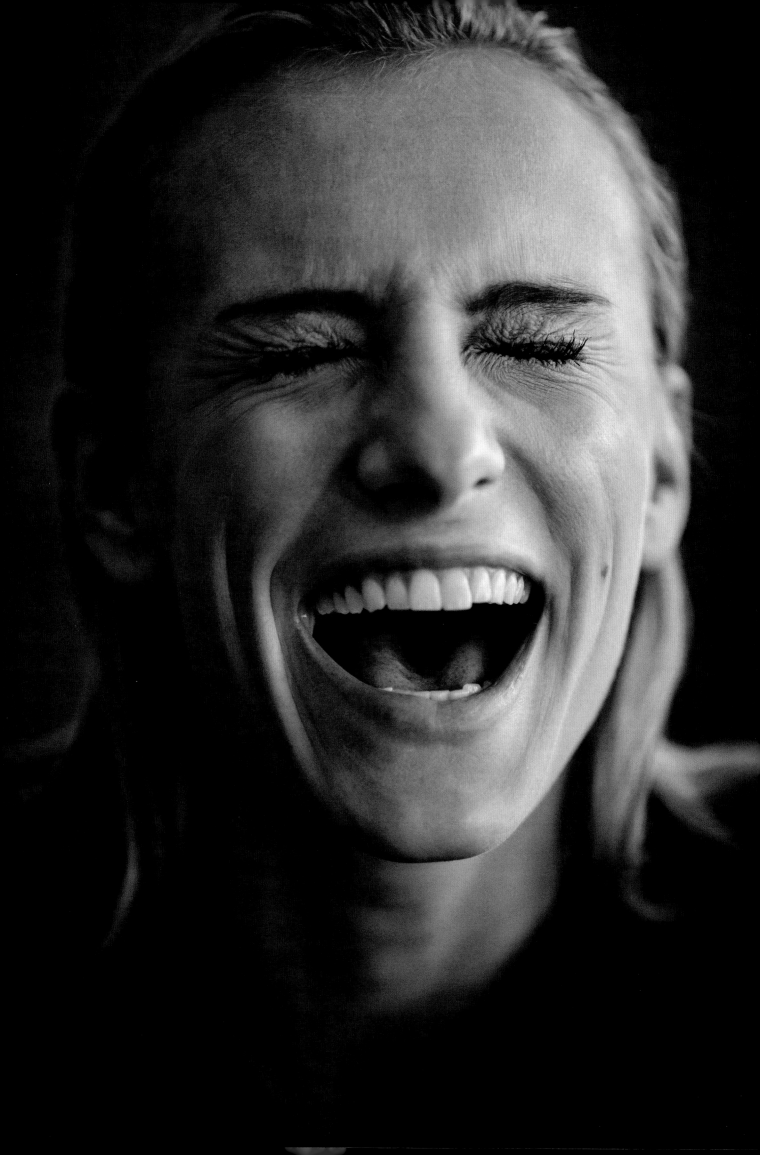

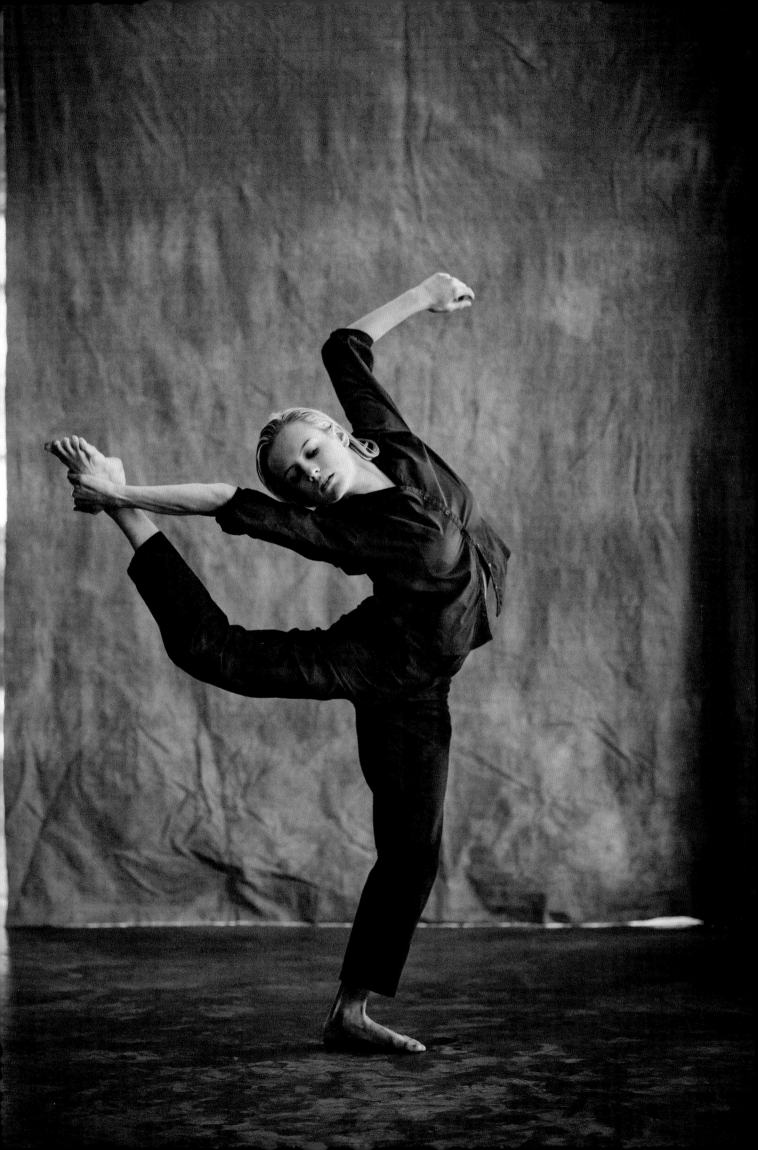

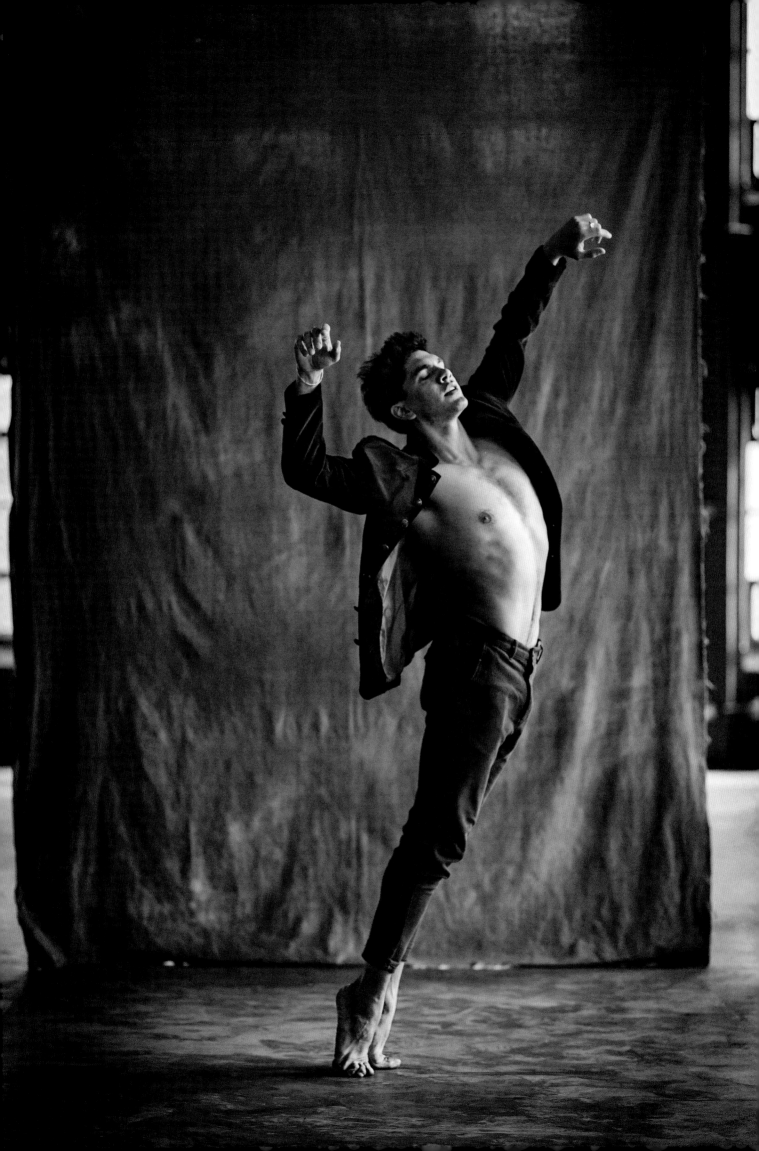

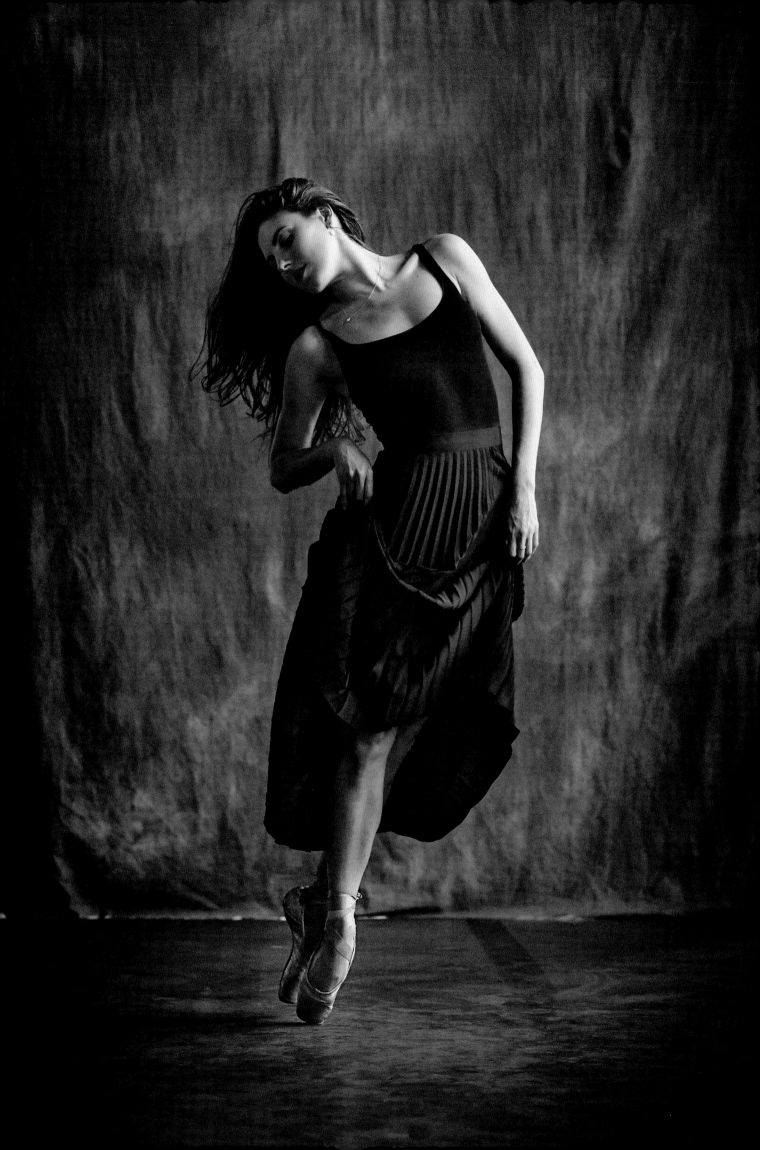

TILER PECK Ballet

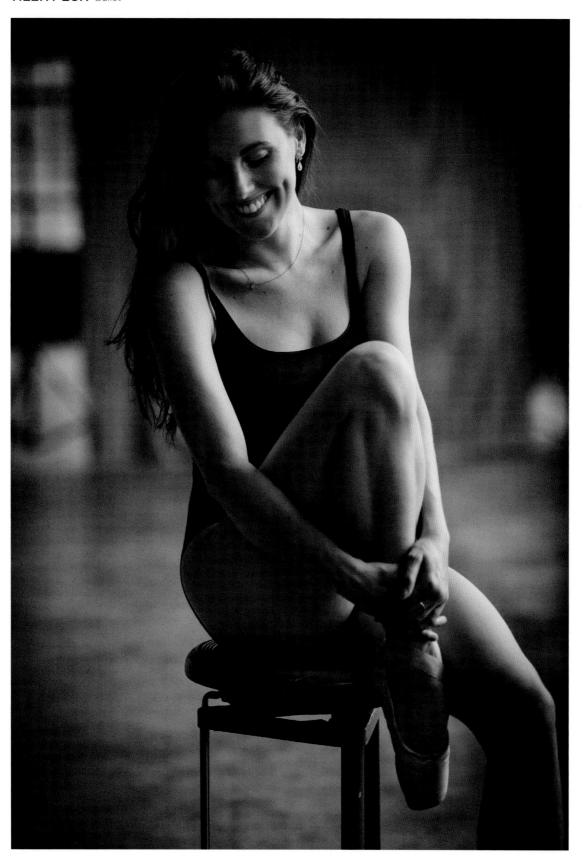

DAVID FLORES Contemporary

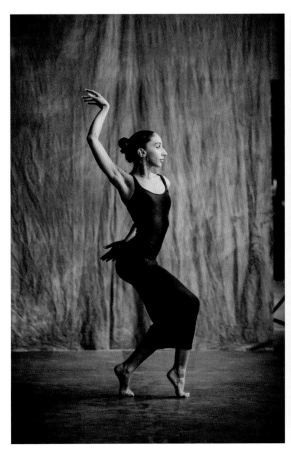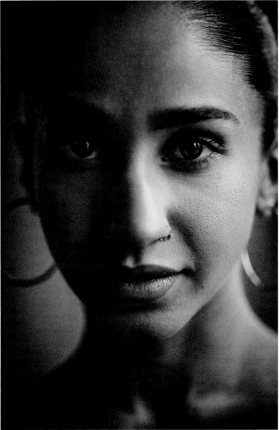

MARISA AMARA CHRISTOGEORGE Contemporary

Dance has always been there for me, and looking back, I definitely used it as an escape. I didn't really know whether or not I wanted a career in dance, but I knew I didn't want to be doing anything else. As I grew older, I came to realize that it was that true love for dance that bound me to it. I started to really appreciate what it has given me and how much it has taken care of me, and like anything in life, you take care of all that loves you. I continue to make that choice and pour that love right back. That is at the core of my forever growing relationship with dance.

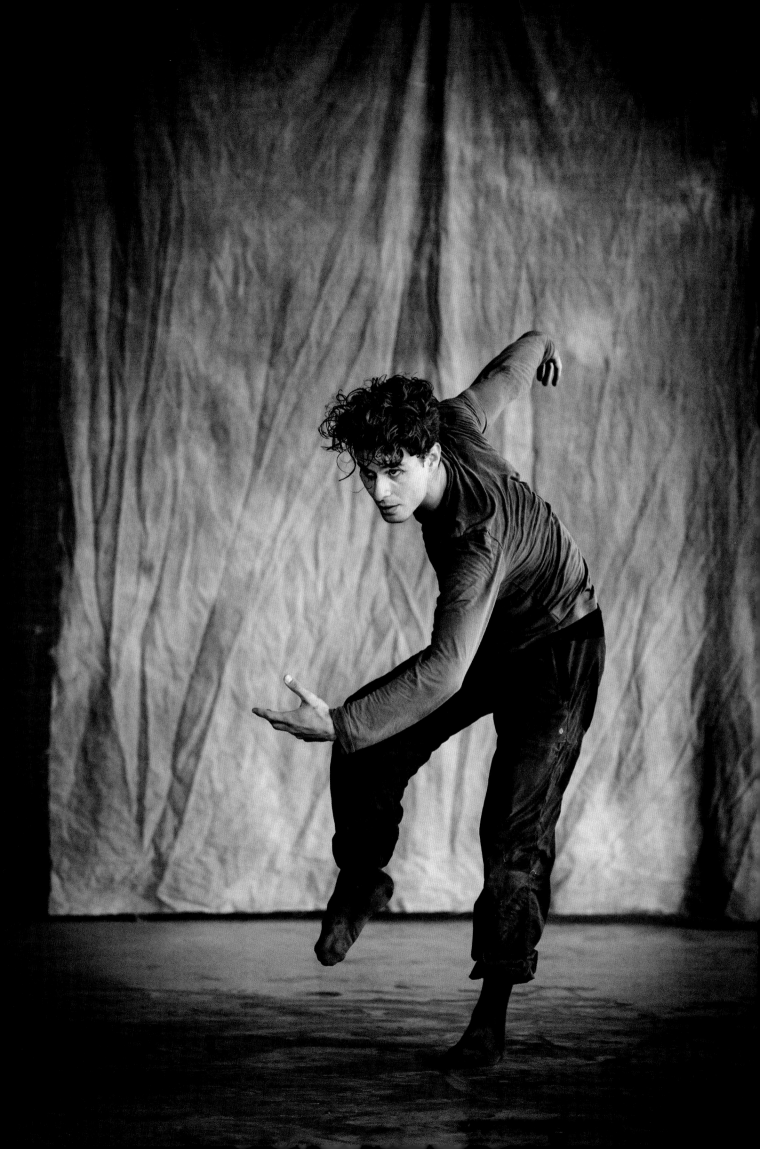

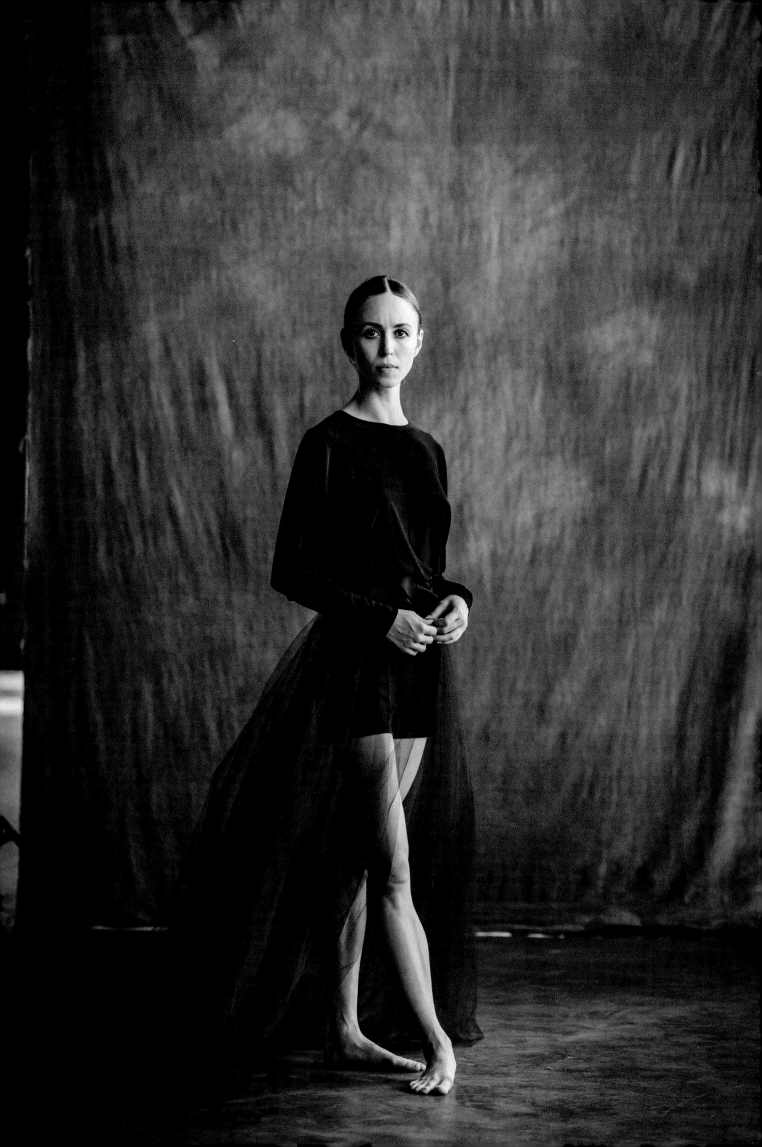

SKYLAR BRANDT Ballet

I have committed myself fully to dance because I feel that it is my calling. I knew at just eight years old that I wanted to become a principal dancer at American Ballet Theatre, and I have taken that dream very seriously my entire life. To me, dance is equivalent to pure elation. I am most fulfilled and joyful when I am dancing. It is one of the greatest forms of expression. It is both a sport and an art. It allows me to transform into any person, character, animal, or otherwise, just by moving my body. I become an embodiment of music. Dancing gives the power to move people on the deepest emotional levels. It is a magical art form that allows dancers and observers alike to experience a departure from their daily lives. Dance provides a space where I can use my imagination to its greatest potential. It continues to awaken my inner child and allows me to soar physically, mentally, and emotionally.

When I dance, it feels completely natural. I have trained my entire life so that my movements are as simple as breathing. And yet, my mind and my body are exhausted to their most extreme limits. The push to execute each movement as precisely and perfectly as possible feels like survival, yet my mind must remain in total and complete control. When I am finished dancing, rather than feeling tired, I am totally energized and inspired. Dance is my life force.

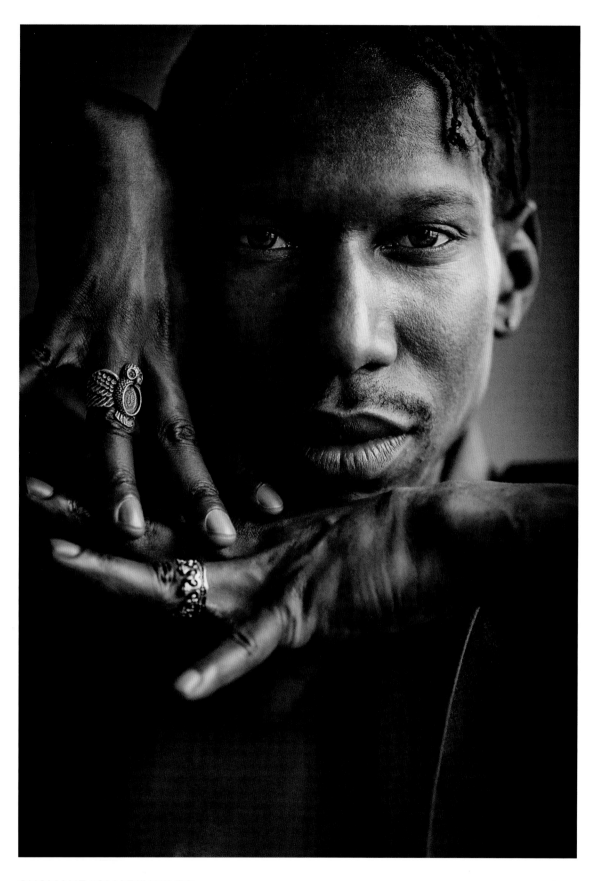

OUSMANE "OMARI" WILES Vogue

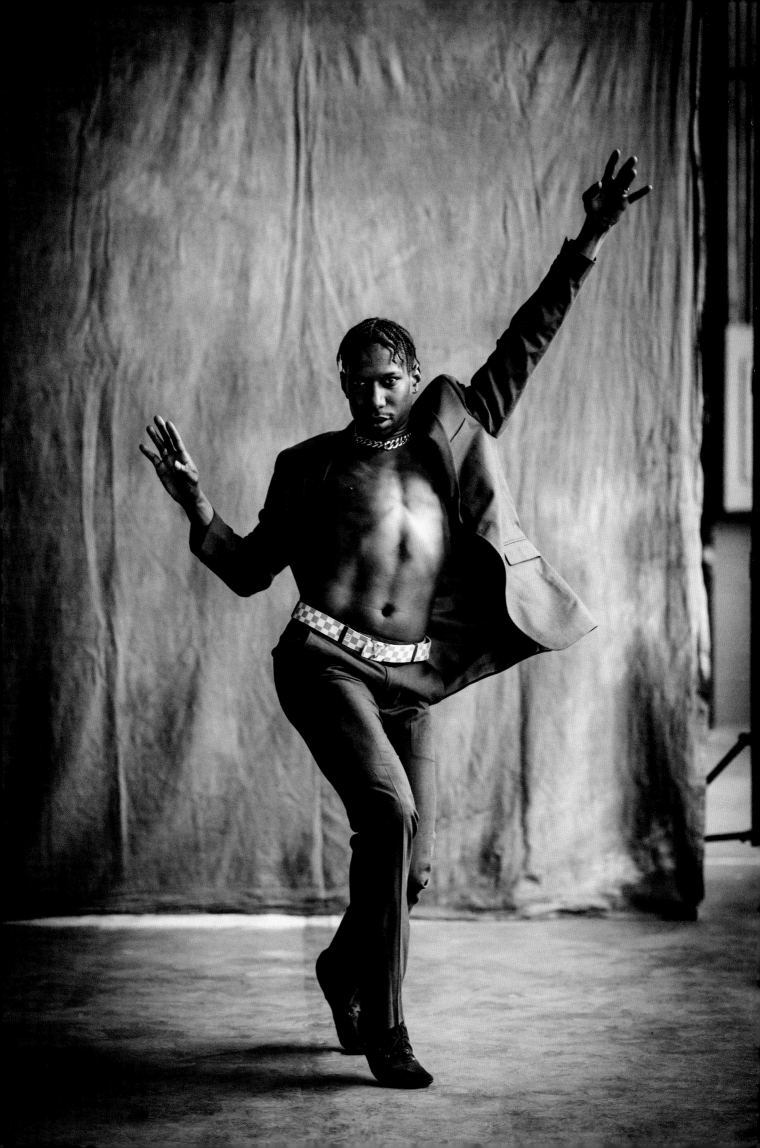

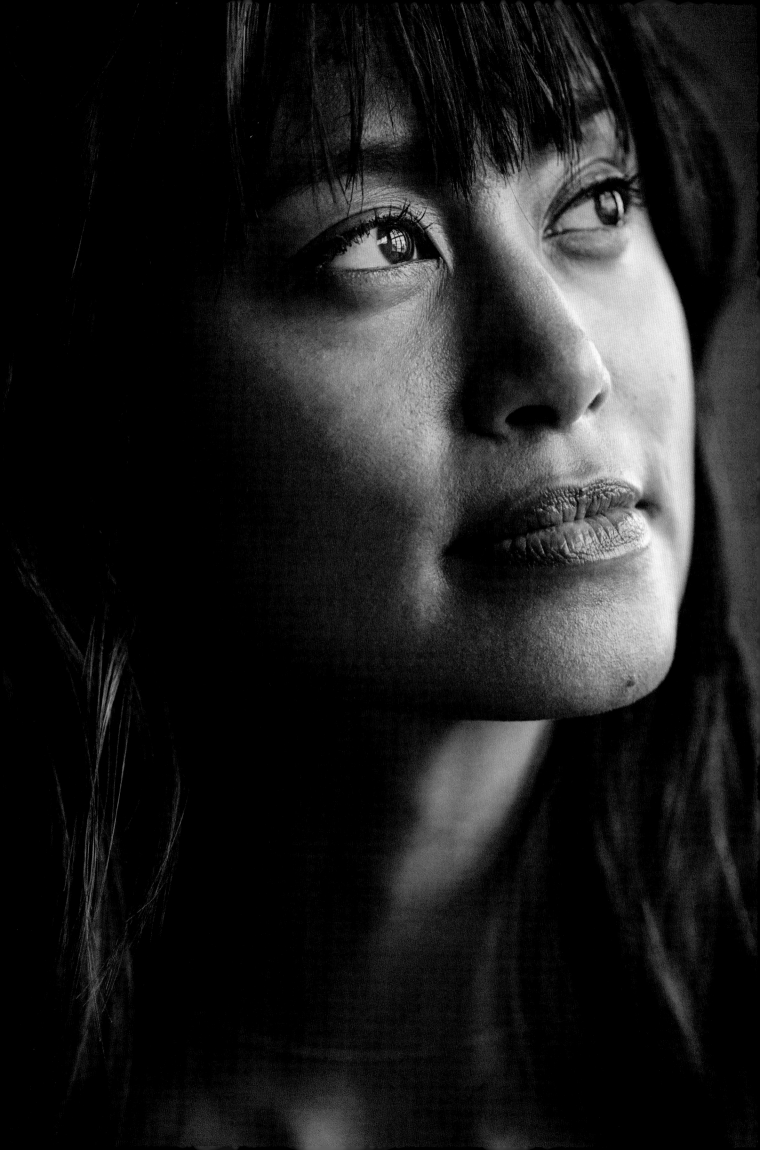

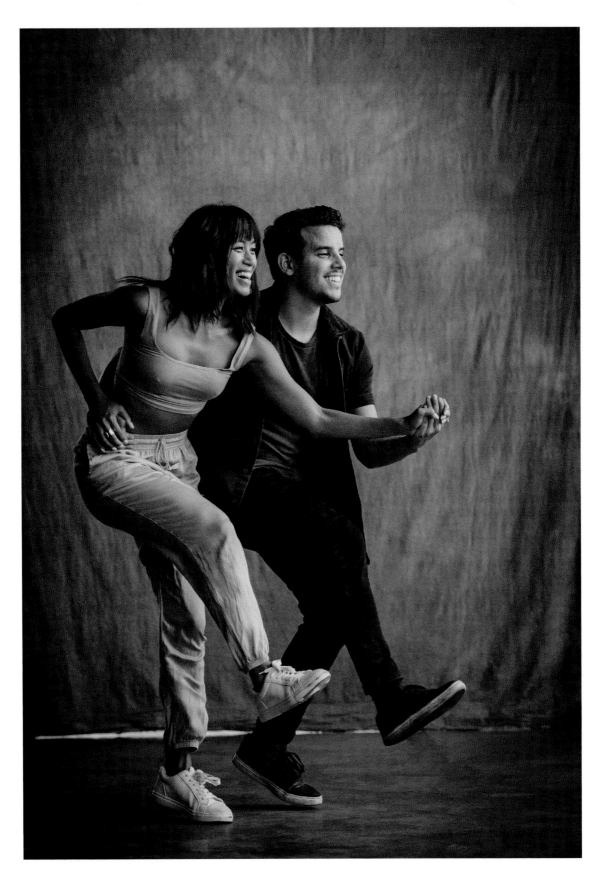

KARLA PUNO GARCIA and DAVID GUZMAN Broadway

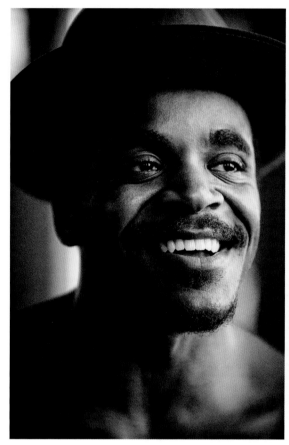 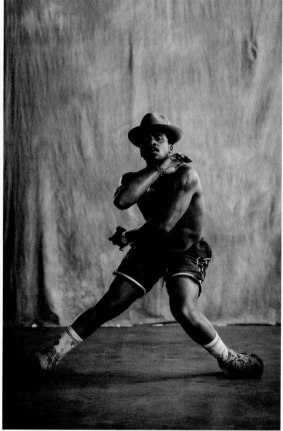

MALEEK WASHINGTON Contemporary

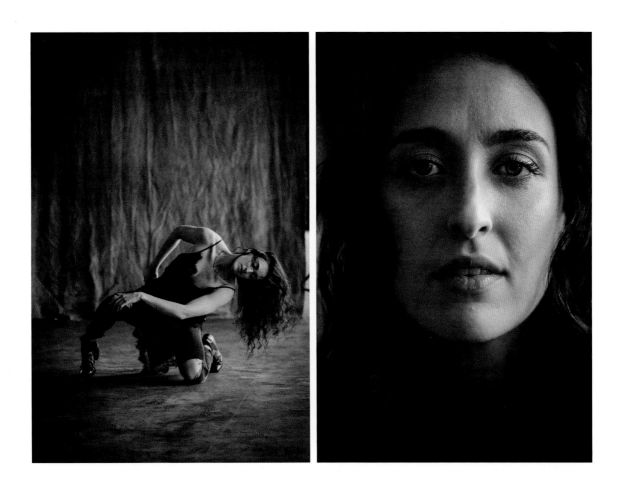

MADELINE WRIGHT Contemporary

When I'm dancing, there's a simultaneous giving and receiving. My attention will be drawn to the feeling or exploration of something very specific, but at the same time my imagination is open to the unexpected and willing to be inspired by new information. I feel very in tune with the variables—the music, the movement, the other bodies in space. I guess it's kind of like having a conversation with the moment.

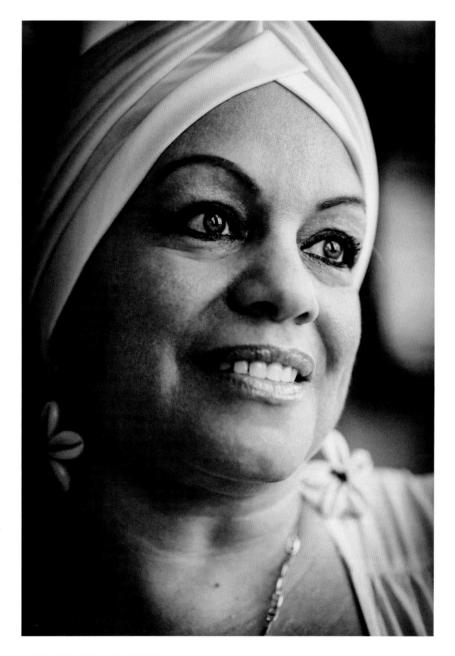

VIOLETA GALAGARZA Hip-hop

I made dance my whole life because I feel I have a purpose. I have a mission to complete. I love to inspire and help my community and the dancers who feel they cannot reach their full potential.

Dance is the way I express myself when words are insufficient. I am expressing a story that reflects my current or past situation. My goal is to leave an impact on the audience when I leave the stage.

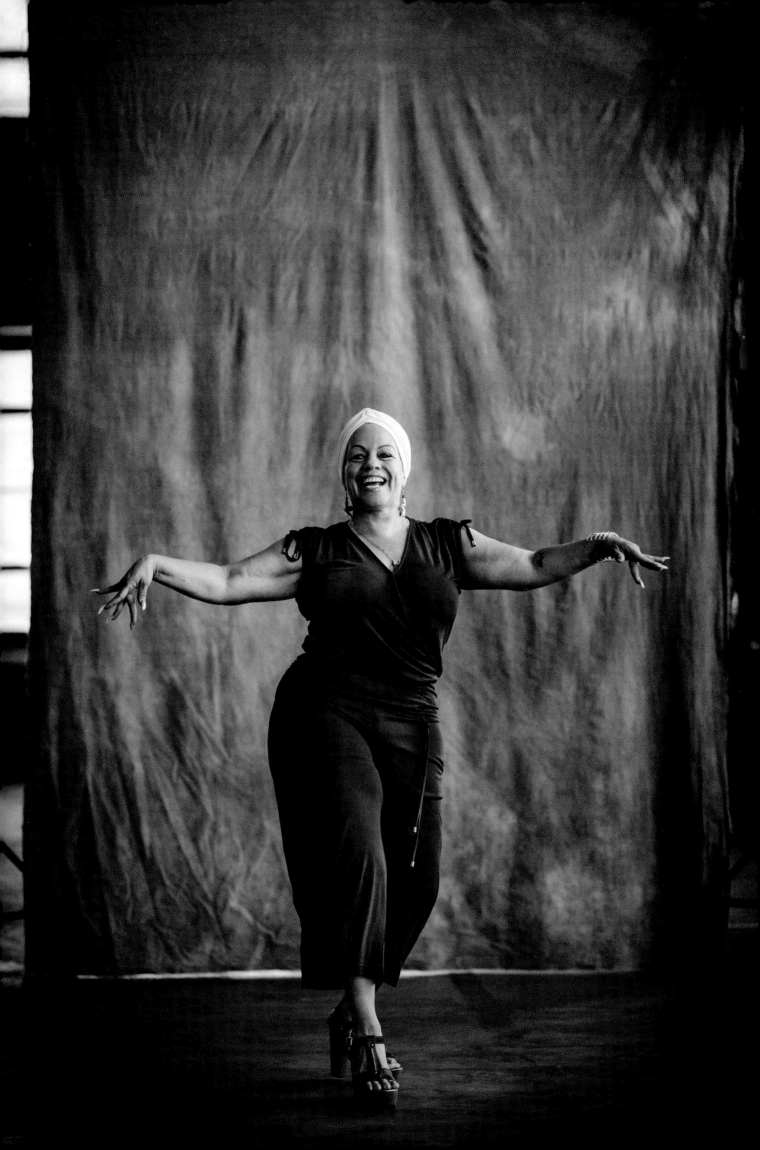

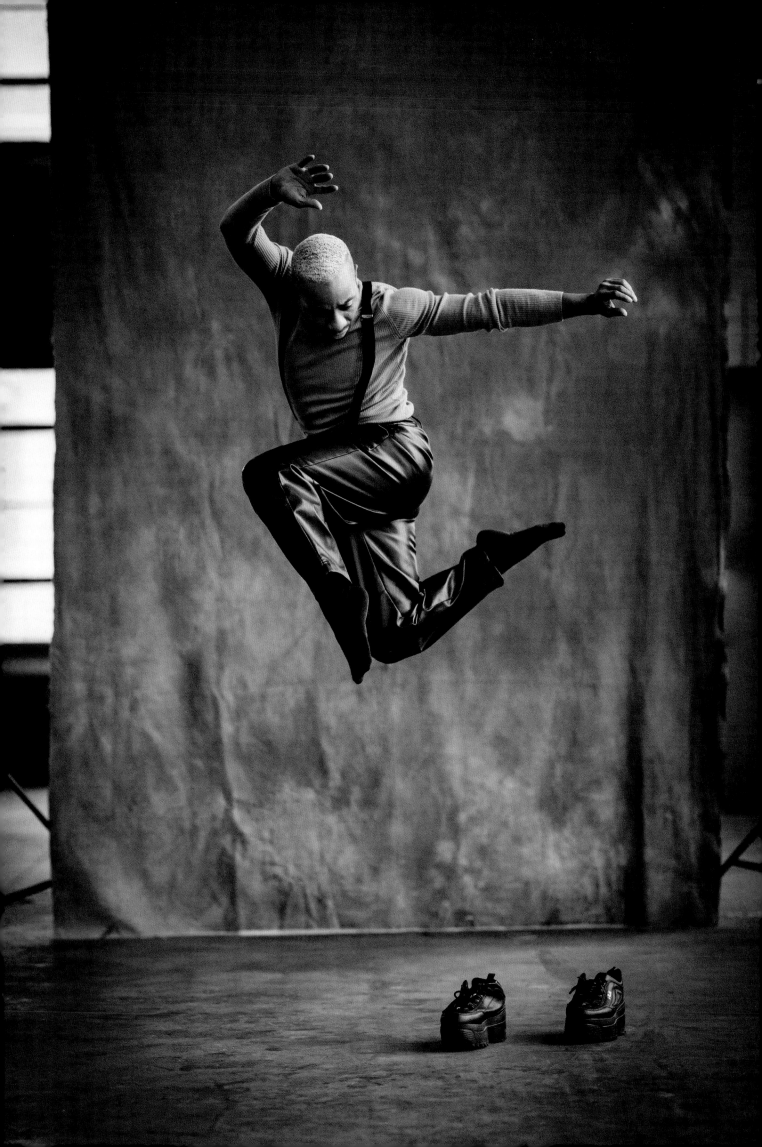

RODERICK GEORGE Contemporary

OVERLEAF: **CONNOR HOLLOWAY** Ballet

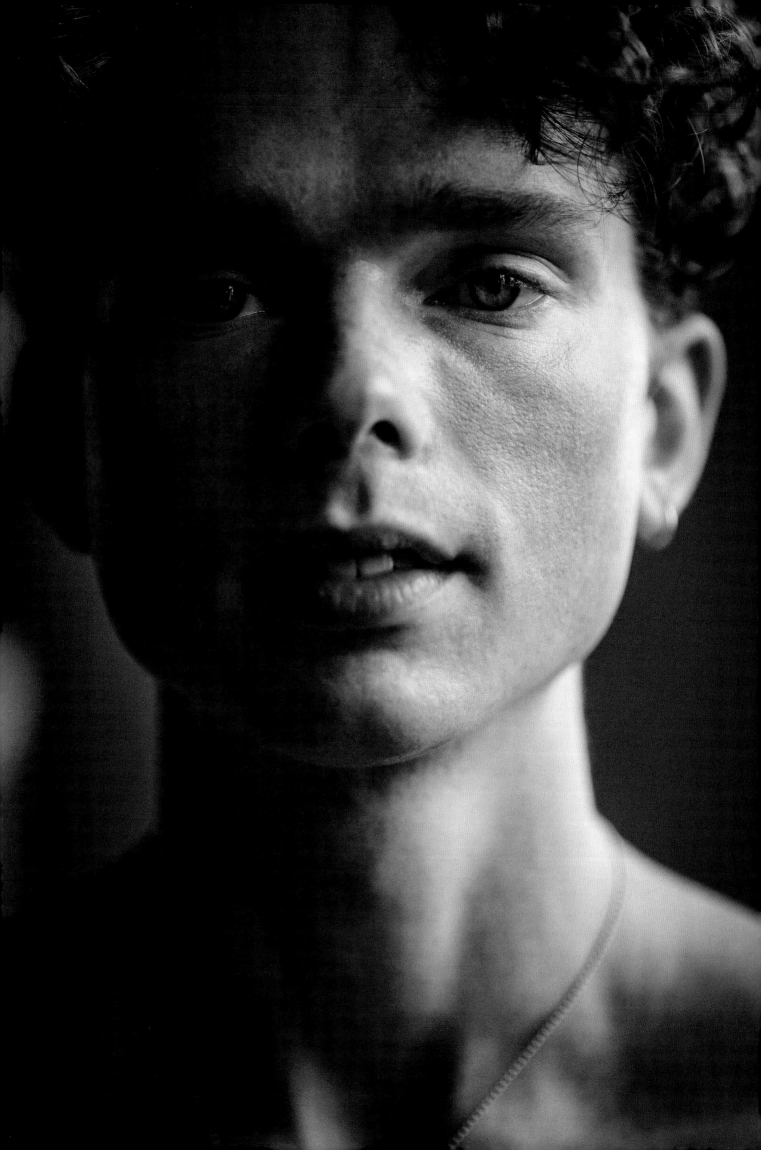

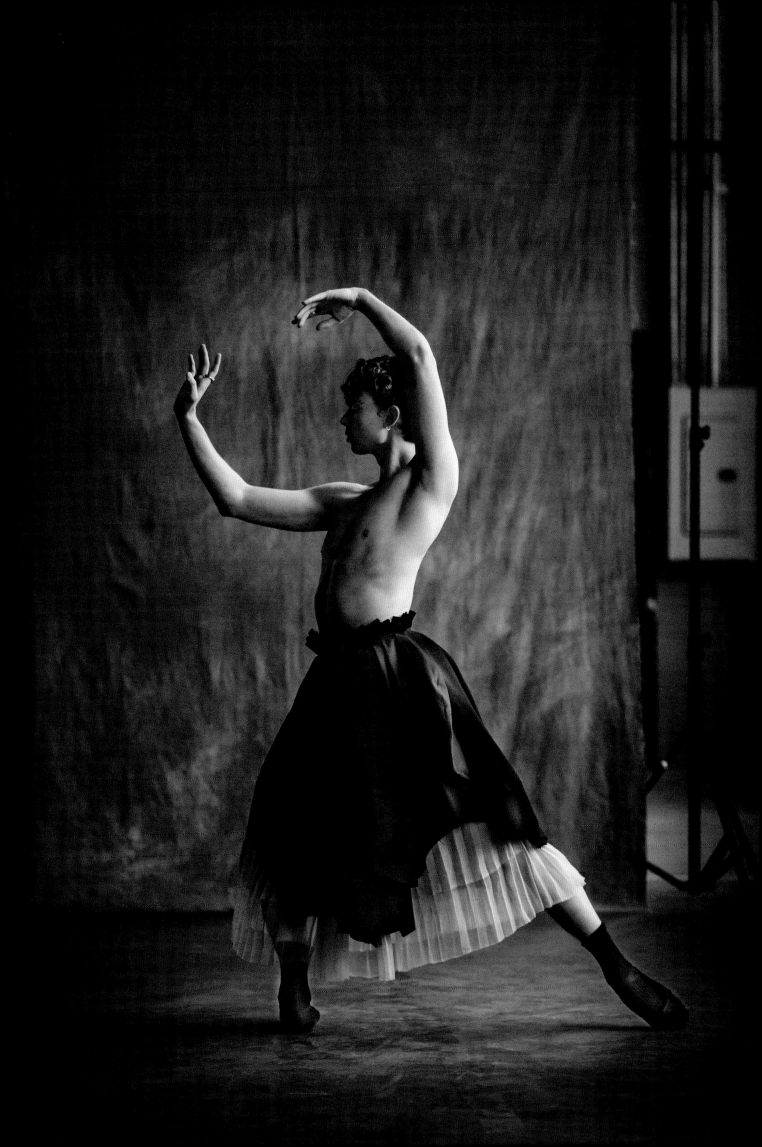

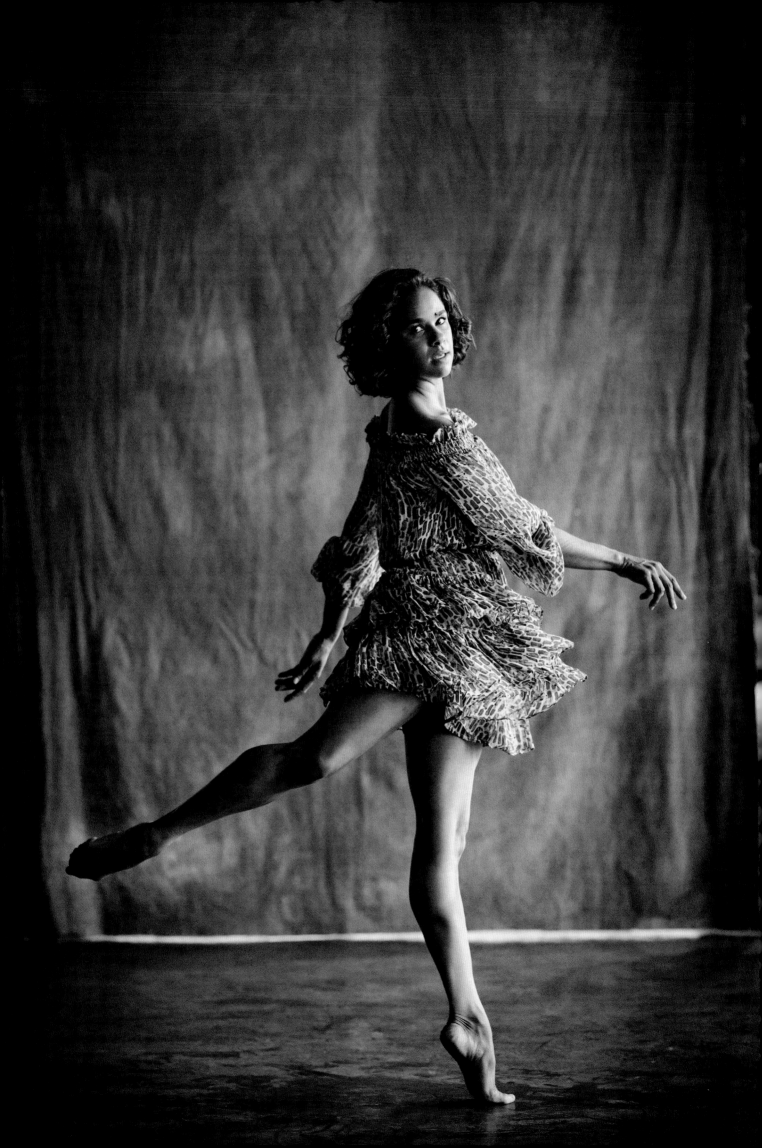

MISTY COPELAND Ballet

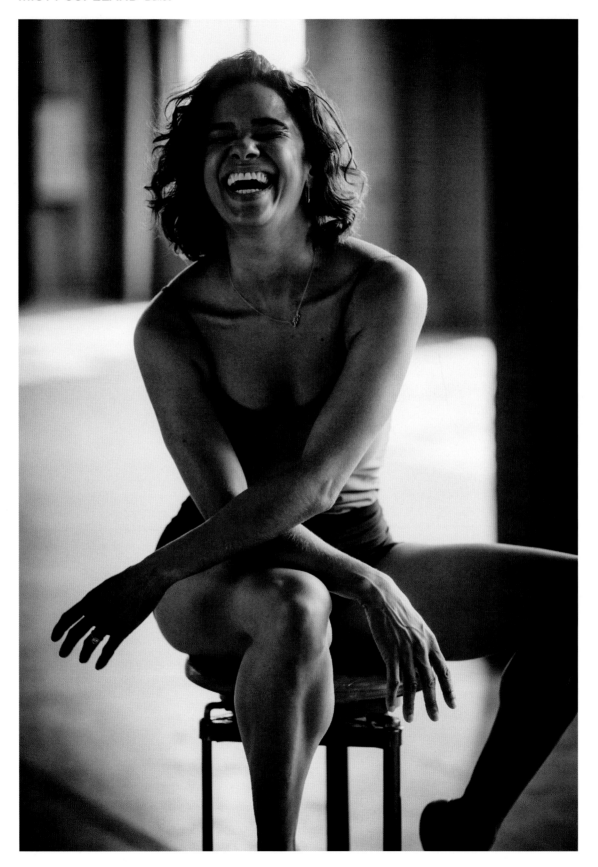

ALEX NORDIN Broadway

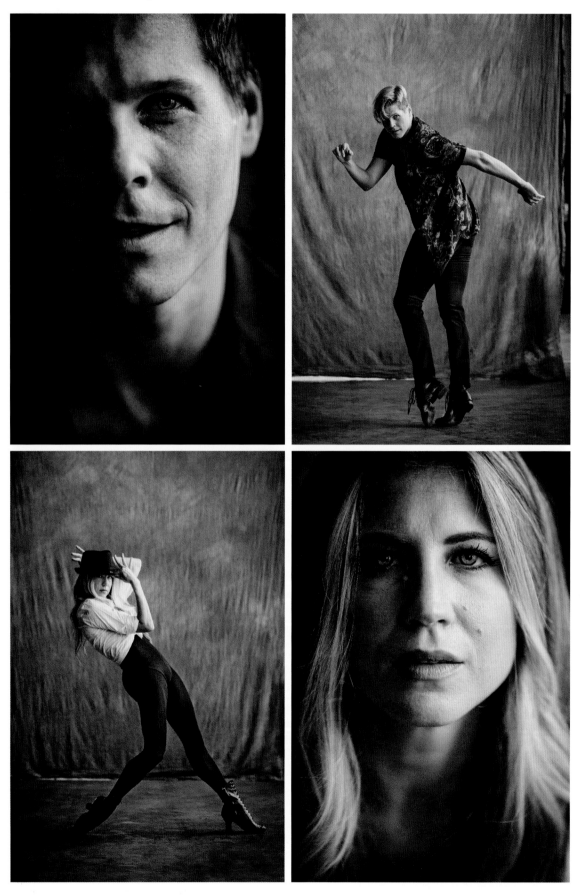

ASHLEY BLAIR FITZGERALD Broadway

MICHELE BYRD-McPHEE Hip-hop

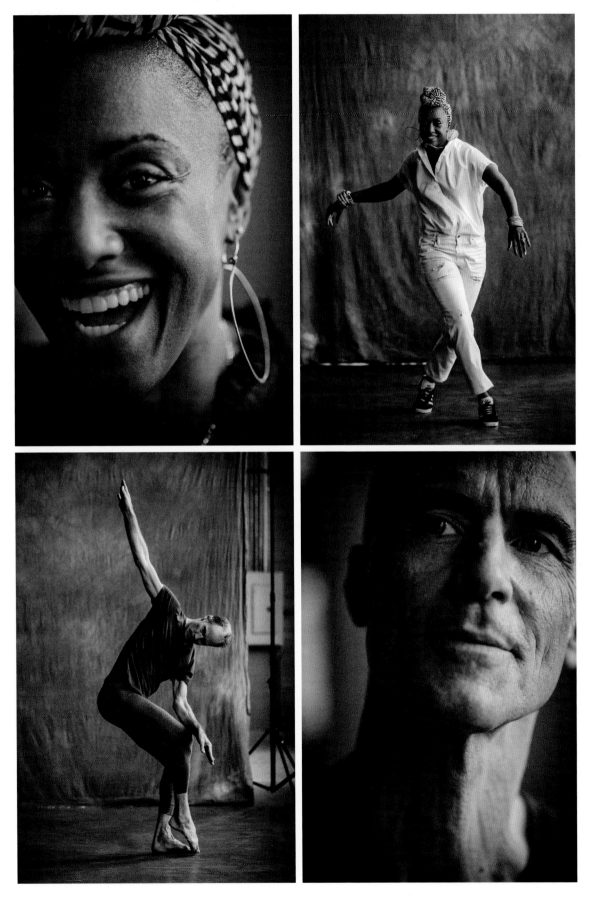

ALAN GOOD Postmodern

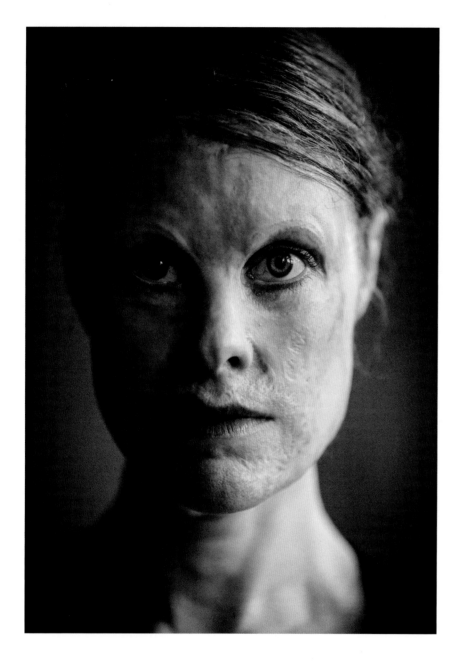

LESLIE FREEMAN TAUB Modern

I have felt real joy in the singularity of my disabled body's inherent shapes and rhythms and in community movement, simply playing and disrupting (or "cripping") space with other disabled folks. To dance as a vocation pushes me both to hone my natural movement vocabulary and to access common language in order to communicate with artists and audiences across borders and layers of identity. I love all the possibilities for connection.

I think dancers often have a more intuitive understanding of collaboration and interdependence than other artists. In pockets of the New York City dance community, this has produced an interesting, potentially generative tension between an empathic urge toward social justice and the kind of resistance to change found in so many historically enshrined or canonized "high art" forms.

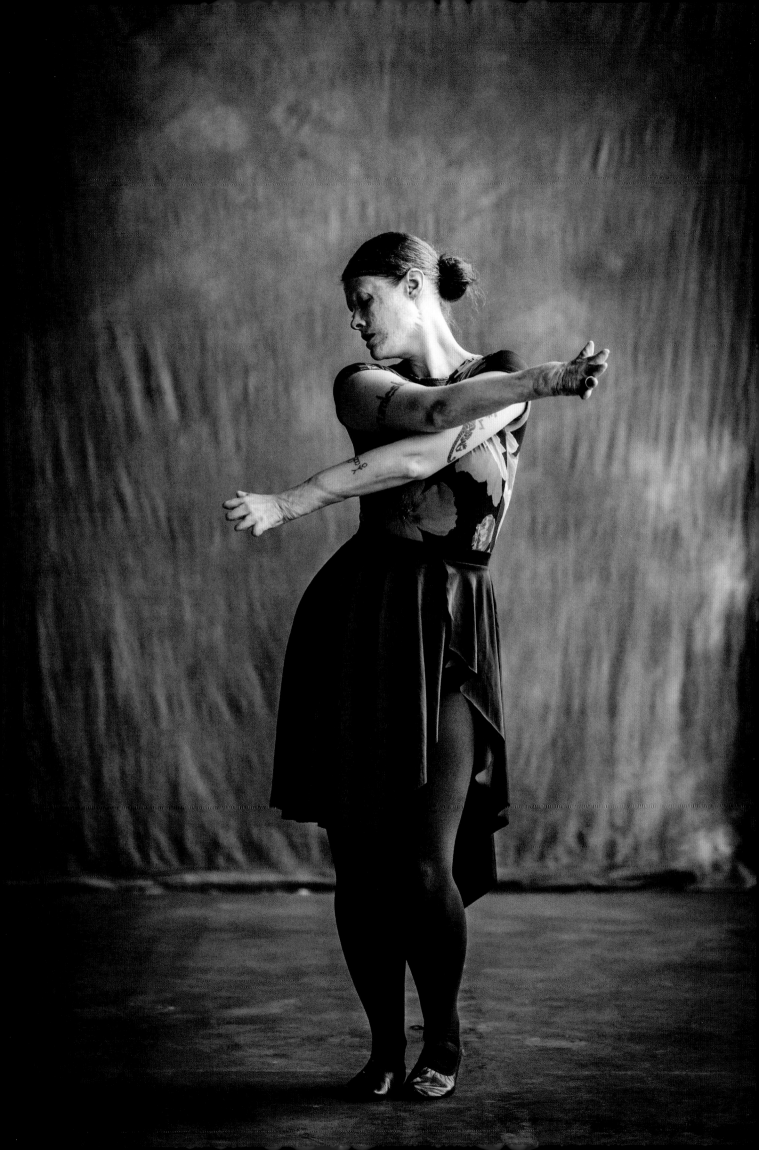

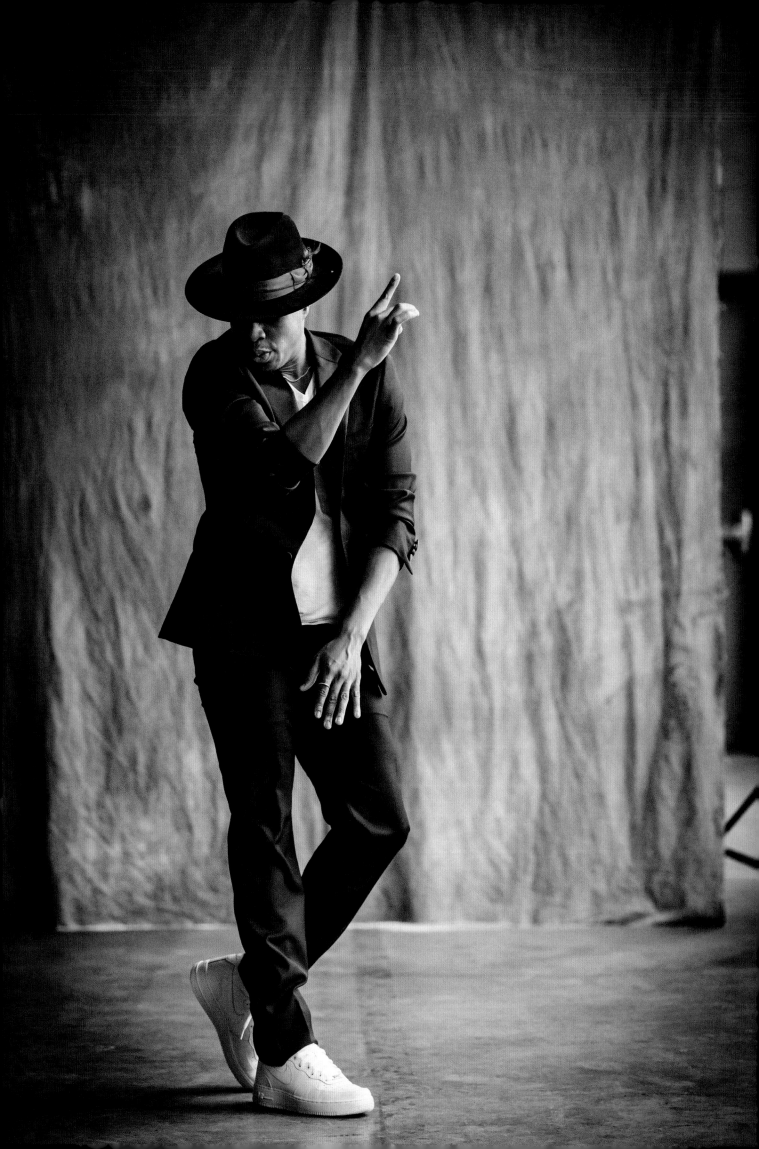

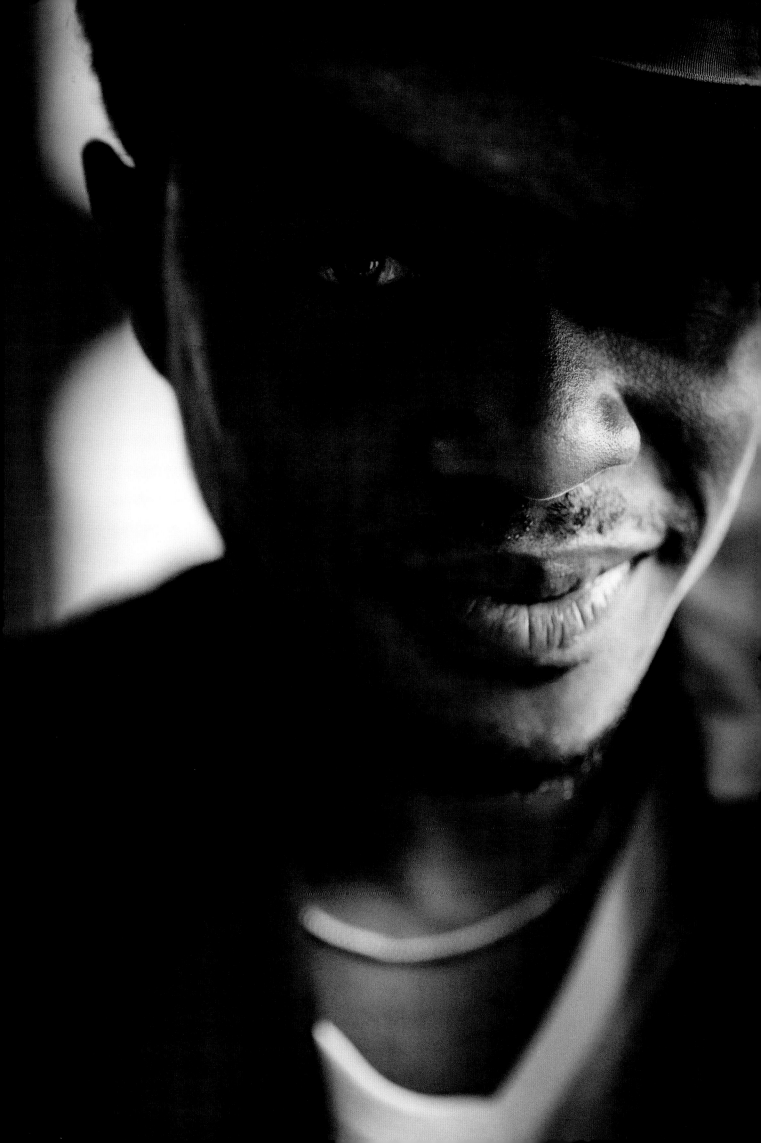

PRECEDING PAGES: **EPHRAIM SYKES** Broadway

CATHERINE HURLIN Ballet

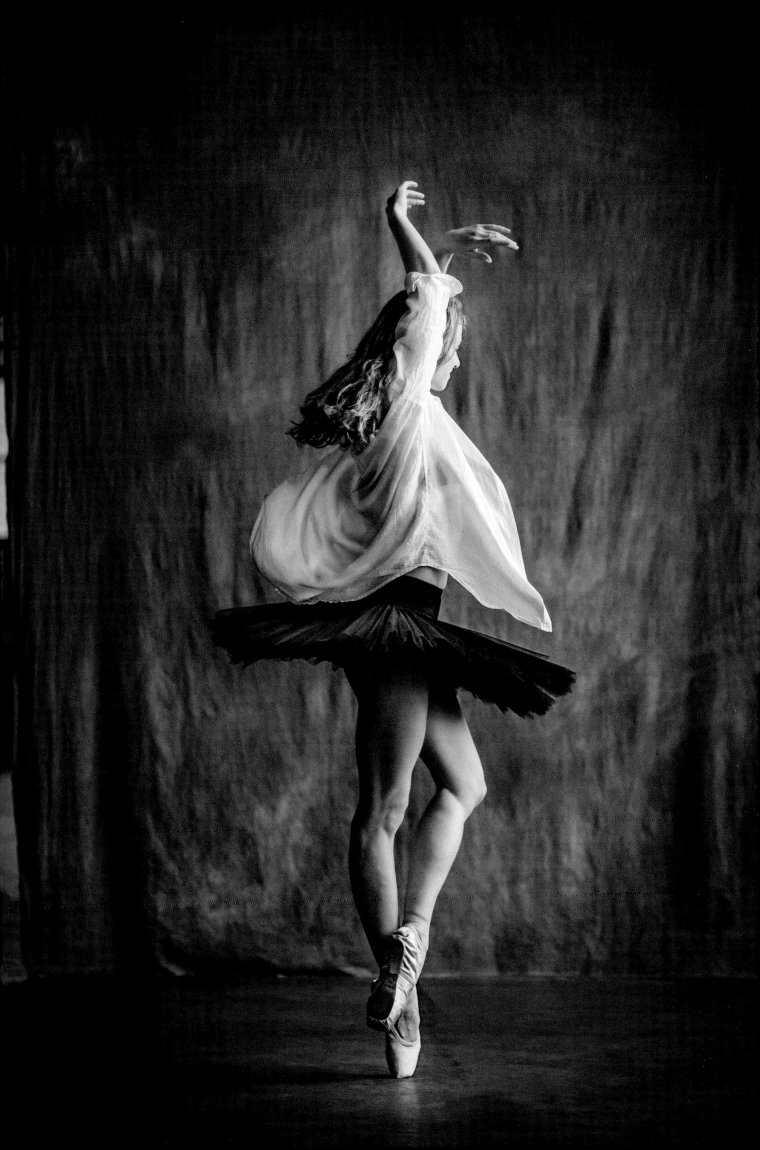

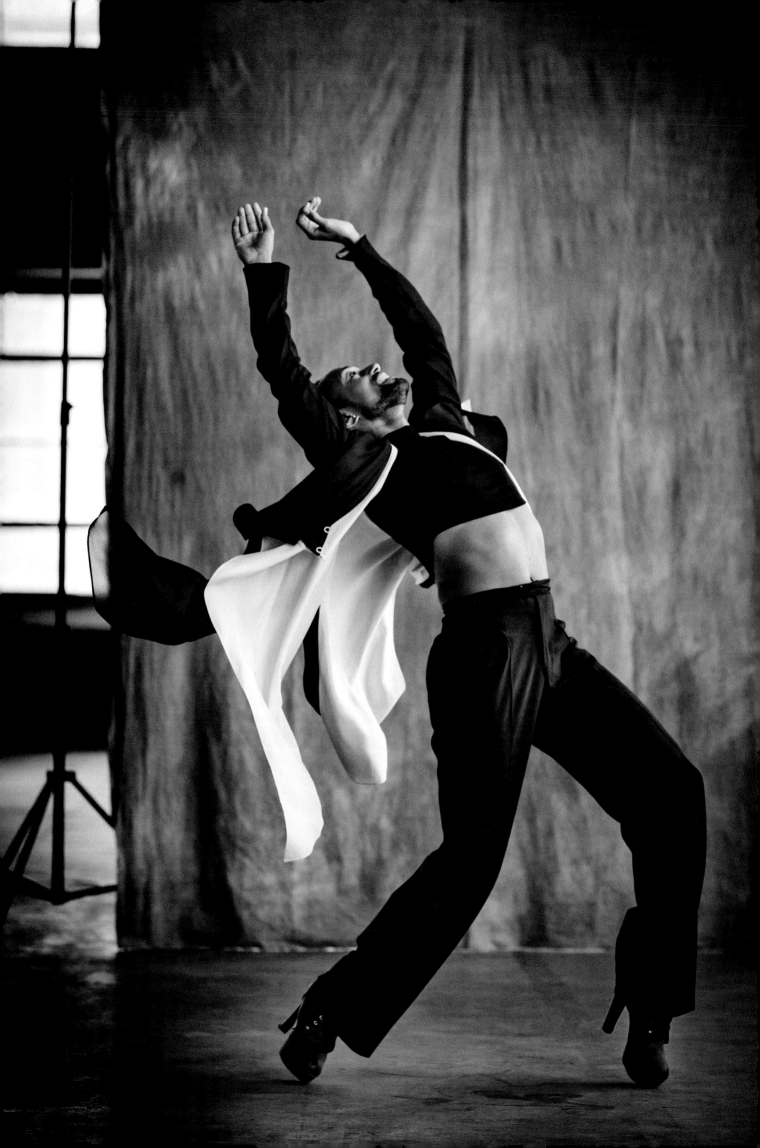

ABDIEL Hustle

Dance is life. The body is the first instrument; hence somatic expression is the oldest and most powerful expression. For this reason, even those who don't practice dance as a career will get the greatest benefit from dance if they view it as a way of being rather than as a hobby. I have dedicated my life to dance because each moment I dance, I feel a life-giving force reawaken me to my soul's existence. That practice has nourished a deeper sense of wholeness by demanding the fullness of me emotionally, physically, mentally, and spiritually.

When I dance, I feel a power immeasurable, a freedom unbounded, and a joyous release. Each time I begin to move, I experience a flow of energy coursing through my entire body. Sometimes it can feel like a surge of water rushing down my back like a waterfall, a light breeze of air brushing across my face, a fierce heatwave of energy burning deep in my core, or grains of soil grounding my feet in the earth. Even when I'm exhausted, I am constantly reinvigorated by dance, so I always emerge more awakened and energized.

As a queer, gender-fluid person of color, I have excelled in my career but not without attacks on my sexuality, gender identity, and race. "Dance like a man," "Your natural hair is a distraction," and "You move too feminine" were commonplace criticisms of my self-expression that I would constantly have to navigate. I found myself struggling to find my authentic voice until I began to accept that everything I am is perfect just the way it is.

When I first found the Hustle dance community in NYC, I discovered a space where I could be my fullest self, my freest self. This space, where participants can exist in an authentic way, inspires self-expression and play and fosters lasting relationships. This is a multigenerational community of social dancers of all backgrounds and abilities—both professional and nonprofessional—who engage in communal celebration of life through rhythm and touch.

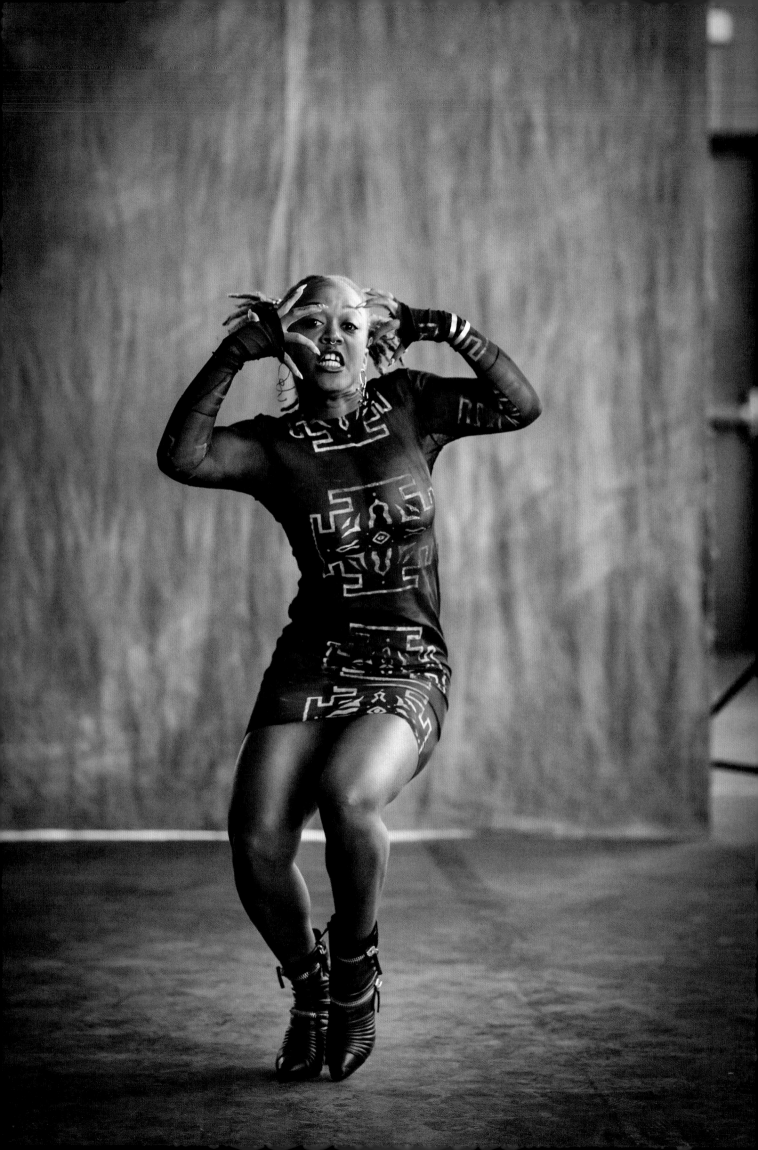

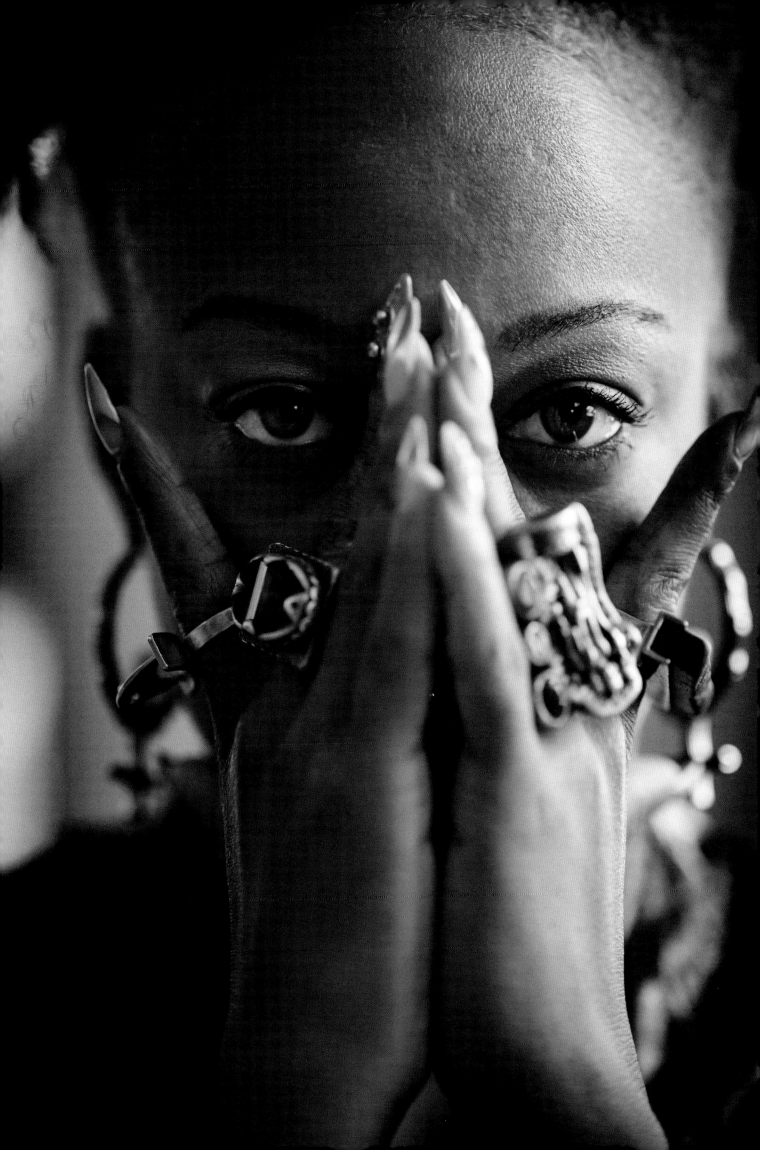

JAMES WHITESIDE Ballet

You know when you find that one thing that you're naturally good at? It could be baseball, or writing, or riding a horse, or math! When you find that thing, you feel like you have a purpose, like you're finally making a worthwhile mark on your life. Dance is that thing for me. It gave me a direction and a chance to express myself, and for that I feel incredibly lucky.

Longevity is hard in any career, but in ballet you've got your physical clock ticking away. Physical pain is something every professional dancer deals with on a daily basis. It changes hour by hour, minute by minute. It's a constant conversation with your body, and sometimes it's a screaming match.

Dancing is social. A career in dance, however, can be rather selfish. It's a strange dichotomy, but they work in harmony, selfish and social. Each dancer looks out for their career while honoring and honing their craft, sharing that experience with others in their company, city, and even online. There's a cultlike fervor attached to dance, and I'm drinking the Kool-Aid.

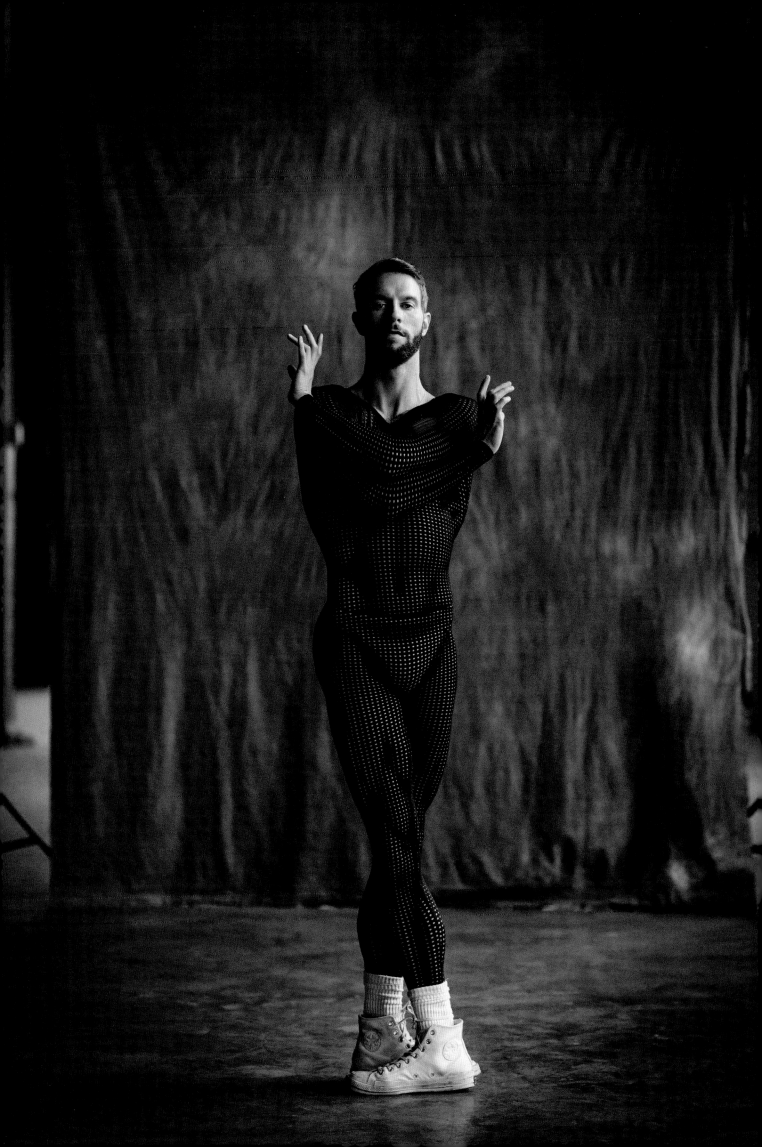

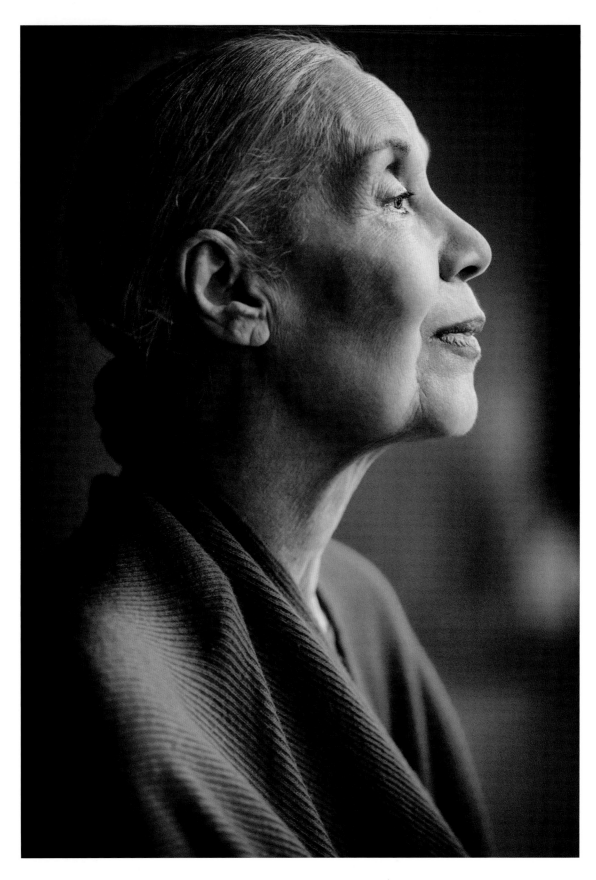

CARMEN de LAVALLADE Modern

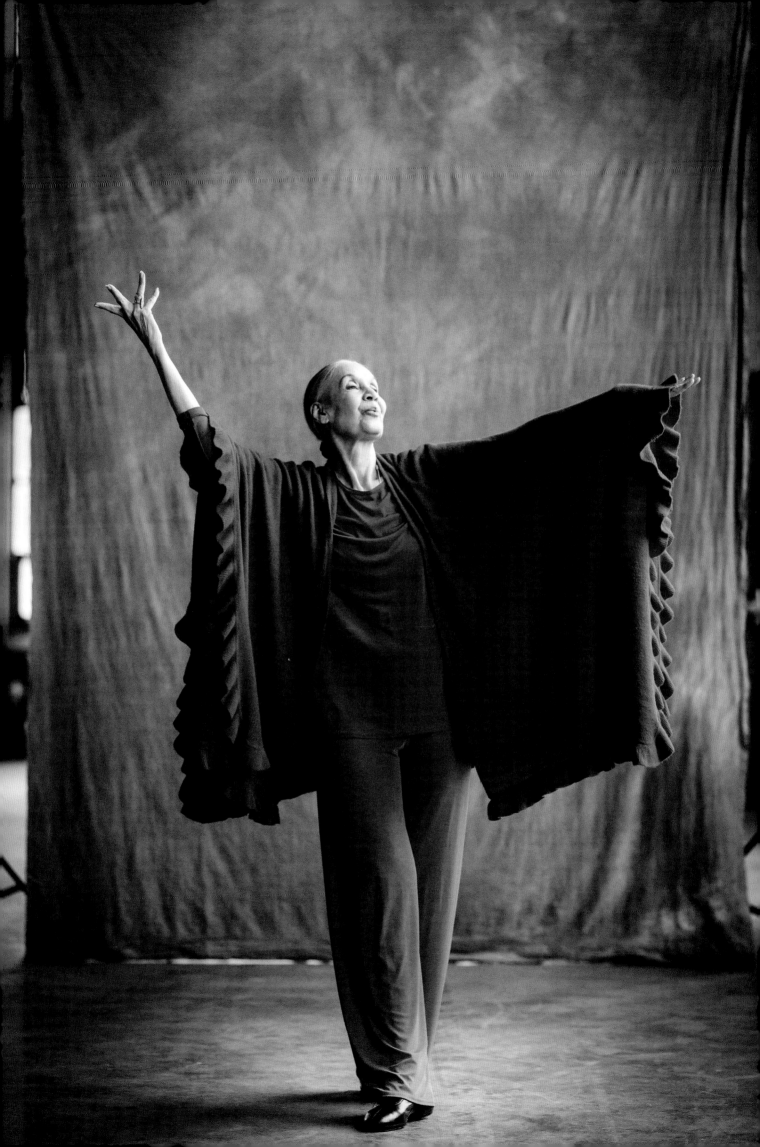

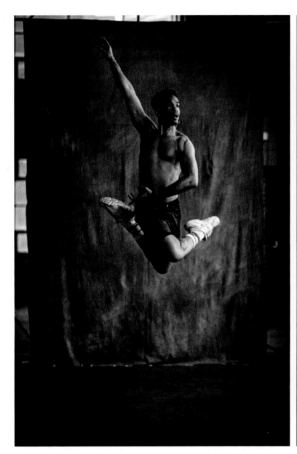 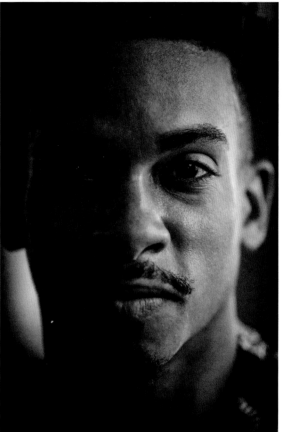

GABRIEL HYMAN Broadway

Dancers are some of the most resilient, intelligent, and creative individuals that I know. The beauty of dance as an art form is that there is not one dancer on this earth who is the same as another. This individuality is the exact thing that unifies dancers as a community. The dance community is filled with an ever-evolving melting pot of artistic uniqueness and individuality. We are forever learning from the past, present, and future of dancers and creators of this incredible community. As the late, brilliant choreographer and dancer Ulysses Dove once said, "There is nothing to prove, only to share."

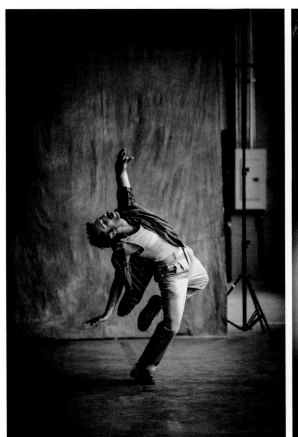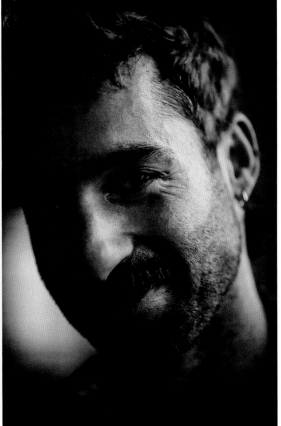

JESSE KOVARSKY Broadway and Physical Theater

OVERLEAF: **JOSEPH "KLASSIC" CARELLA** Flexn

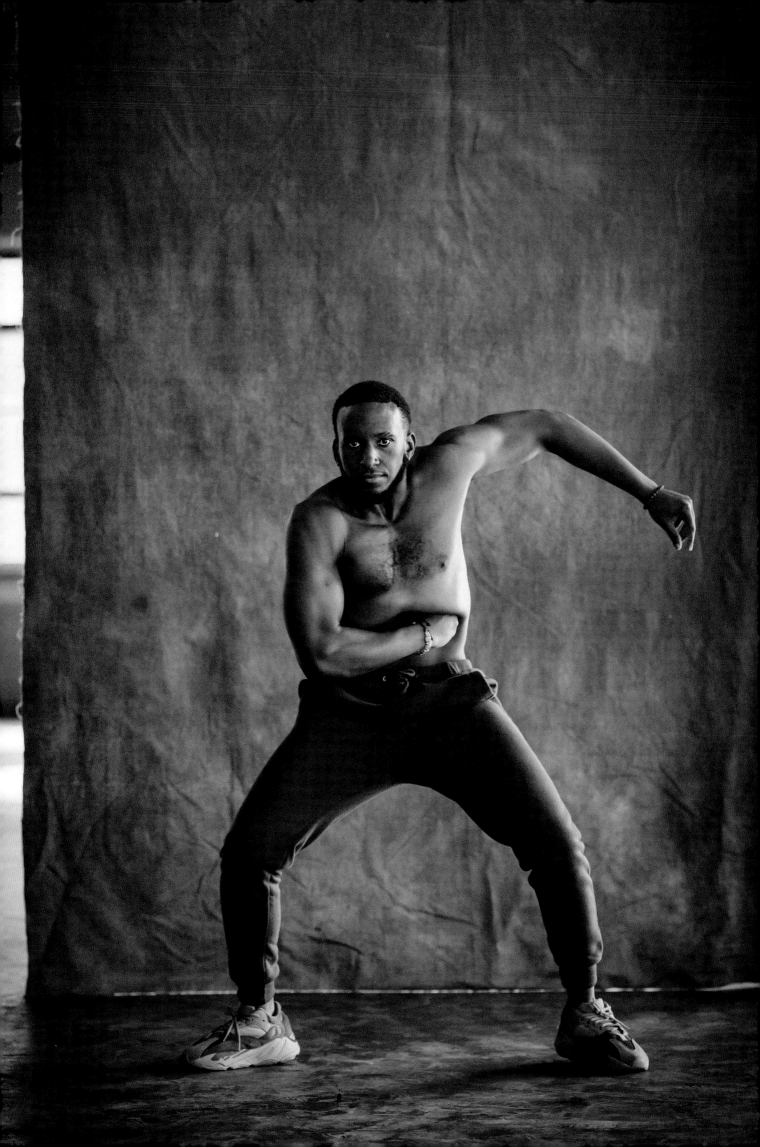

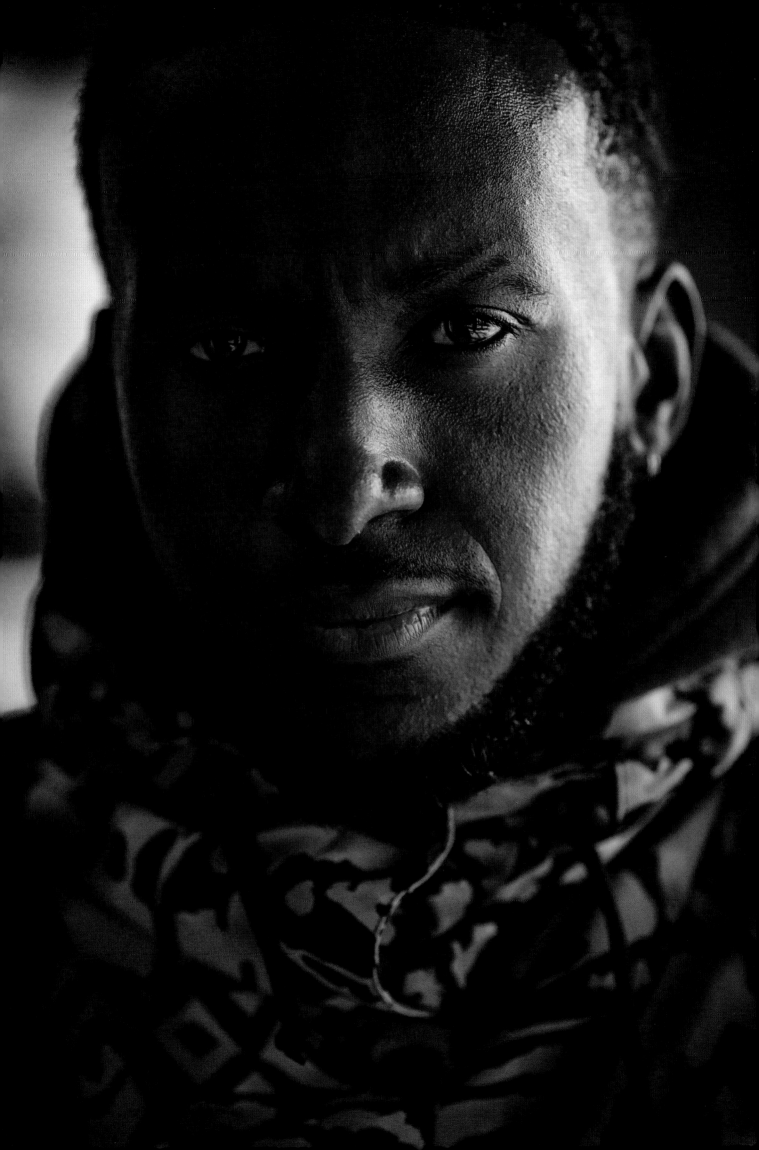

TYLER MALONEY Ballet

Dance has always been my first form of expression. When I was a young boy, it was a safe place for me to express myself freely and to this day it still does that. Dance has been a constant in my life and has given me stability in difficult times. The routine of going to ballet class and starting at the barre everyday became my rock. It was a ritual before it was a profession, and it introduced me to a community that loved me for me and nurtured the creativity within me.

The beauty of the dance community is that it is universal. It doesn't matter what genre, where you are from, or what level you are—everyone can connect to dance. Everyone is a dancer; we all just approach dance in our own way. There are some who perform on huge stages and some on the streets or in their living rooms, but we can all see and respect the beauty our bodies translate. We use our physical being to tell stories and to communicate, and that universal language makes the dance community so unique.

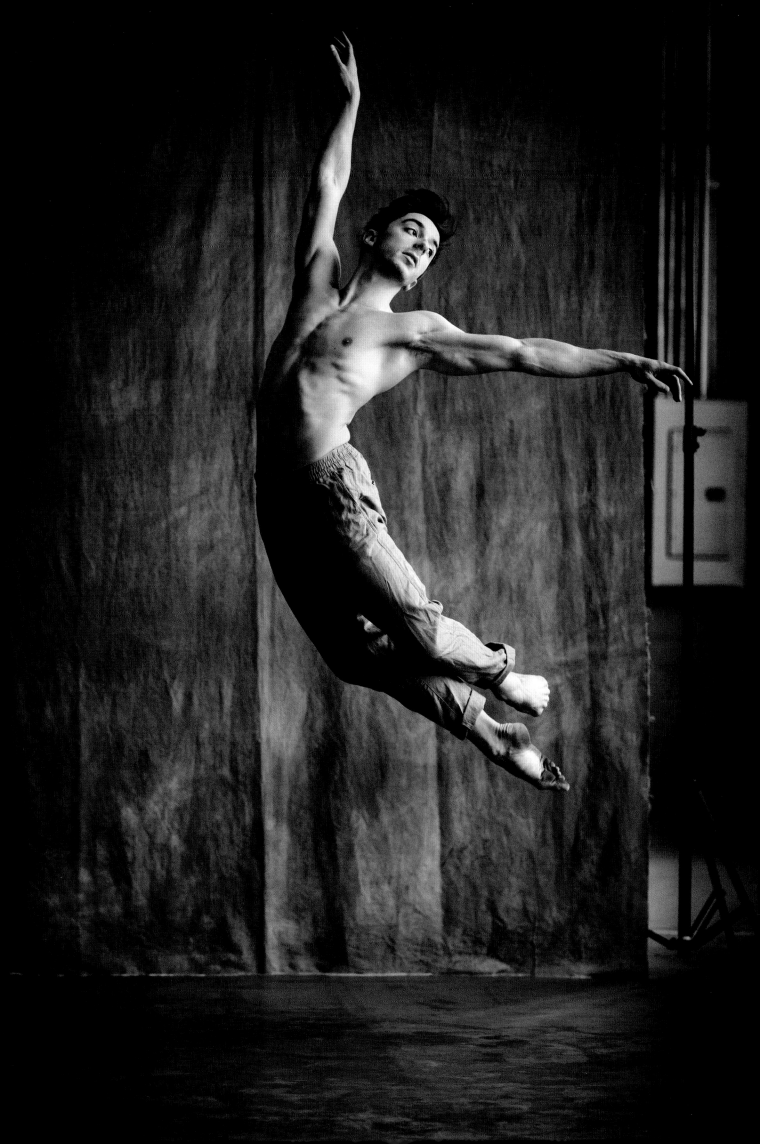

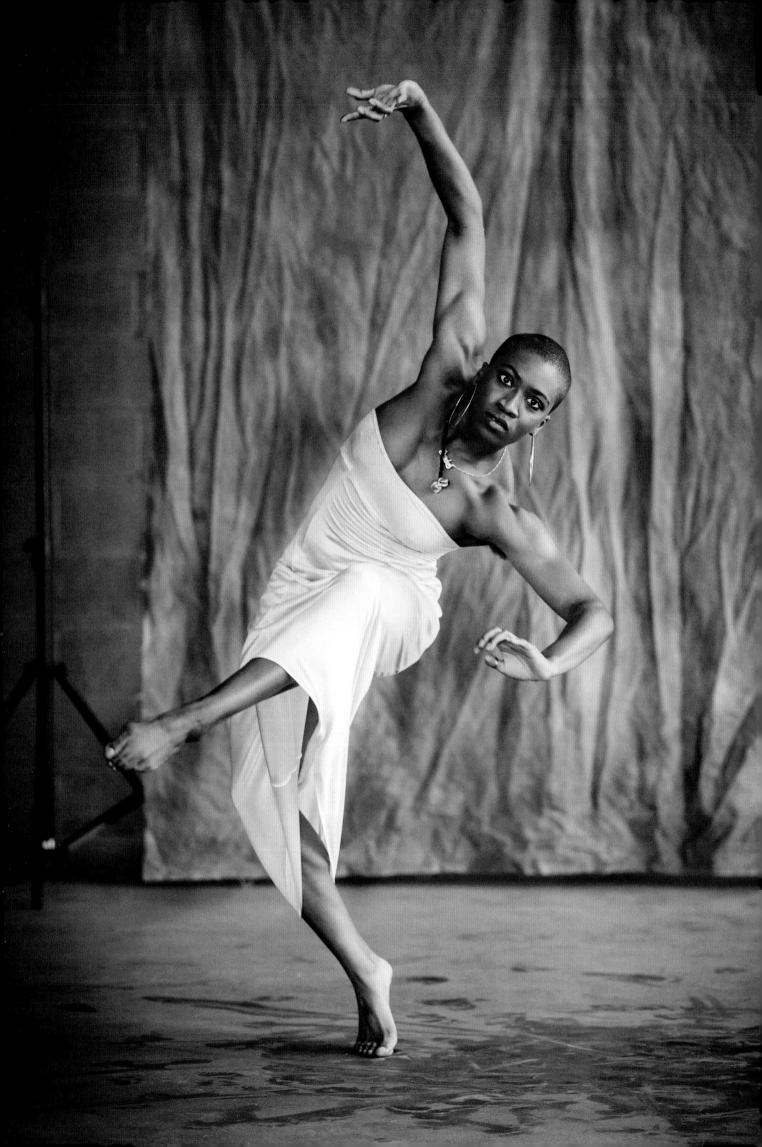

DORCHEL HAQQ Contemporary

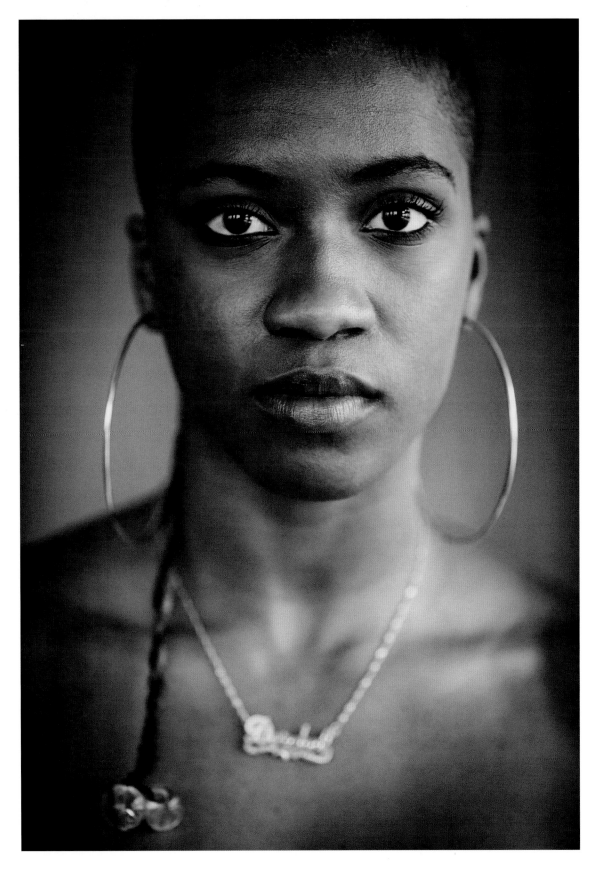

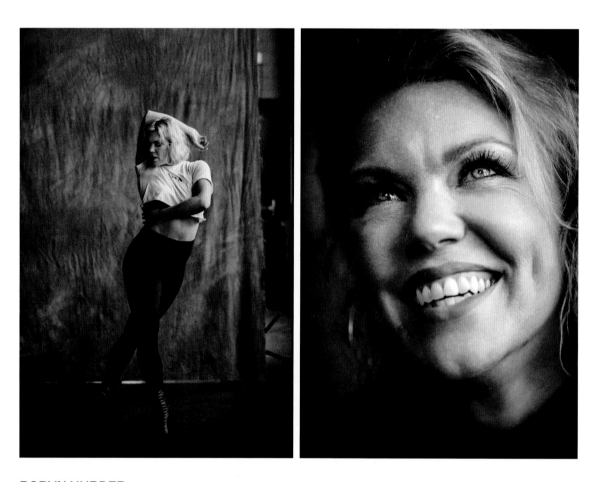

ROBYN HURDER Broadway

MAX CLAYTON Broadway

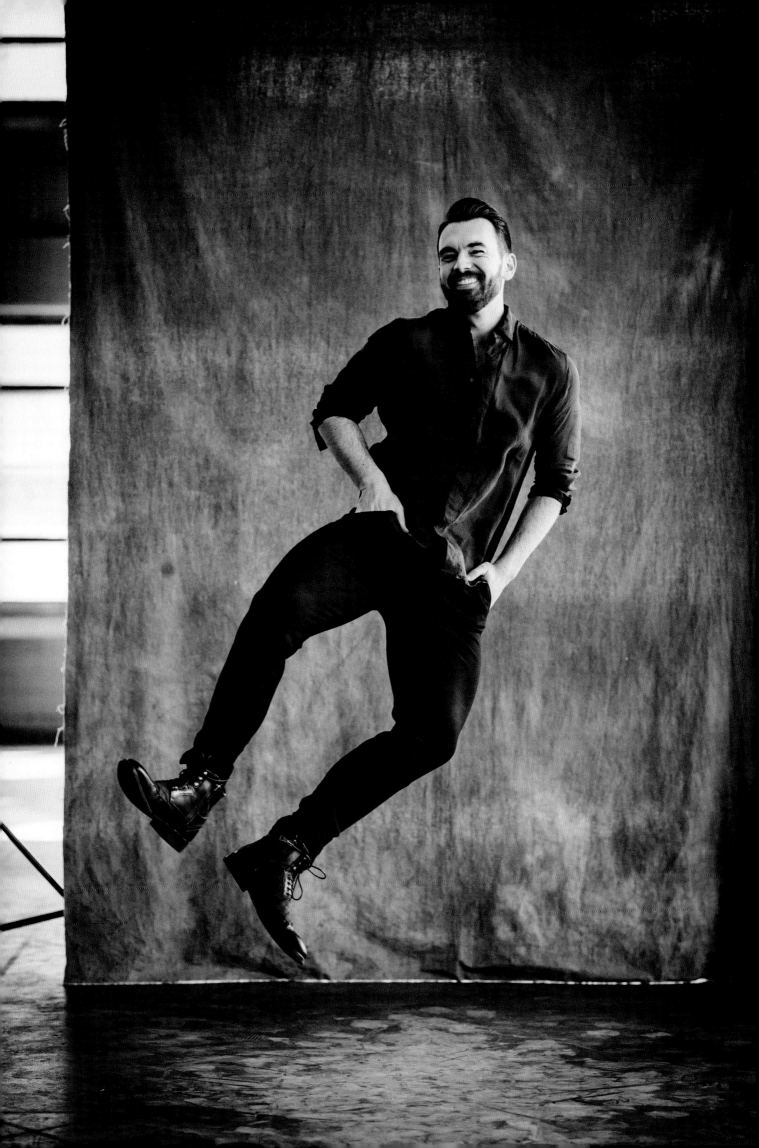

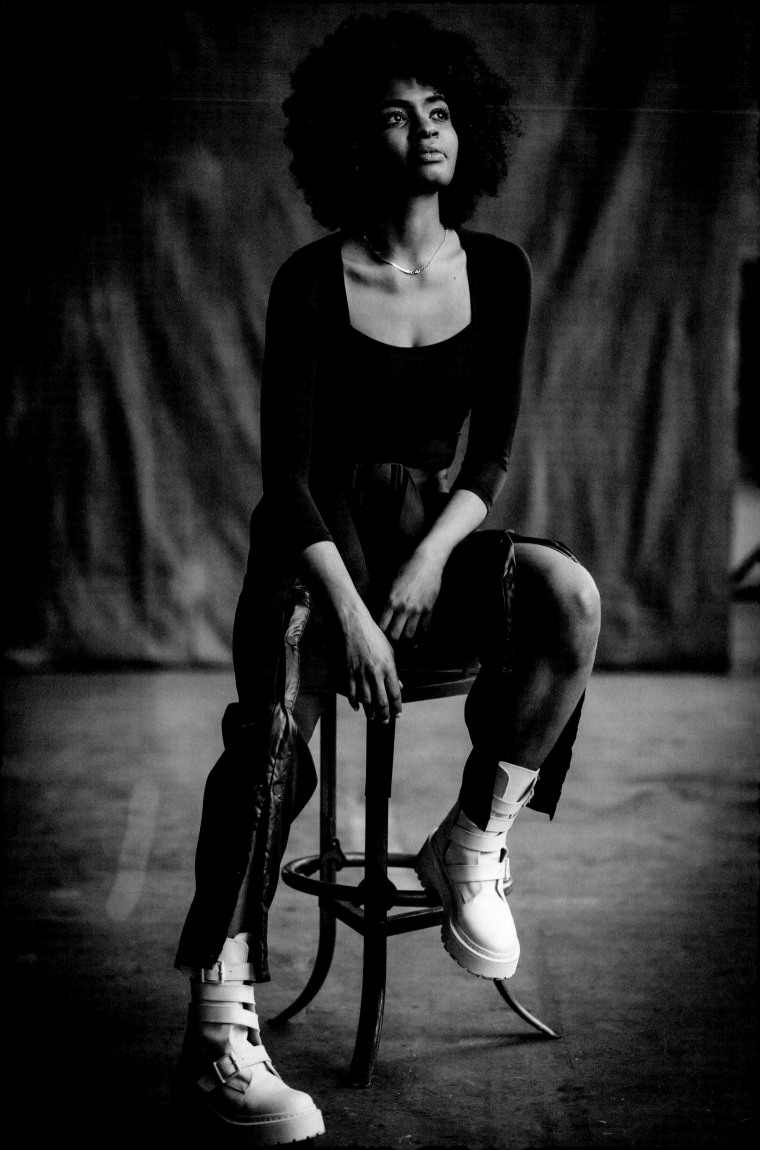

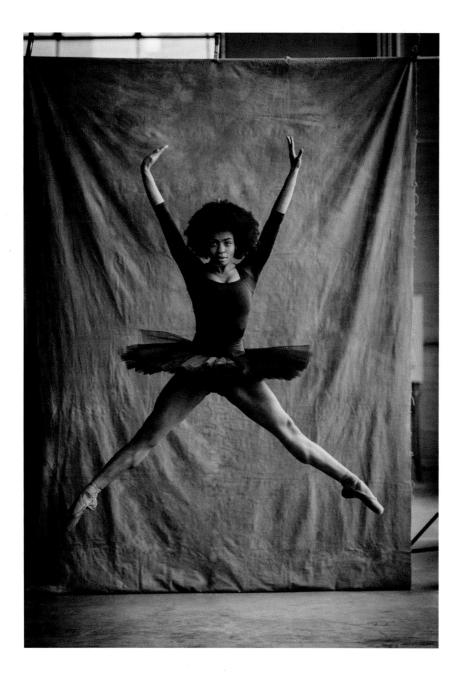

ALEXANDRA HUTCHINSON Ballet

I want my twenty-three years of formal training to shine when I dance. The physicality of dancers can be extremely intense. Sometimes that intensity is the object of the dance, yet there are times when the goal of the dancing can be the opposite. Compounding the physicality of ballet is the fact that performing dancers cannot show fatigue, that they are hurt, that they have an agitated state of mind, or any one of the many challenges that come along with the hectic pace of traveling while on tour. By practicing, I cultivate internal strength every day that ultimately makes me physically stronger. As Arthur Mitchell, founder of Dance Theatre of Harlem, once said, "You represent something larger than yourself." In that regard, when I dance, I feel the choreography, the music, and the magic of ballet. It is exhilarating.

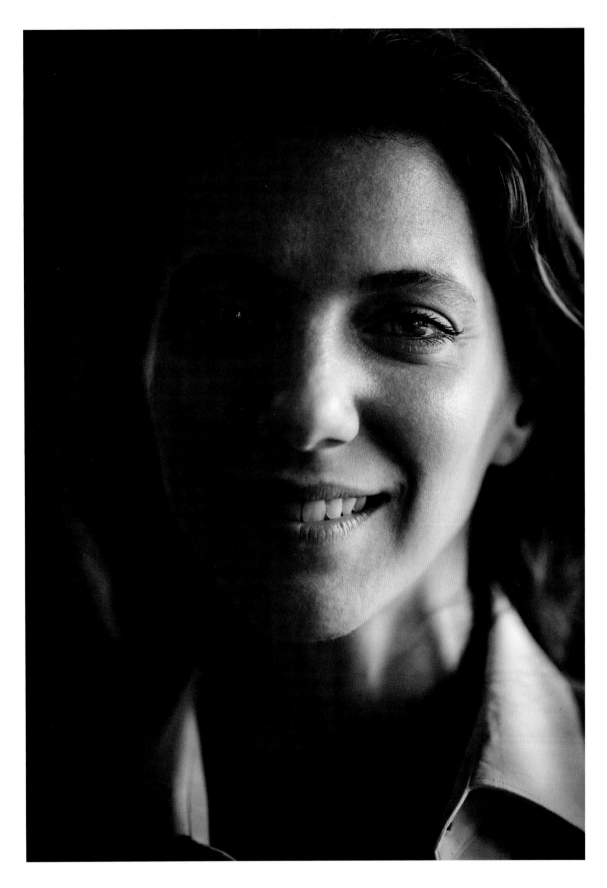

LUCIANA PARIS Ballet

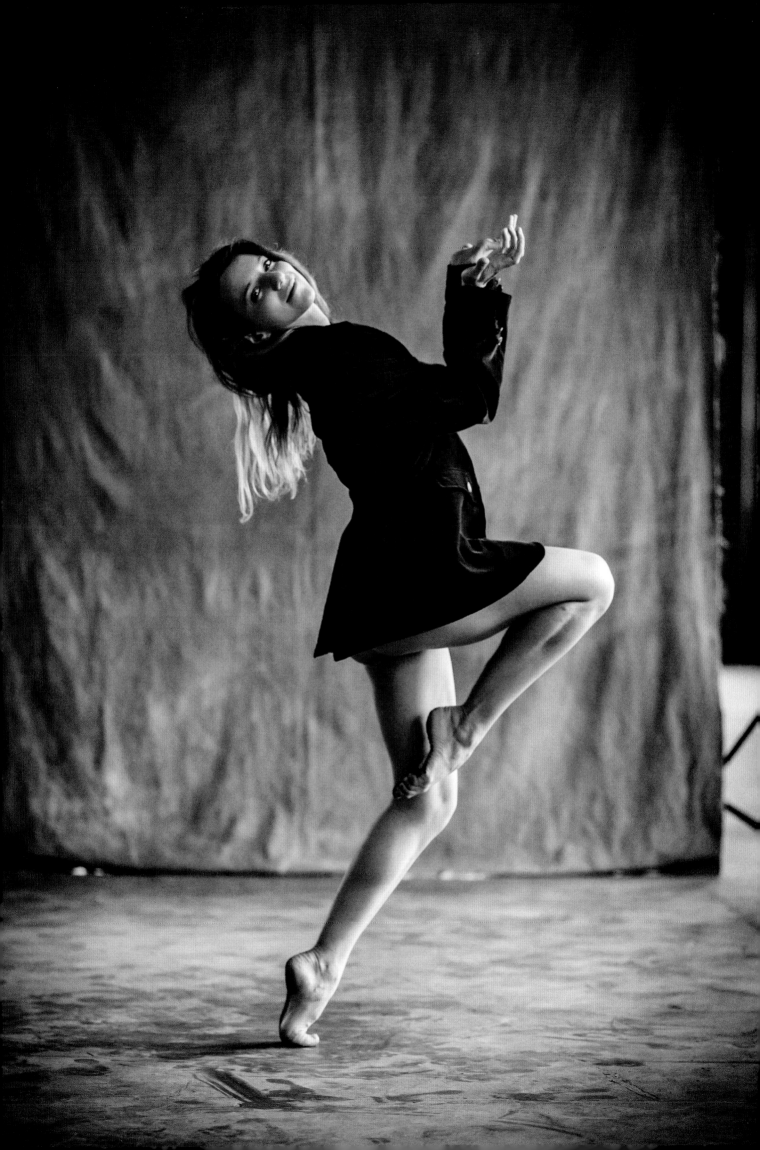

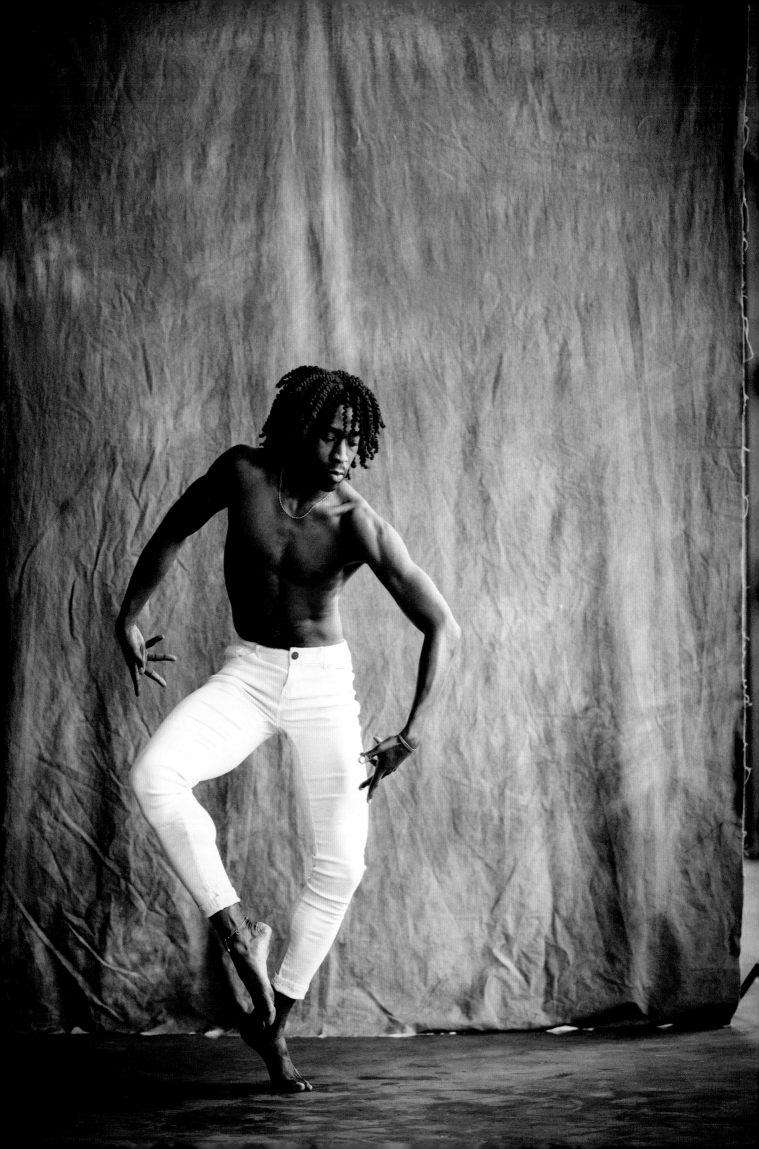

CHALVAR MONTEIRO Contemporary

Dance is a simultaneous buildup and release of ideas, emotions, and energy. Once that exploration of expression has reached its peak, I'm usually depleted in the most fulfilling way. I believe it's a sensation most artists seek out day after day: the opportunity to bare your soul in an effort to bring people closer.

Our individual triumphs and obstacles are the essence of our art. For me, dance functions as a living and breathing journal entry, allowing audiences and folks in our community to see the common thread of our humanity. Ultimately, I feel it's the desire to expose our journeys while unearthing new methods of sharing our stories with folks near and far that unites us.

OVERLEAF: **LONI LANDON** Contemporary

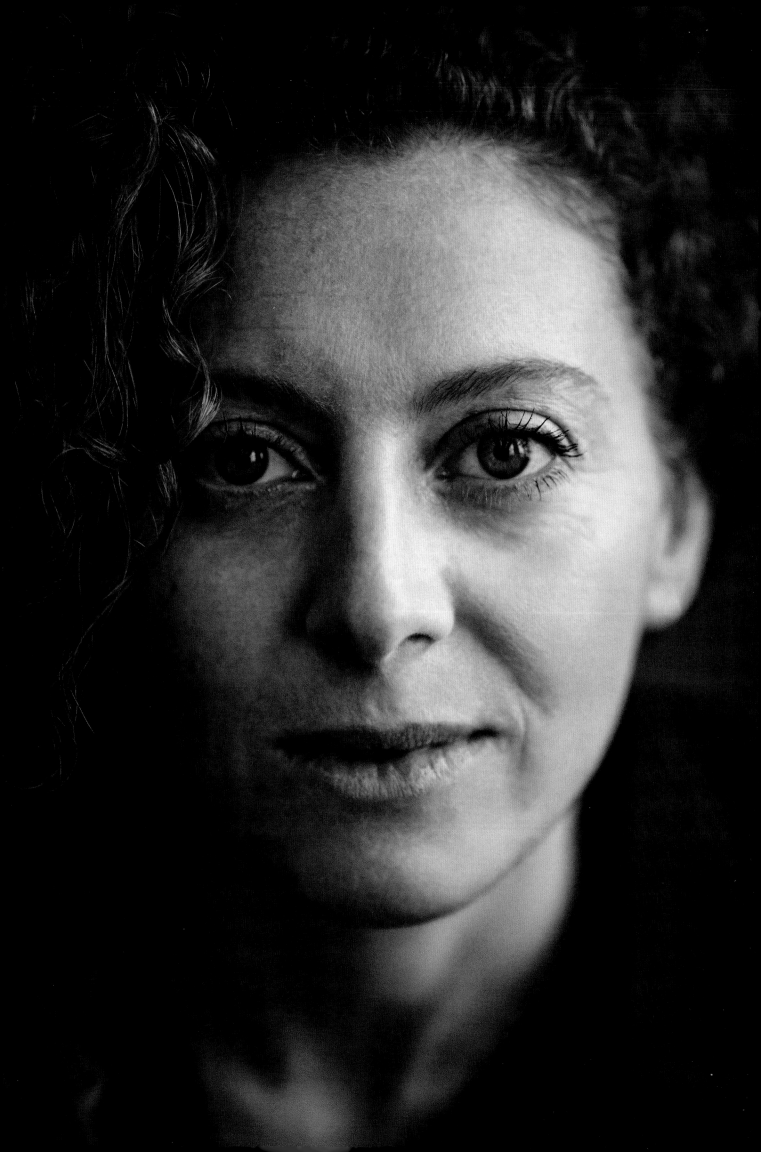

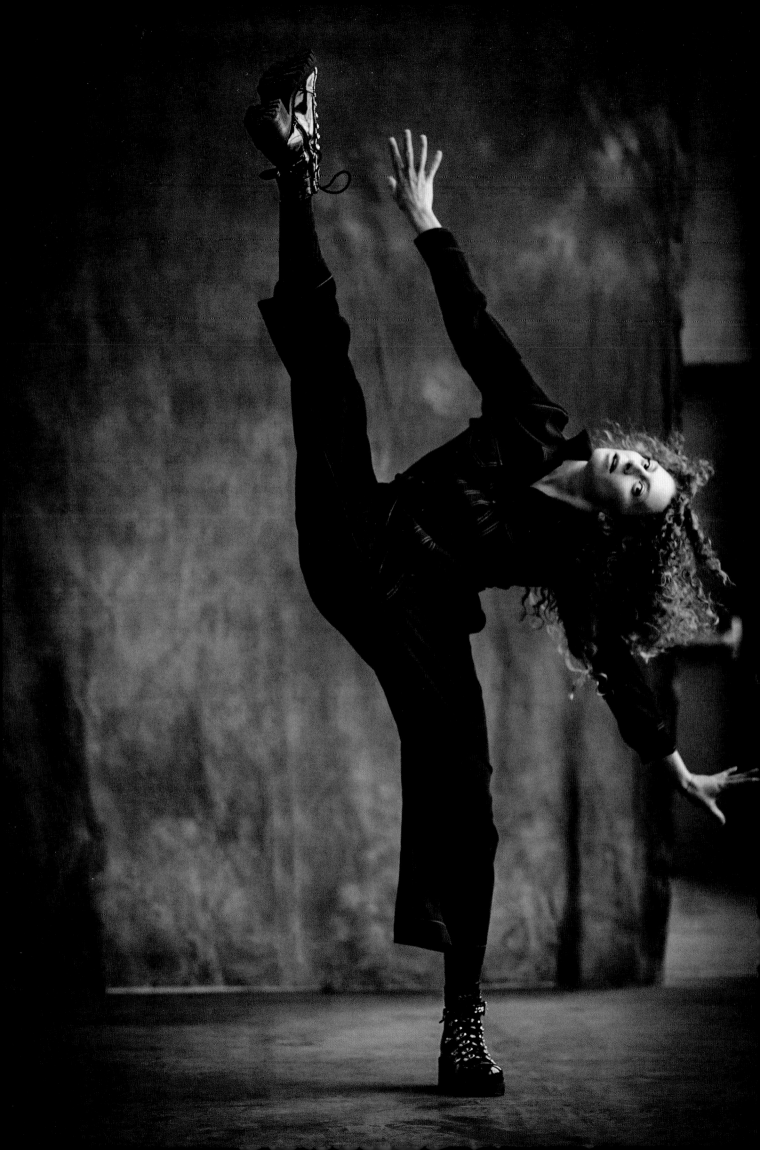

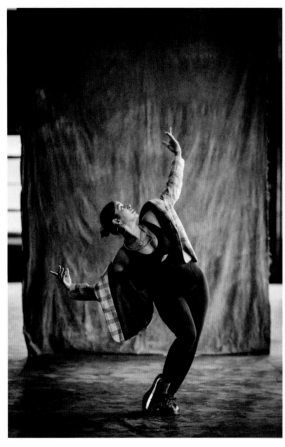 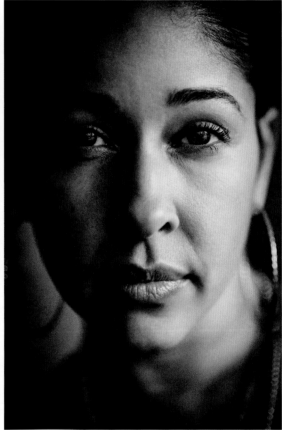

AMANDY FERNANDEZ Hip-hop

My biggest challenge has been that I started dancing a lot later than most dancers. My parents weren't happy about my career choice, so I didn't pursue dance until college. Without any support, I jumped in with faith that everything would work out. I always felt like I had to work harder than most because I didn't start at a young age. Without any training, I worked hard and did the best I could with what I had, and thankfully became successful. You have to be your own person. Authenticity is what separates each of us while at the same time unites us.

GREGORY LAU Contemporary

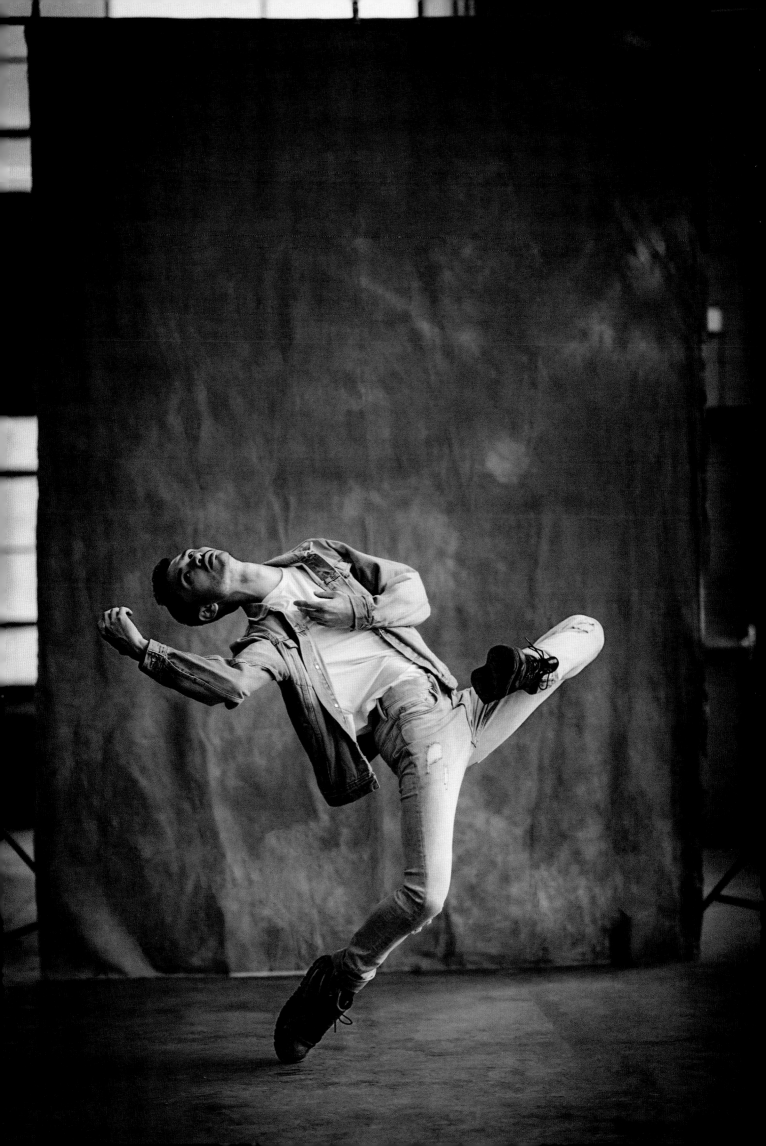

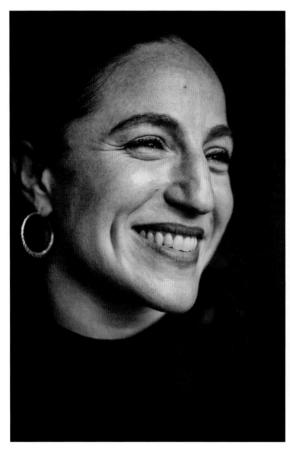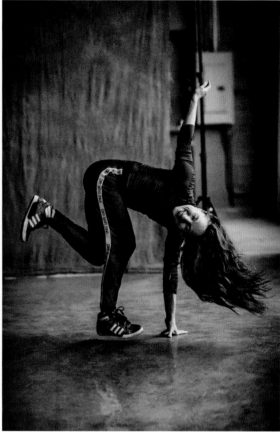

EPHRAT ASHERIE Hip-hop

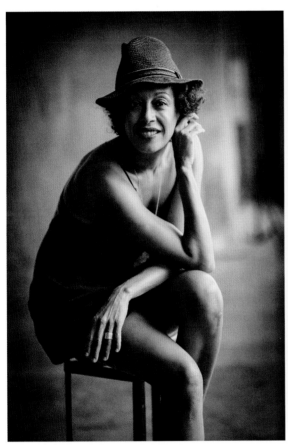 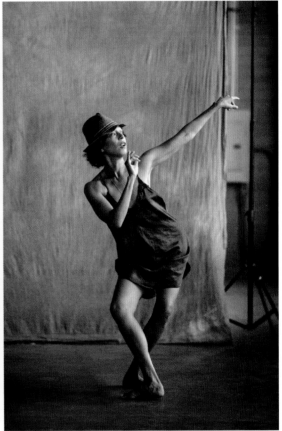

STEFANIE BATTEN BLAND Dance Theater and Immersive Theater

Dance and theater nabbed me pretty early on, as it was a way of my communicating indirectly with people's inherent biases and yet a direct way to connect with their hearts. That is a place that is full of contradiction and honesty at the same time. It is the complex place that makes us unique as a human race. It is a place that invites belonging for all, if we choose to do it.

XIN YING Modern

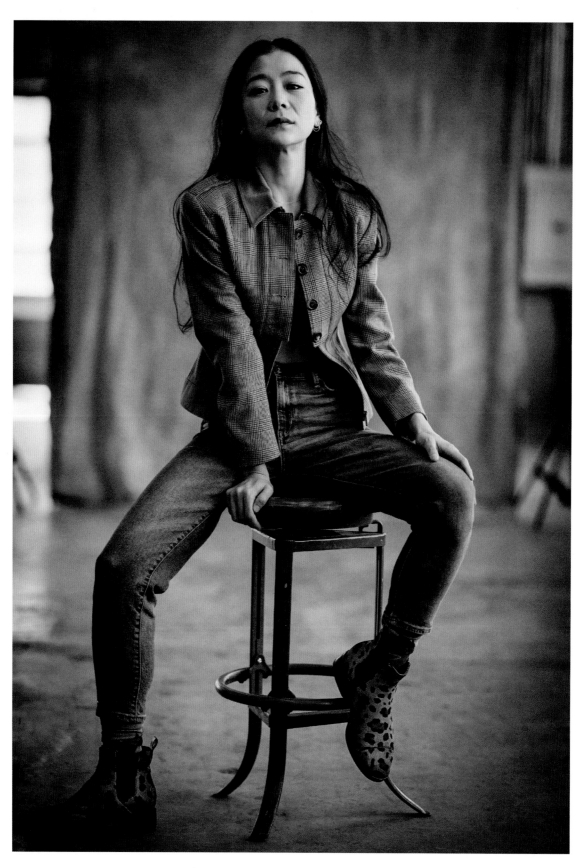

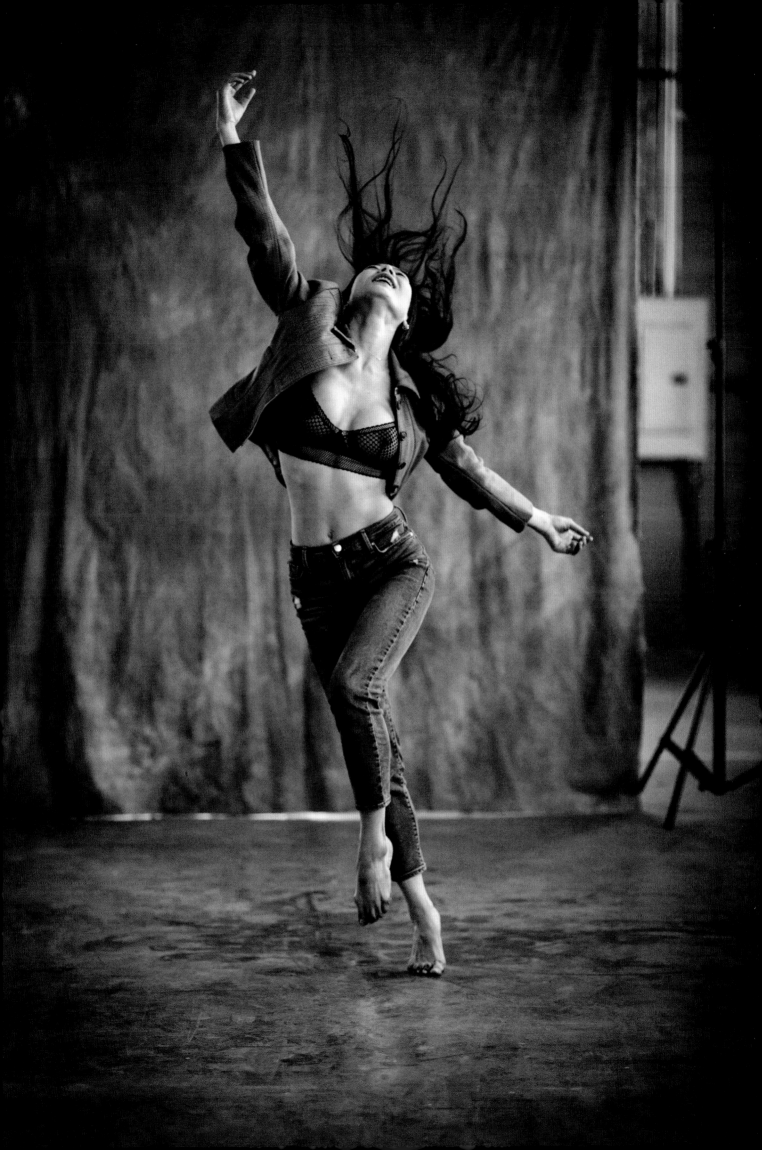

JESSICA AMBER PINKETT Contemporary

I have been dancing ever since I could walk. It came so naturally to me. I learned so much about myself and the world through dance. It's truly my connection to the rest of the world. Through dance I am able to communicate clearly, sort through my emotions, become vulnerable within the safety of my vessel, and just move.

I feel beautiful when I dance. I have spent a good portion of my life not liking who I was. It got to a point where I didn't recognize myself, but dance became my therapy to reclaim myself. I finally saw who I really was. I am a sensitive being who has grit, and I feel the need to sink my teeth into everything I do in order to be fully immersed in the experience. I feel grand and vast and full when I am dancing. Imagine you are dropped in the middle of the ocean, and you ride the waves without fear of sinking or being swept away in the tides. . . . What a beautiful feeling that is. To be full of power and courage. I want to feel that way all the time.

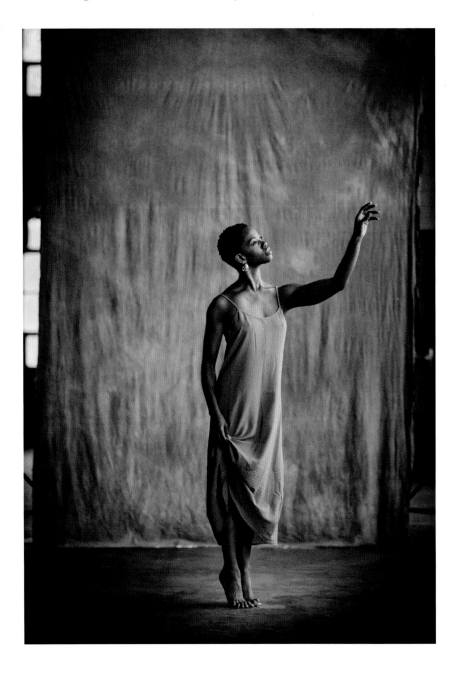

JESSICA AMBER PINKETT Contemporary

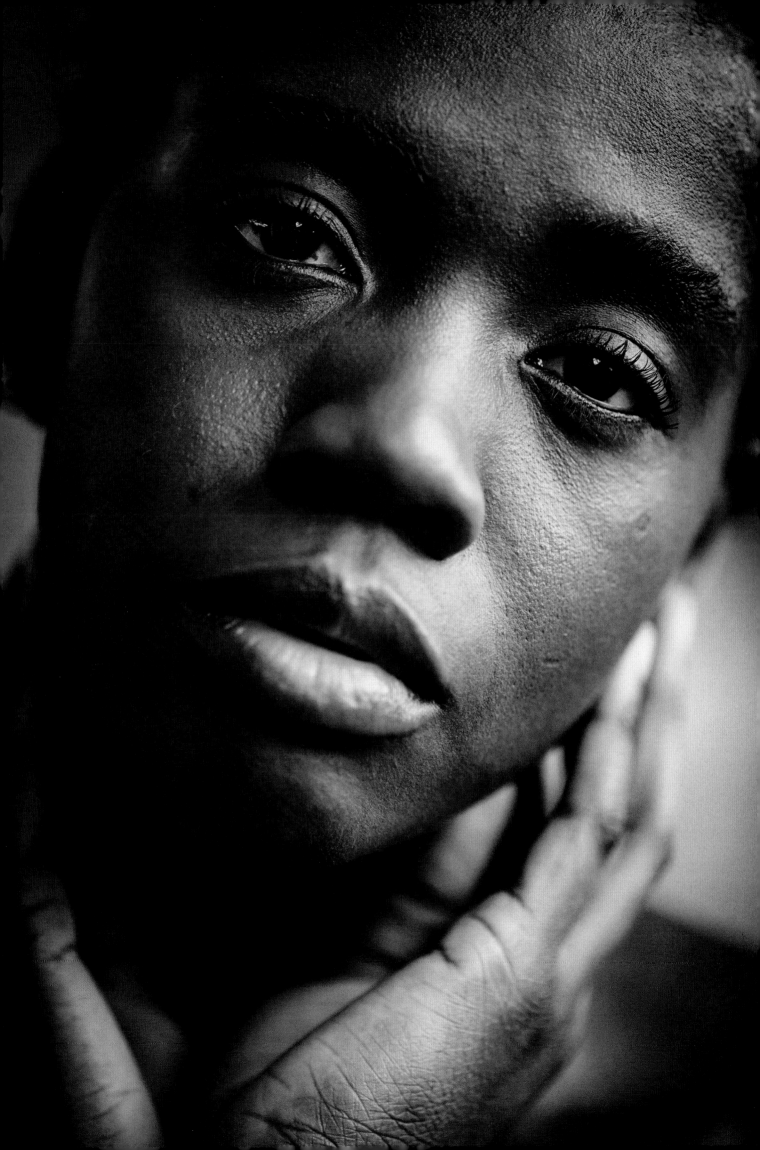

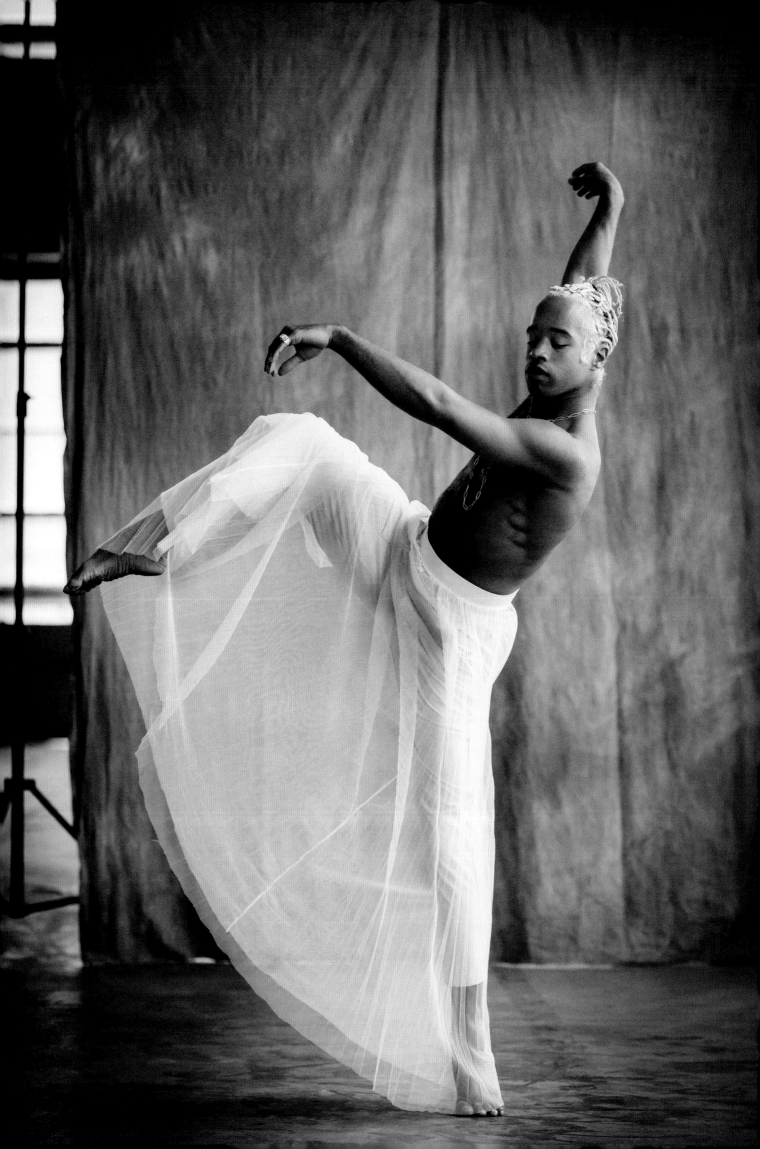

GABE STONE SHAYER Ballet

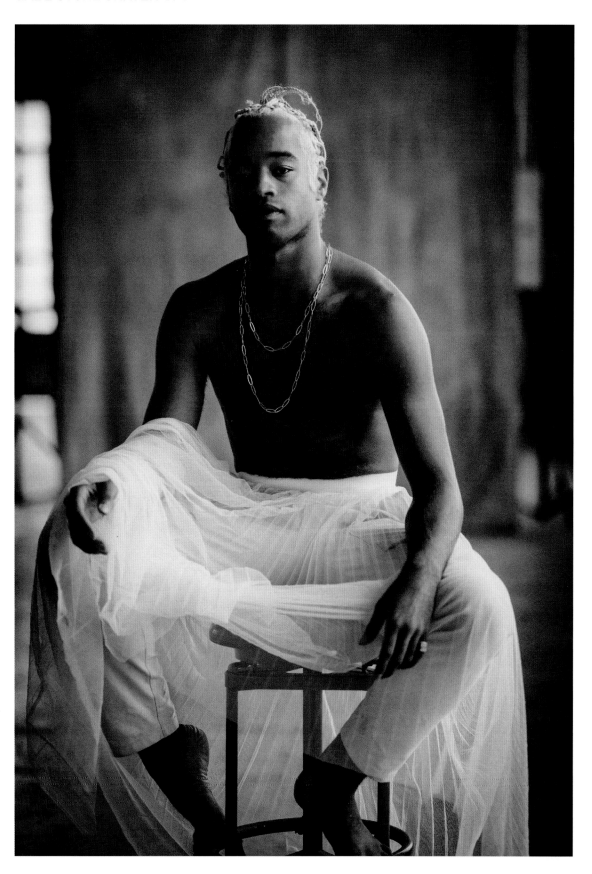

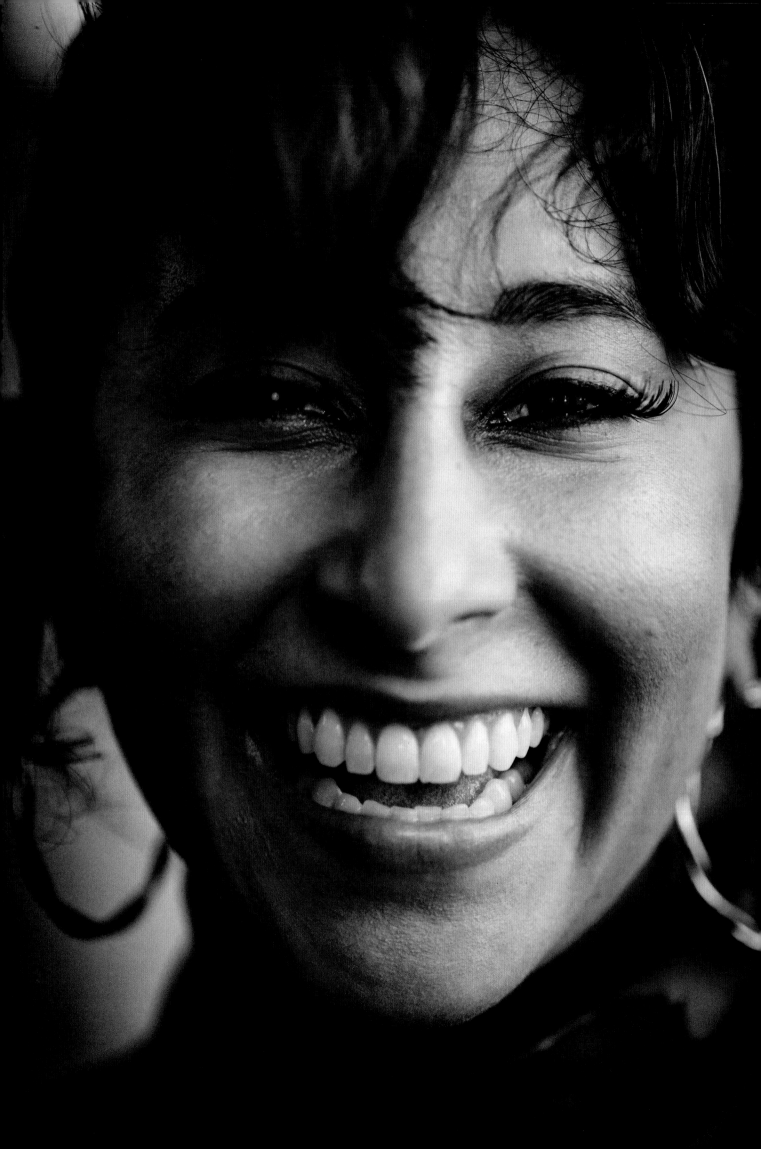

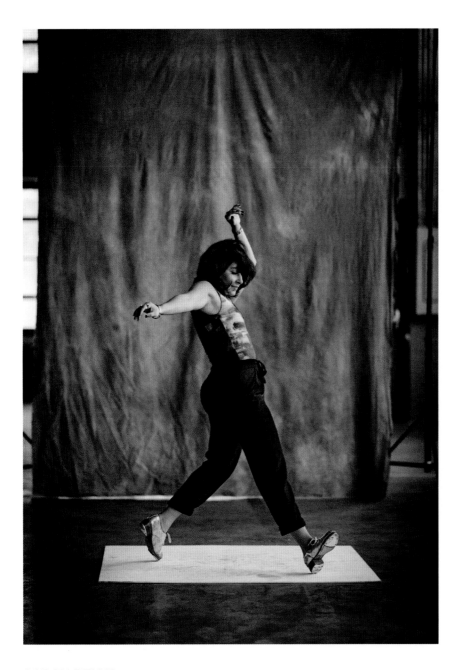

SARAH REICH Tap

As a tap dancer, I'm particularly inspired to fulfill my purpose of serving the art form. I wake up every day with desires to keep the dance alive and well while honoring the past and pushing for a fresh future. There is always work to be done! There's always a kid to inspire, a jazz club to lighten up, and a class to teach.

I find that rhythm is a language that helps express certain feelings and emotions. If I have a certain emotion built up in my life, I will use tap steps that require a similar energy. Some steps are nostalgic, like a time step. If I'm feeling light and easy, I'll play a swing feel. I can create anything at any time, and having that power feels amazing.

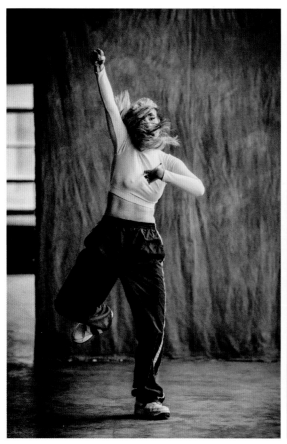

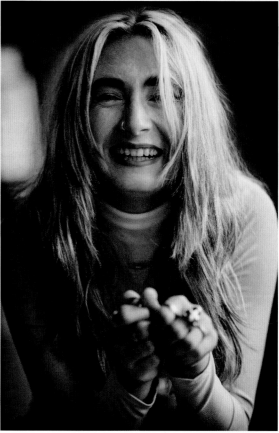

DANA "LIONESS" WIENER Hip-hop

JENNIFER GOGGANS Modern

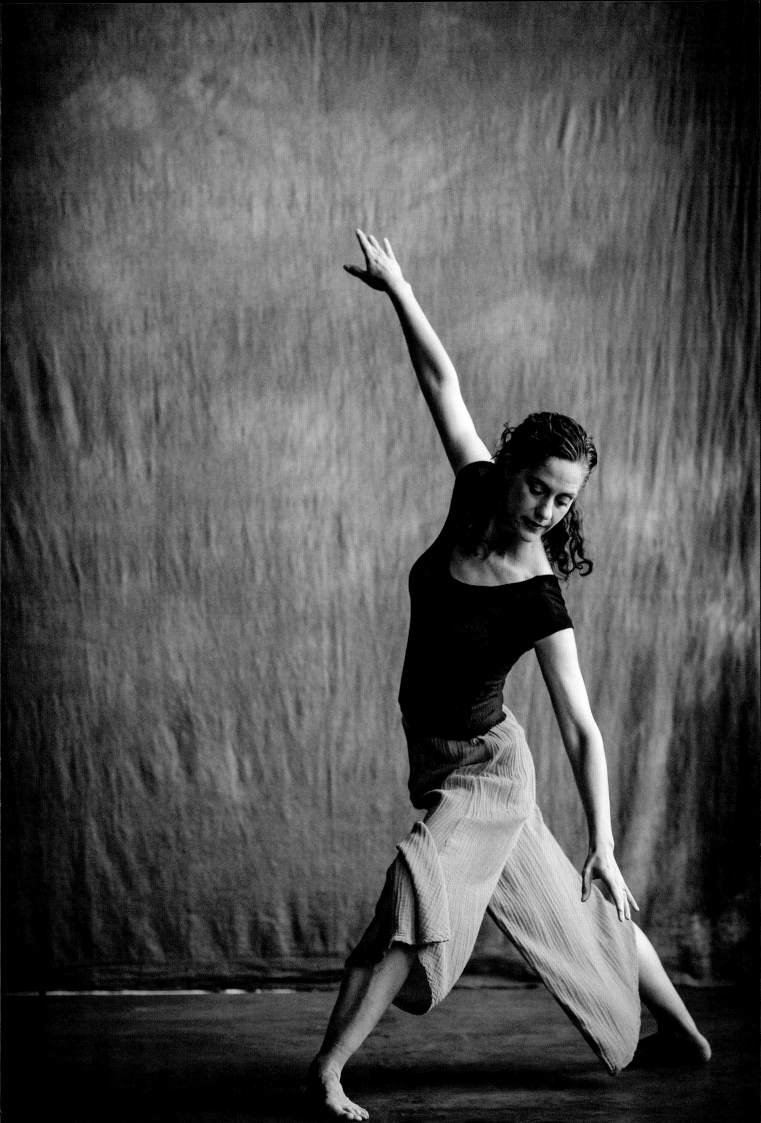

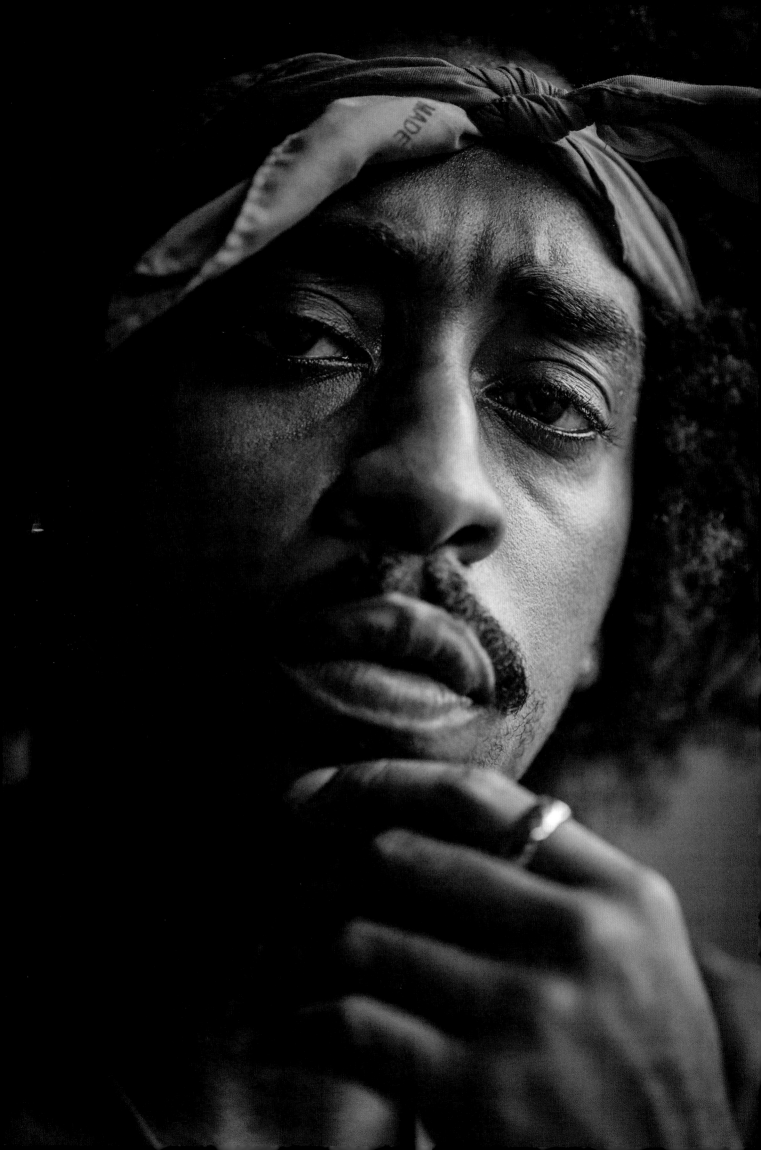

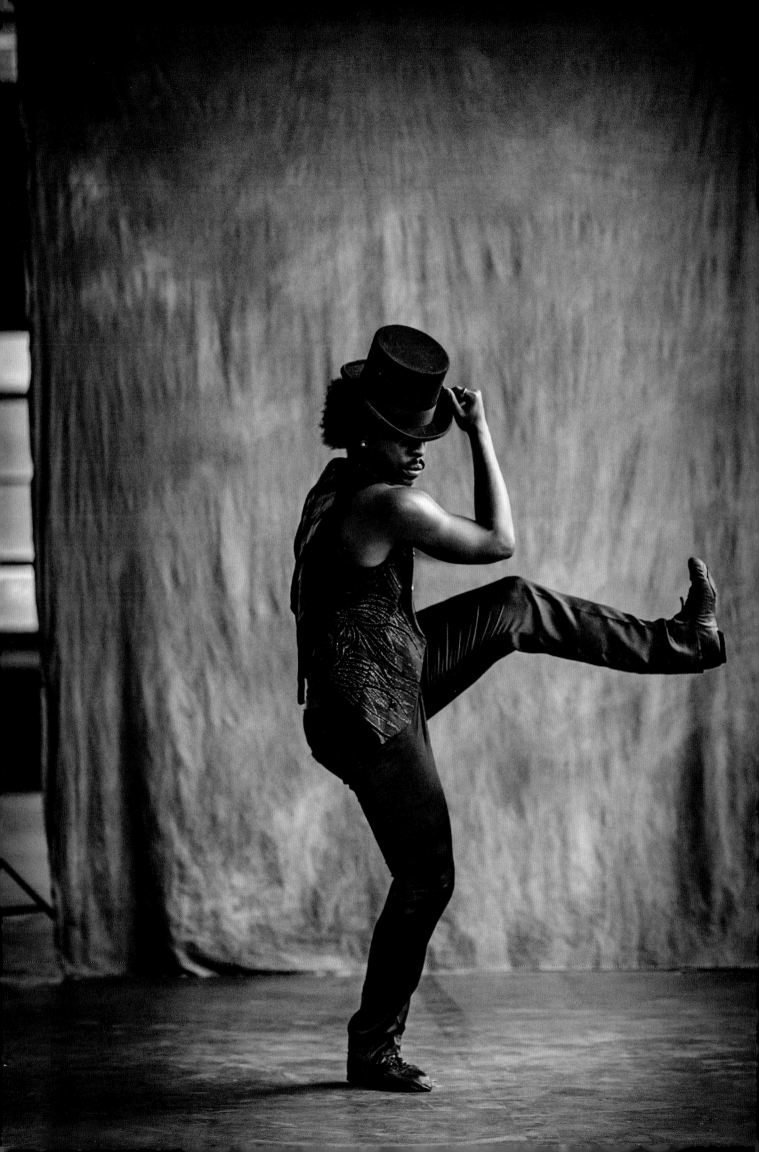

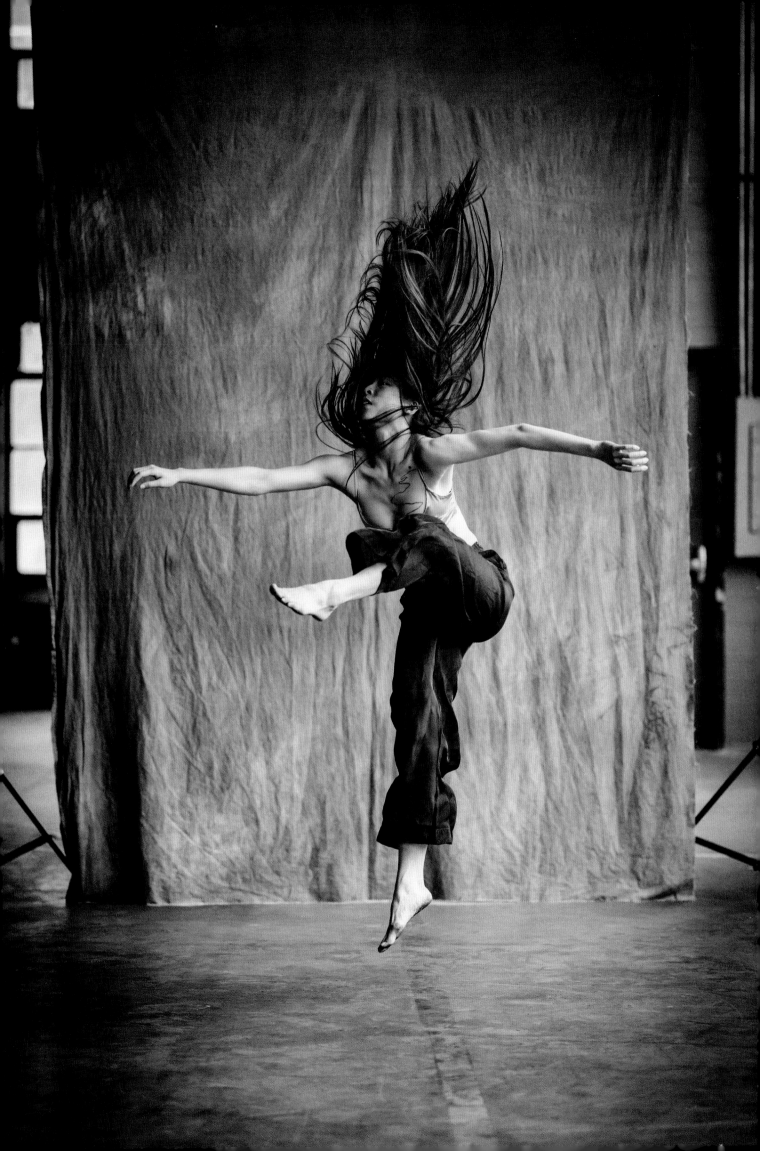

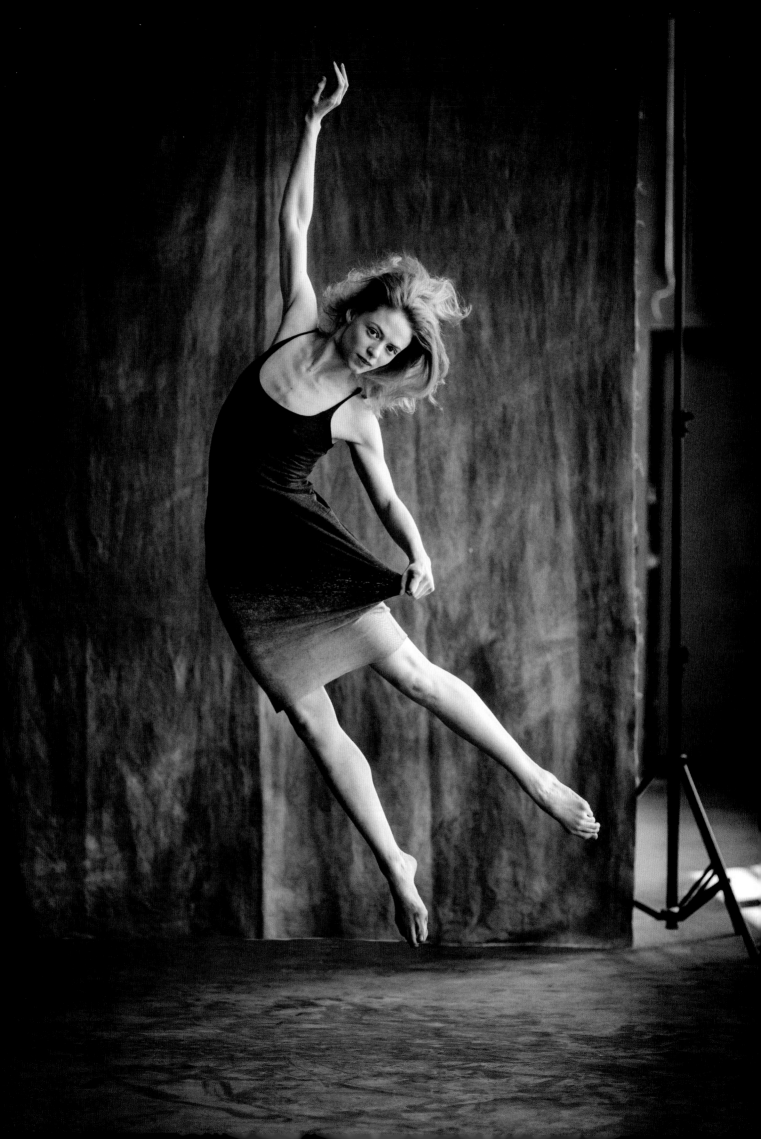

HEATHER McGINLEY Modern

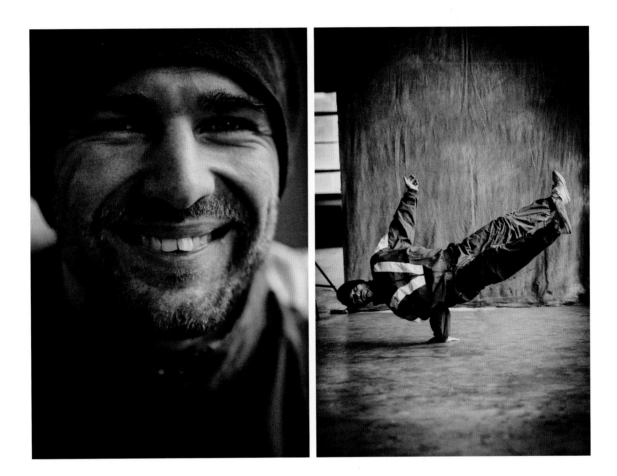

RISE Break Dance

Dance is that one moment in my day when I can truly be alone to escape and reconnect with my soul and spirit. It's movement that you can constantly experiment with and evolve and bring different expressions of yourself to impact other people.

I love it so much that I constantly want to be in that state of evolution, but it's important to find balance mentally and emotionally. I try to switch up my training methods and respect how each body part feels at different points, listening to my body more as I get older.

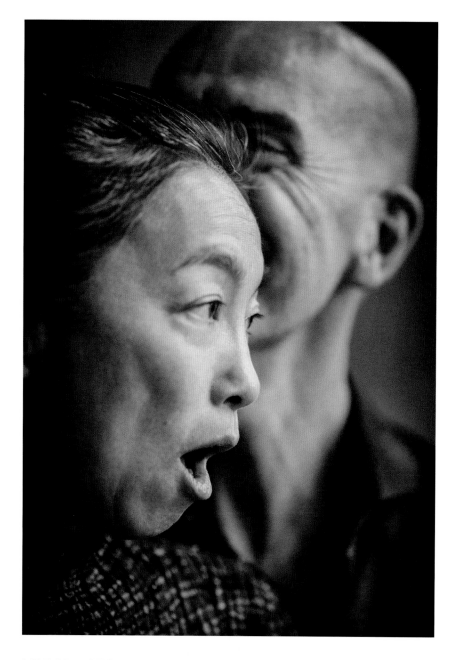

MIKI ORIHARA Modern

If you are dancing with others, there is a togetherness; and when that happens, it is very strong. I love dancing with others. It could be duet, trio, or group. Connectedness is amazing to experience.

STEPHEN PIER Ballet

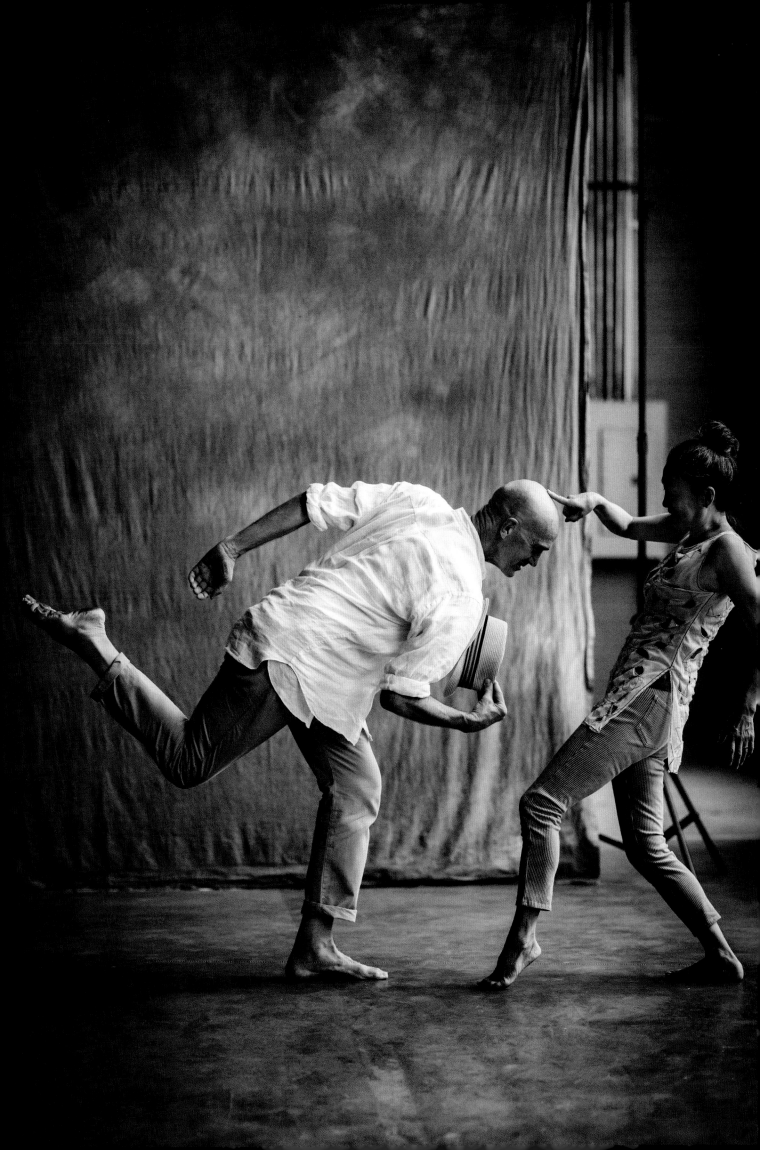

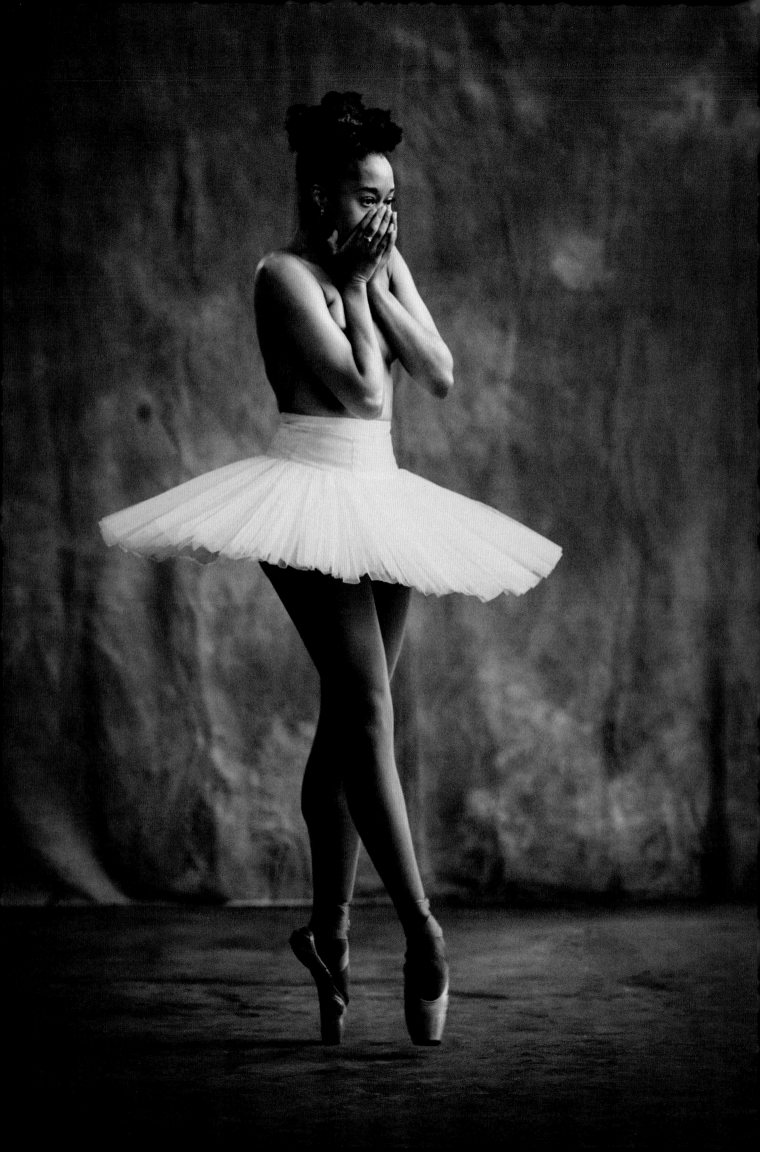

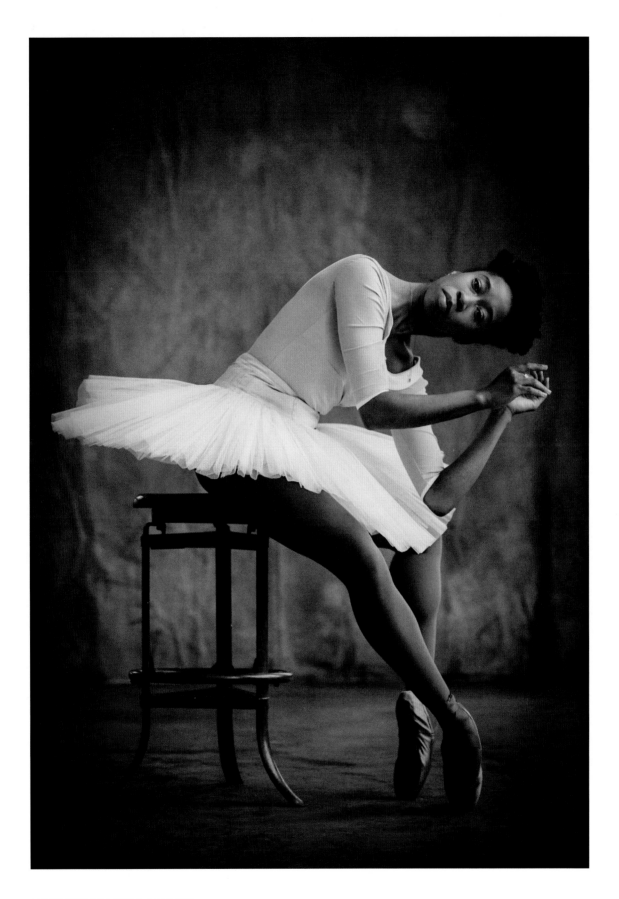

DAPHNE MARCELLE LEE Ballet

Dance allows me to expand beyond the realm of being human. I can enhance feelings and emotions, and share that with audiences.

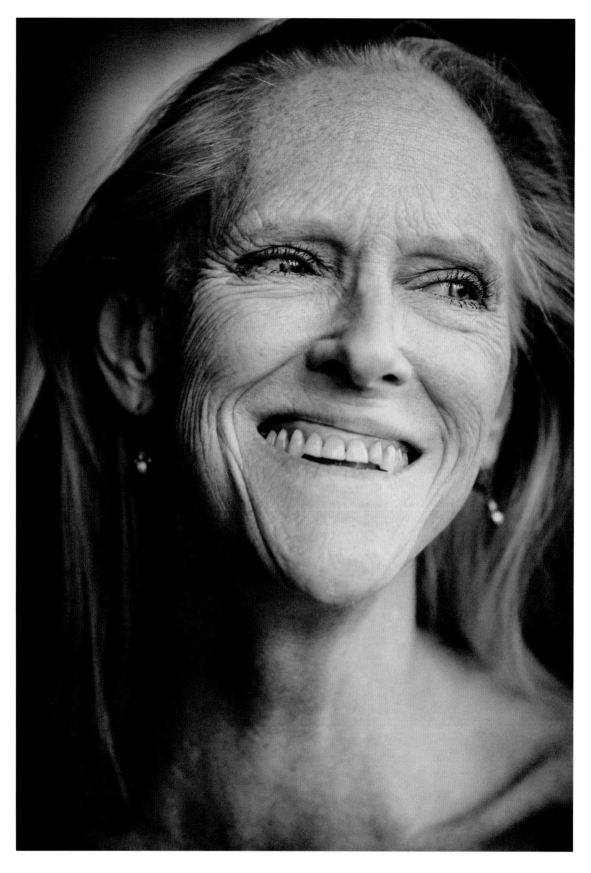

JANET CHARLESTON Modern and Contemporary

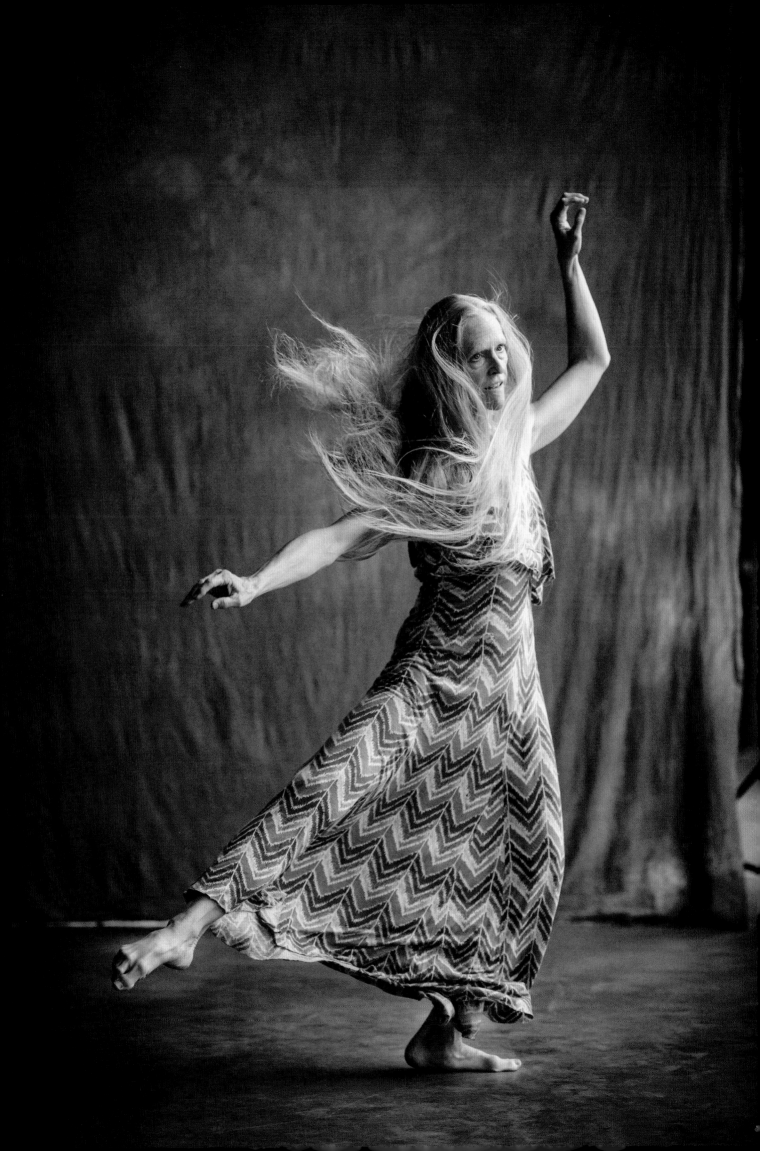

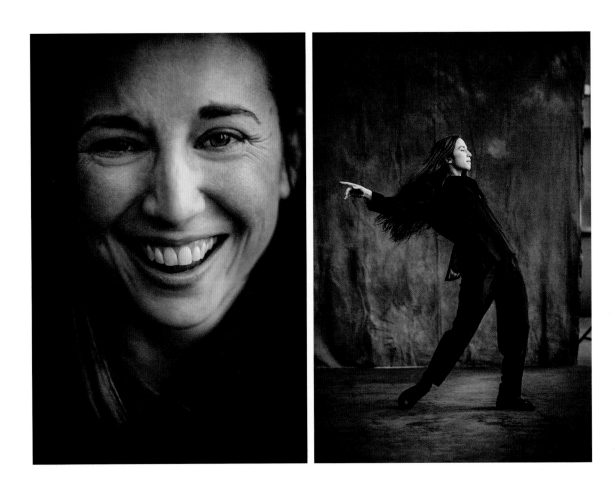

NICOLE von ARX Contemporary

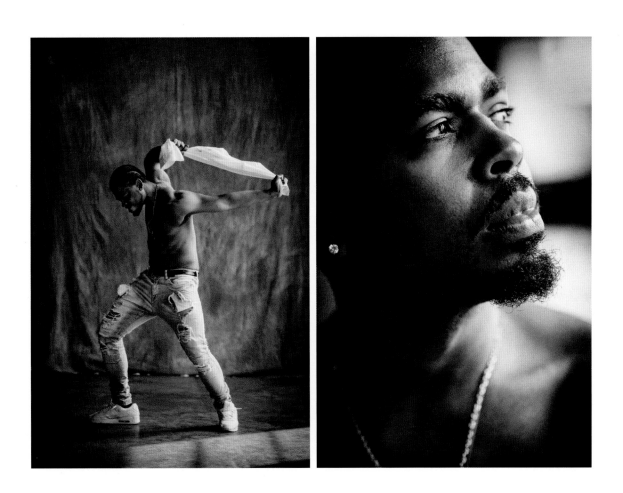

FRANCISCO "FRANCOTH3ARTIST" GORDILS Hip-hop

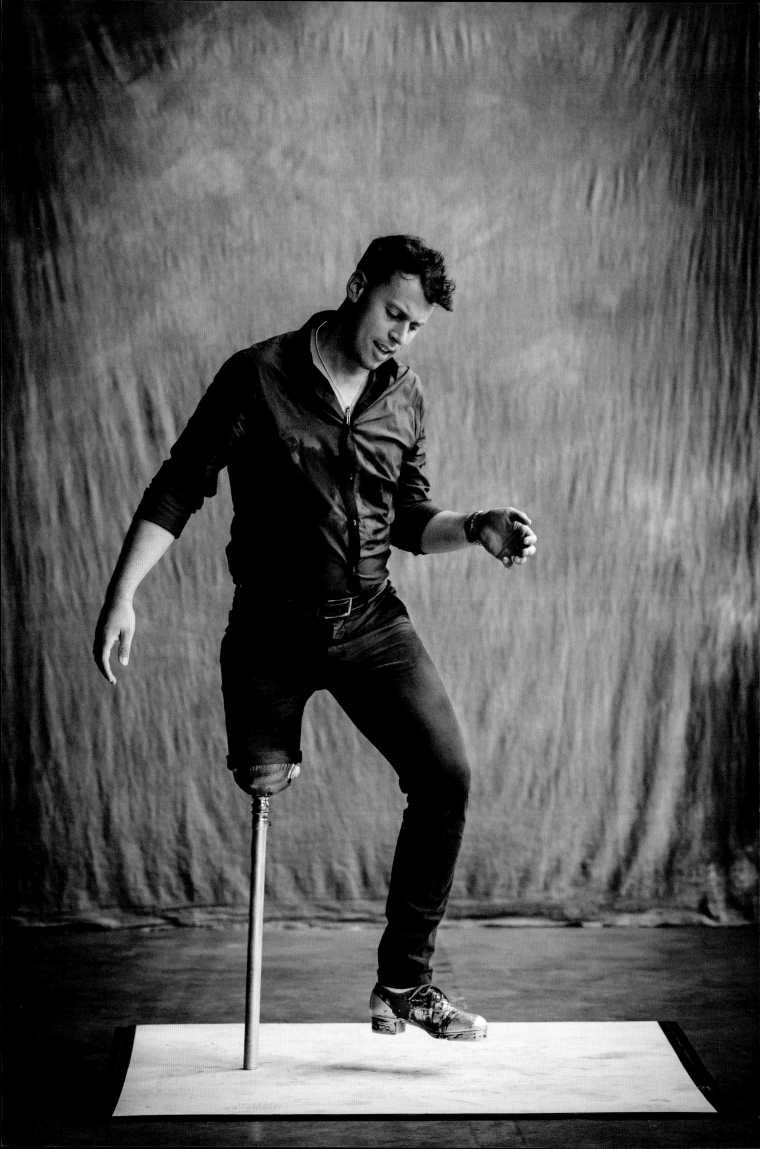

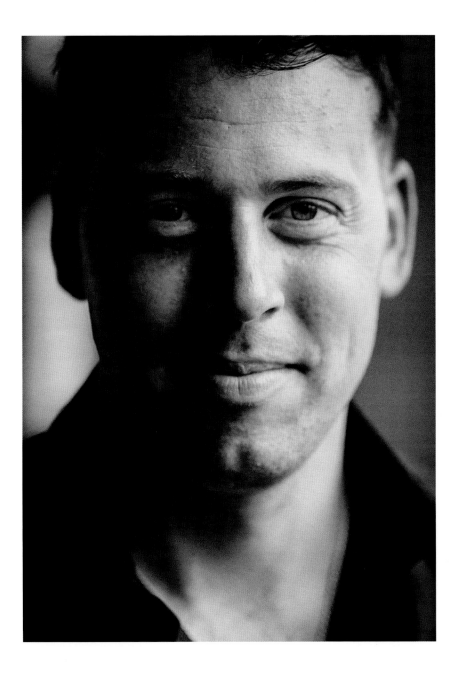

EVAN RUGGIERO Tap

Dance has always been the backbone of my career. I think if you ask most artists in the entertainment industry where they got their start, they'll say, "My parents signed me up for dance classes when I was young." Which is true for me. Dance, specifically tap, was the only hobby I had as a child that really kept my attention. When events in my life became "life or death," dance remained a constant and helped me navigate that time of uncertainty.

Cancer in my right leg, resulting in amputation, was hands-down the biggest obstacle I've faced. After two years in the hospital receiving treatment, I learned how to walk again and retaught myself how to tap dance using a "peg leg."

I am always in the moment. Whether that's being in the moment for myself or for an audience. I'm very focused, though. When I was younger and in dance school, I was always smiling and had such stage presence. I still get giddy and smile when I hear an audience clap and cheer halfway through a performance.

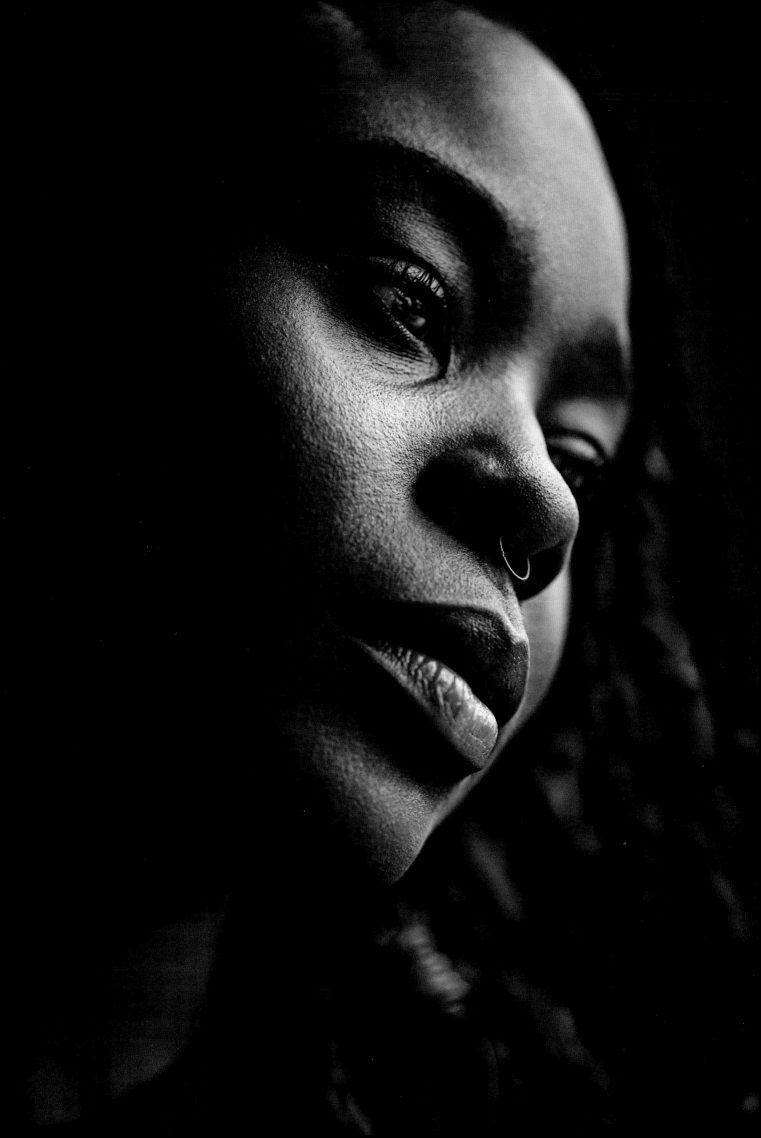

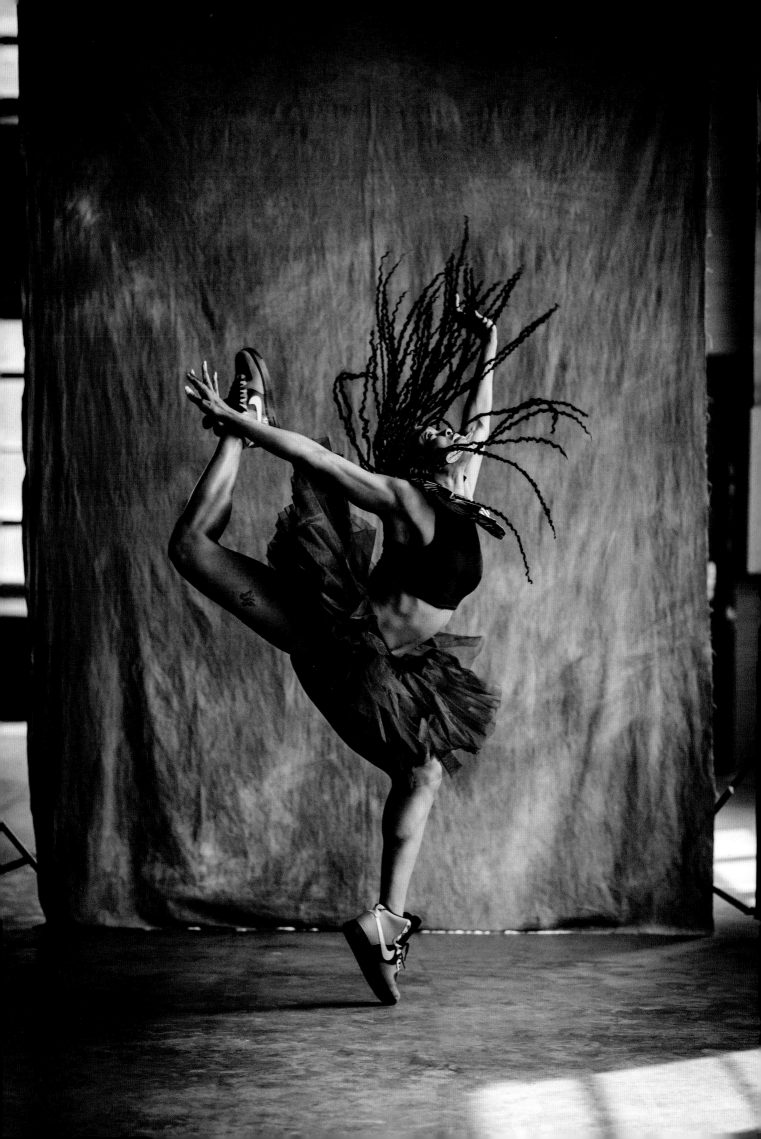

RYAN VanDenBoom and MORGAN MARCELL Broadway

Like music, dance is a universal language. It's the ultimate form of communication and expression. If we want our feelings, art, opinions to be heard, we have to learn a language that's accessible to everyone. Dance feels like the way in for me.

When I dance, my mind stops. My brain is absolutely working overtime to process choreography, protect my body, and coordinate. But my mind isn't chattering. It's calm. Afterward, I feel alive. The sweat and ache and adrenaline remind you that your body really is a vessel, and if it's used correctly, that energy is beyond powerful. —*MM*

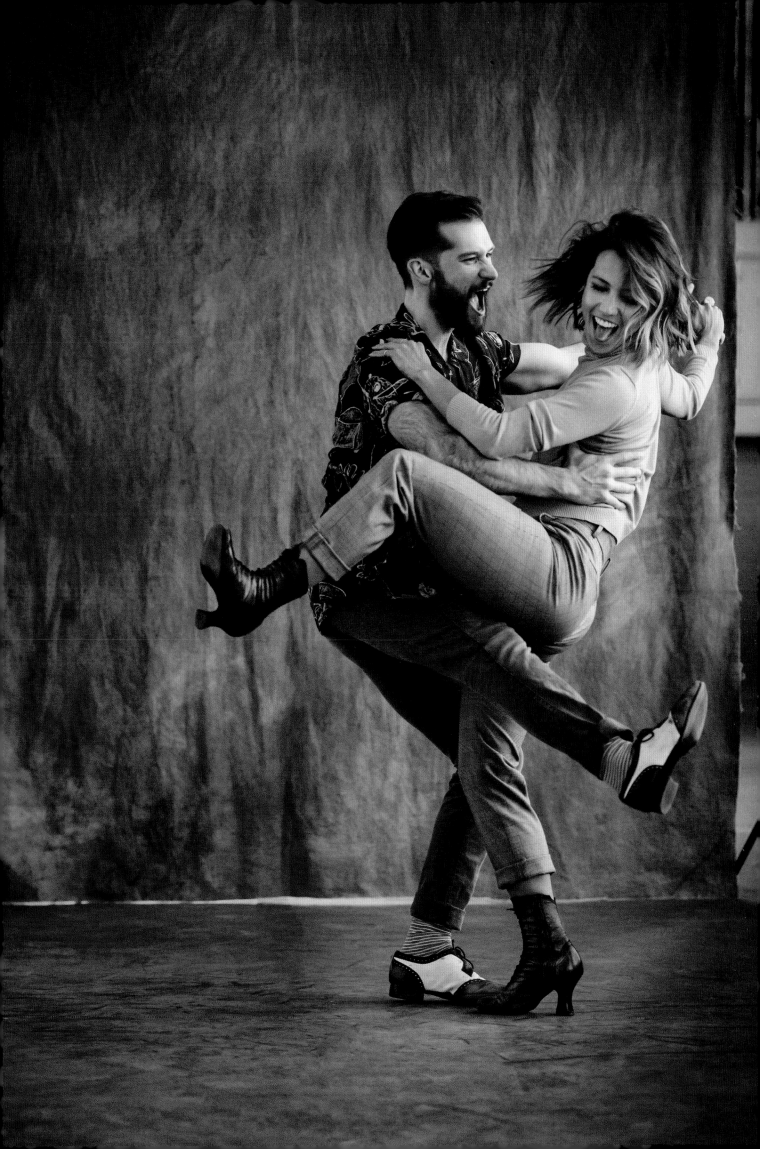

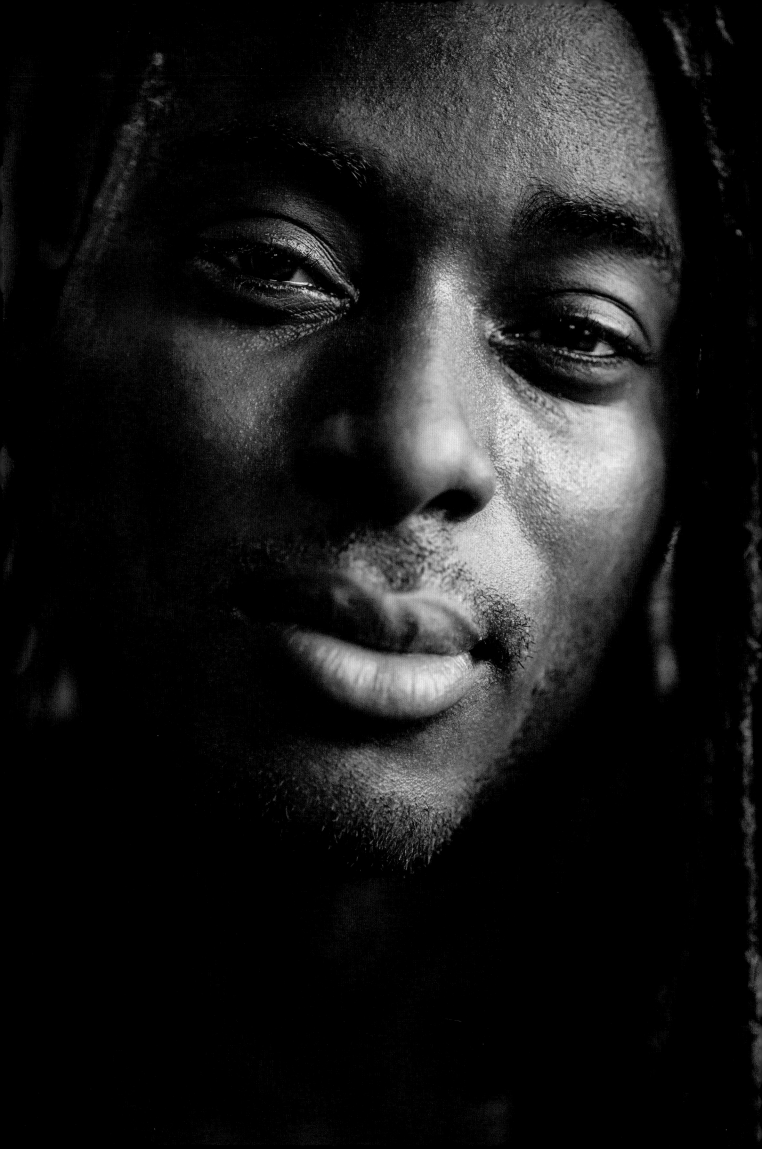

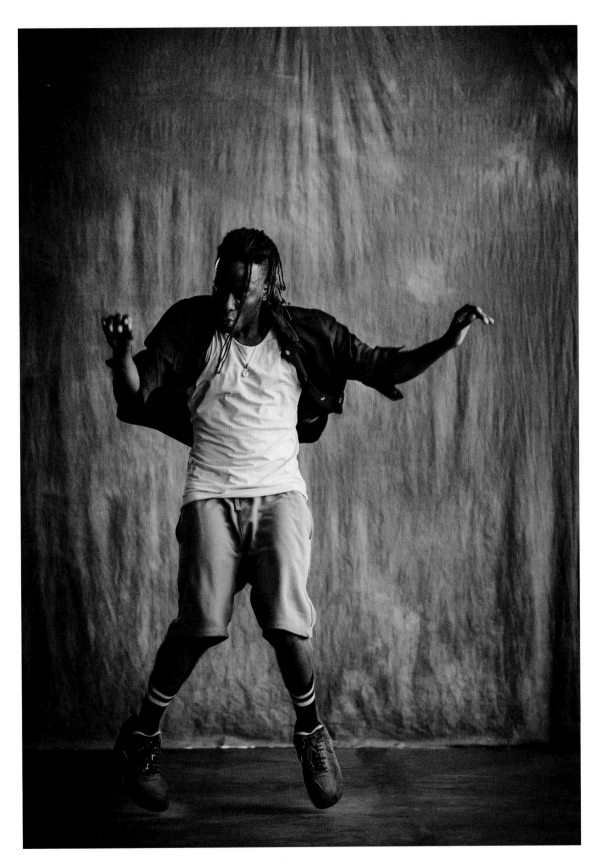

LAMONT R. RICHARDSON Hip-hop

I tend to overexplain myself because I believe people won't understand my point. Dance makes me feel my most direct in communicating, and is a direct line to how I feel about myself on any given day—I can lie to myself, but my movement won't lie to me.

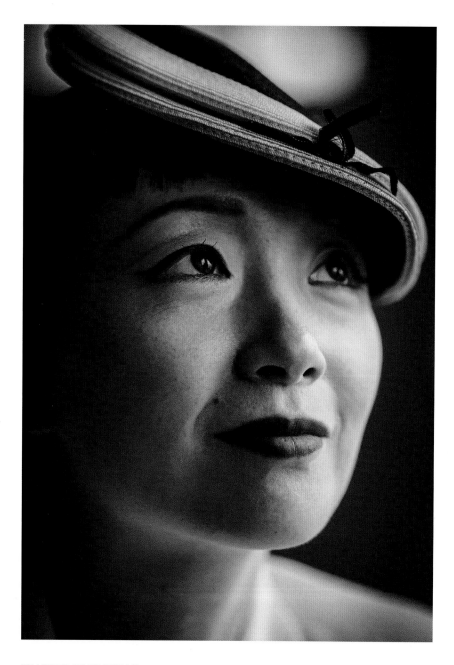

ZHONGJING FANG Ballet

I believe some people are born to be artists, and ballet is something I was born to do. I feel that I become alive the moment I'm on stage. There is a different aura around me when I start to dance. It's as if I'm manifesting each moment in time . . . I move when the music moves, and music is the soul of dance. It creates the atmosphere and takes me to this very present moment, and every move I have learned before the stage doesn't matter anymore, because I must re-create it over and over again; I must stay in the present.

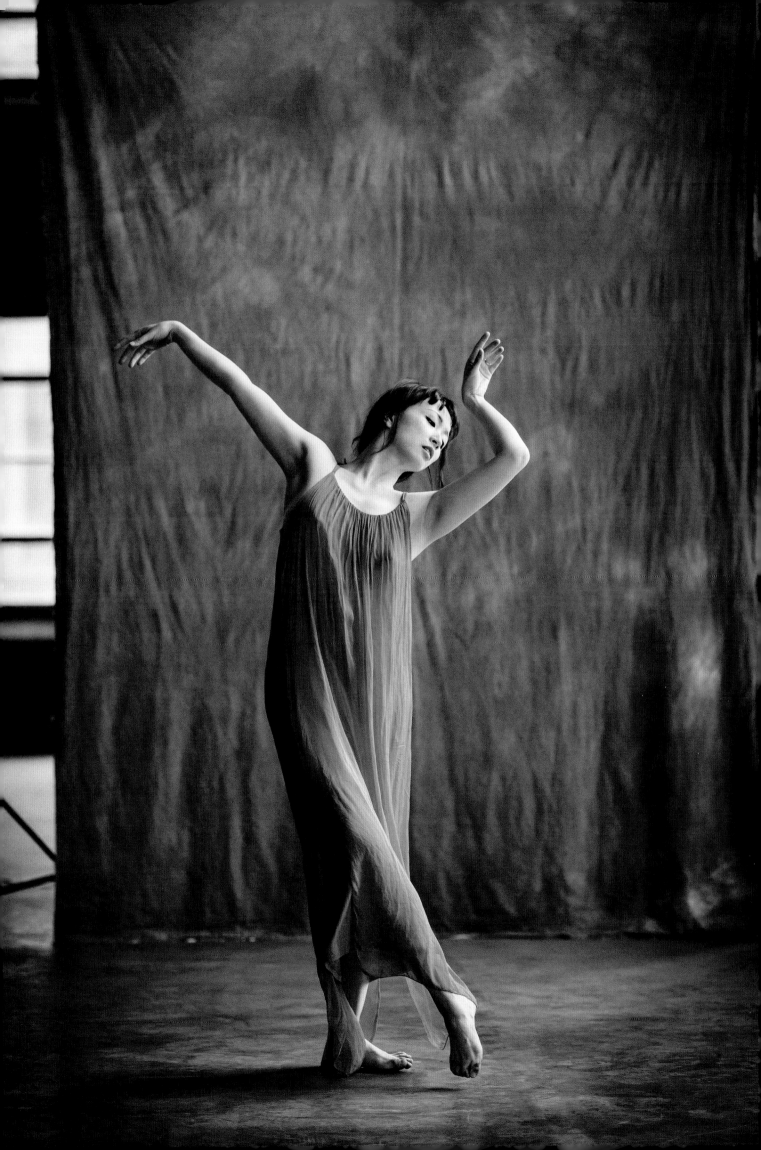

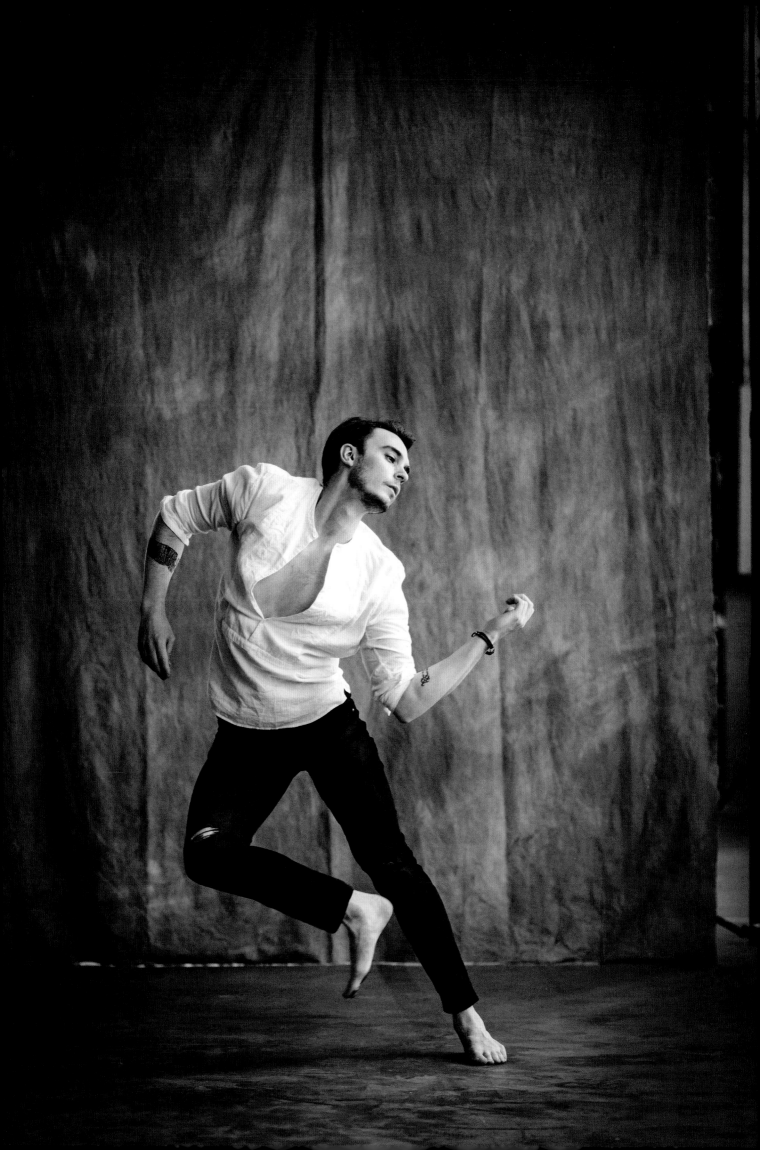

REED LUPLAU Broadway

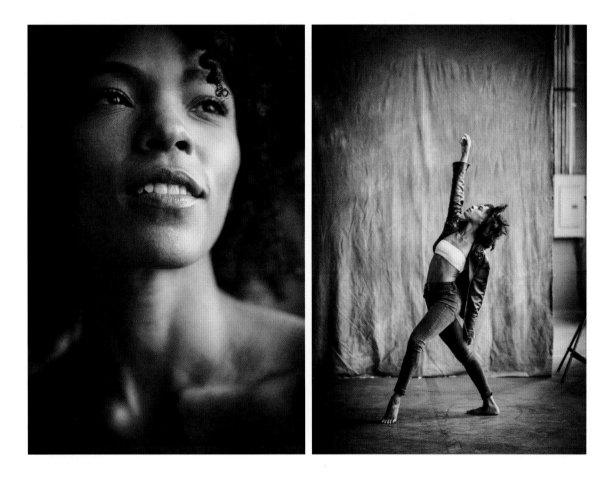

SAMANTHA FIGGINS Contemporary and Modern

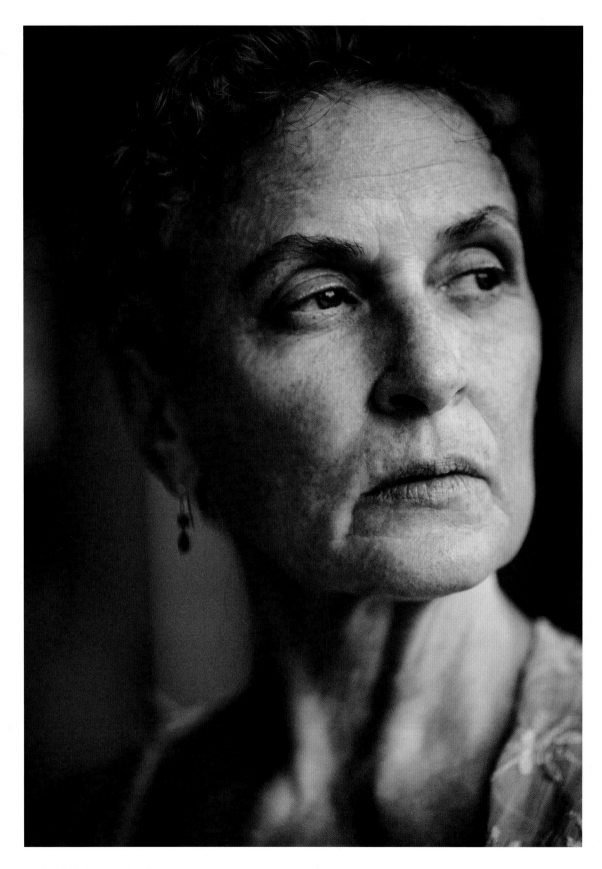

TERESE CAPUCILLI Modern

The most fulfilling place to be is on the very edge of a physical and emotional cliff. Those moments of suspension and near loss are where true expression lies and where you have let your audience in to see a part of themselves. Here is where I feel most alive.

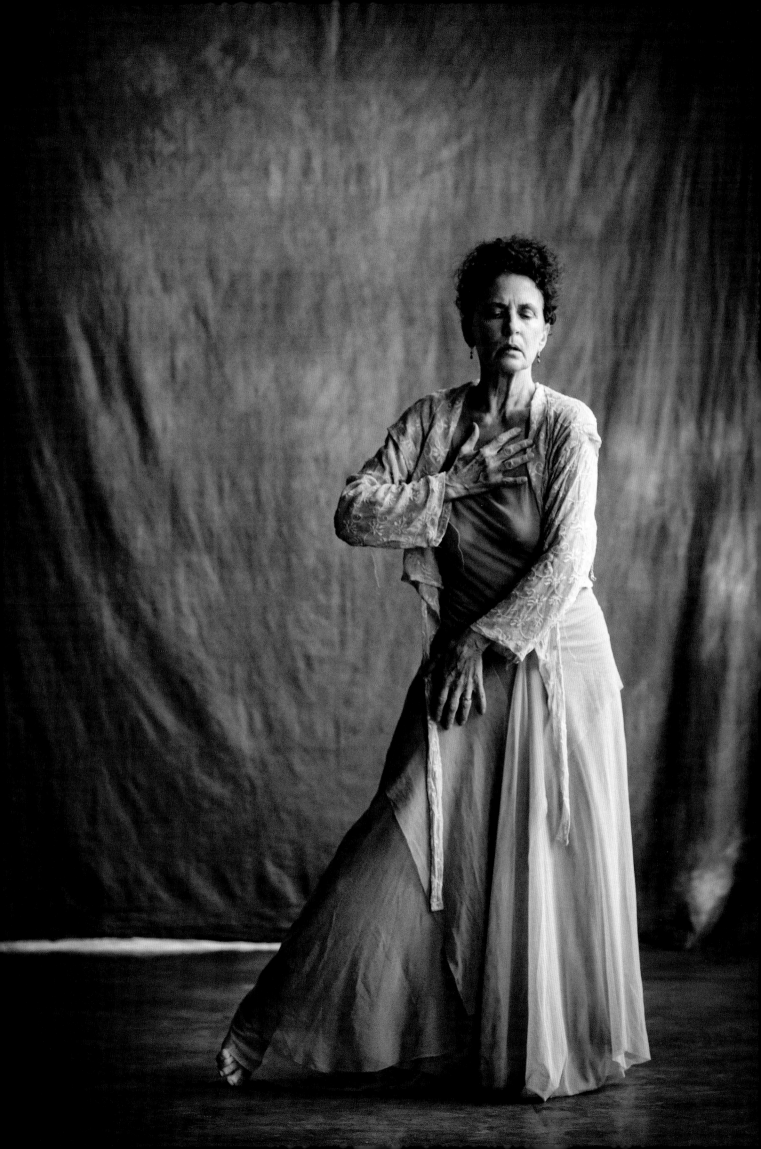

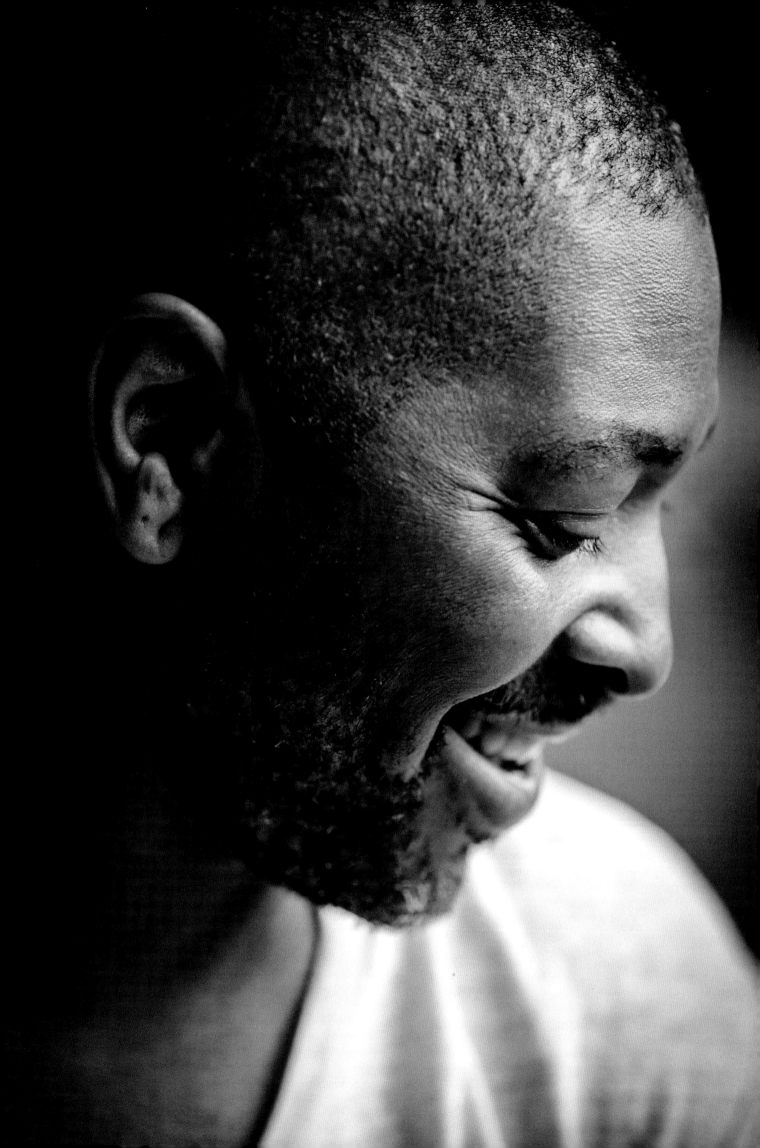

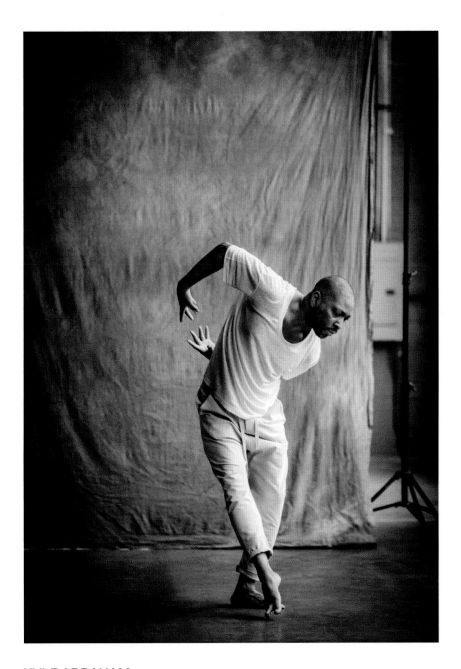

KYLE ABRAHAM Contemporary

Dance doesn't seem like an option or a choice. It is my reality. Even when I've thought I'd left it, it was with me … at the club, improvising in my room, and/or bopping around in a chair while doing office work.

As dangerous as dance can be, it's always been my safe space. It's the way I worked through my emotions as a youngster, dancing in my room to Prince and The Smiths. Today, the movement and the musical choices have expanded. But the need and purpose of dancing—pain, trauma, and expressing my truest joy—are still very much my reality.

Even as an introverted personality, I always love being among the dance community. I don't know if it's being around a group of people who you know grind to the pavement to pursue their dreams, or if it's just a general understanding that we're a part of a very unique art form that is underfunded but abundant in its imagination and expression.

OVERLEAF: **A.I.M. by KYLE ABRAHAM** Contemporary

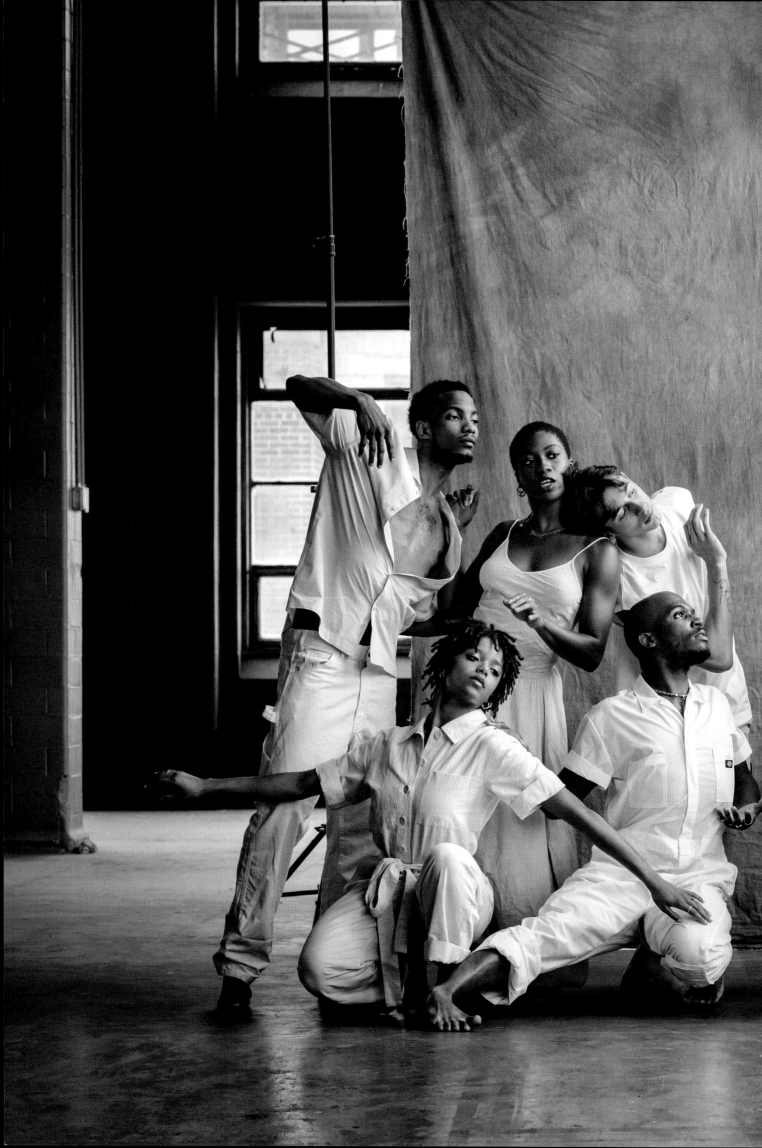

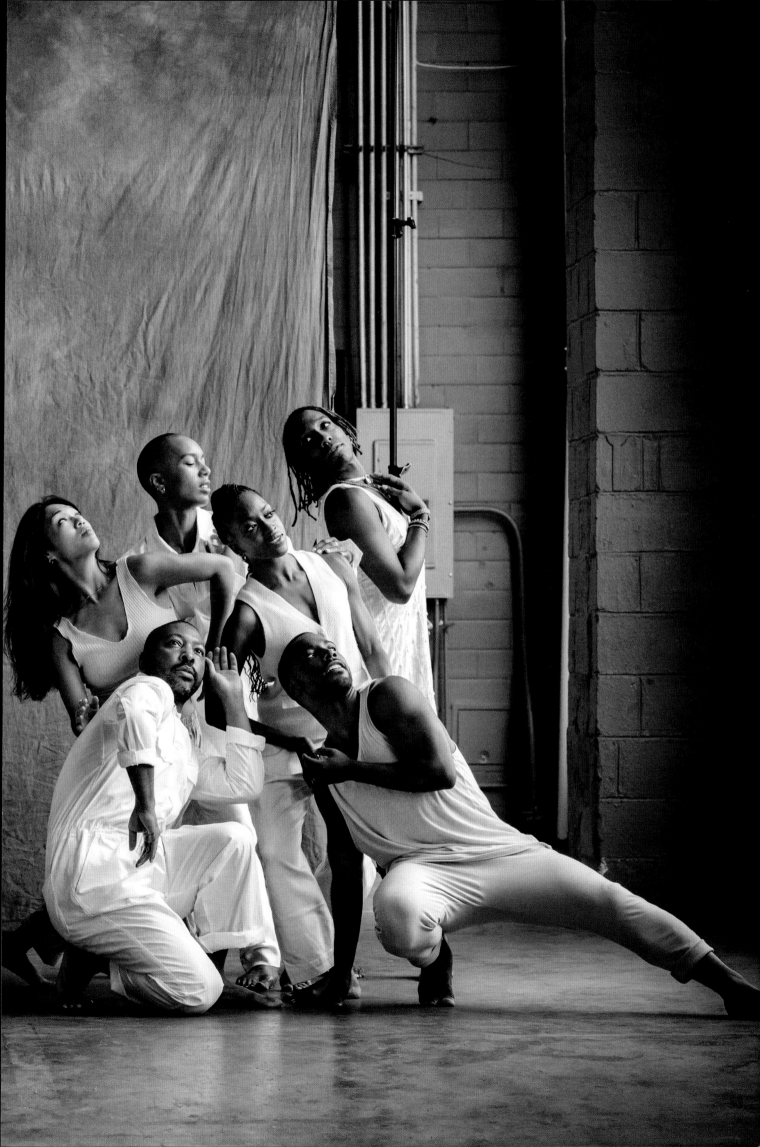

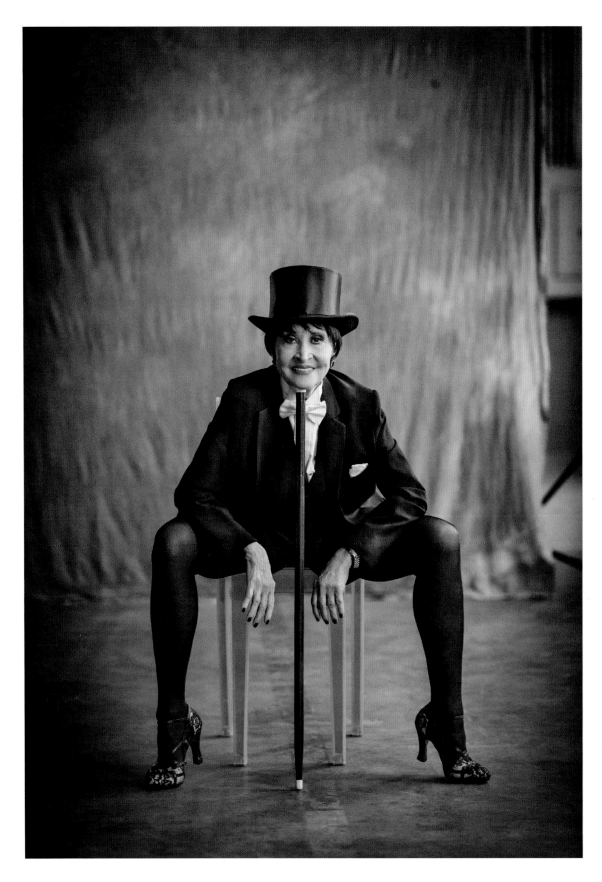

CHITA RIVERA Broadway

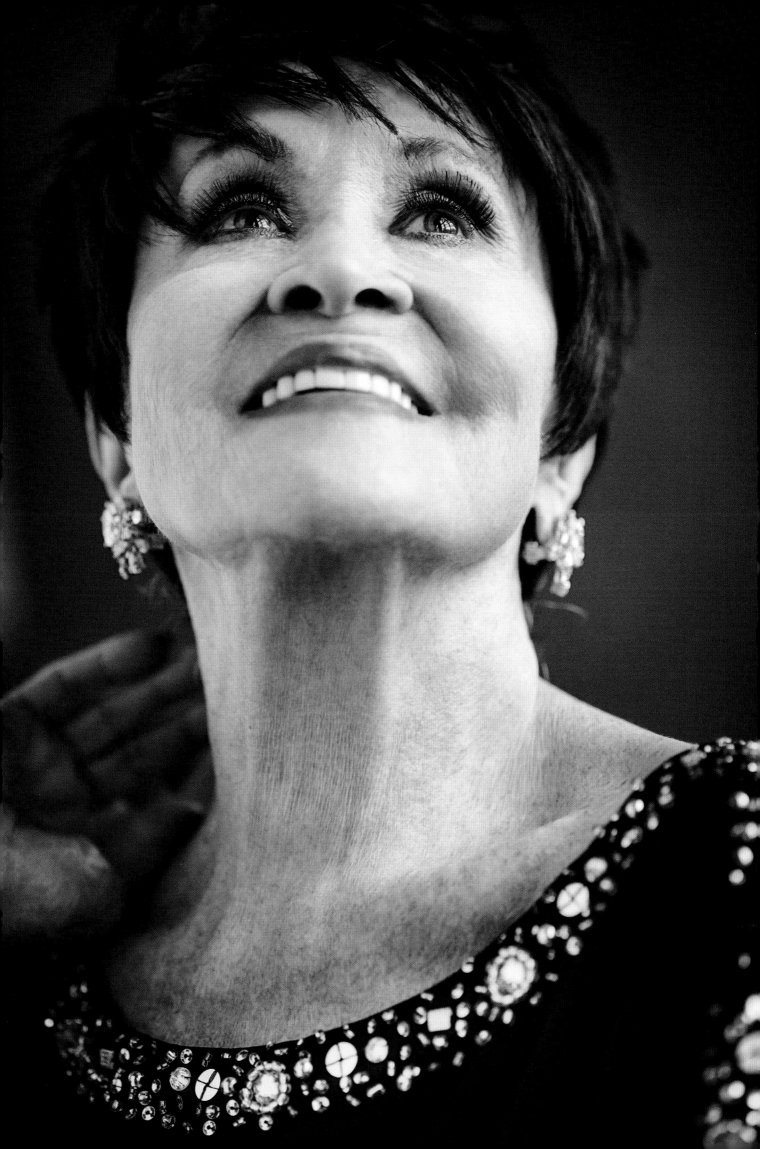

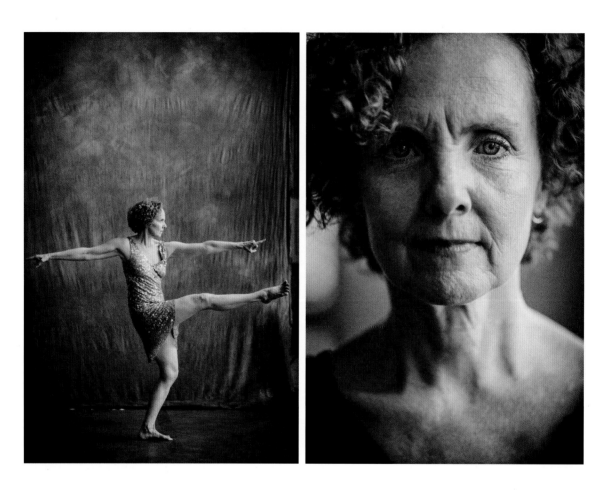

MEGAN WILLIAMS Modern and Contemporary

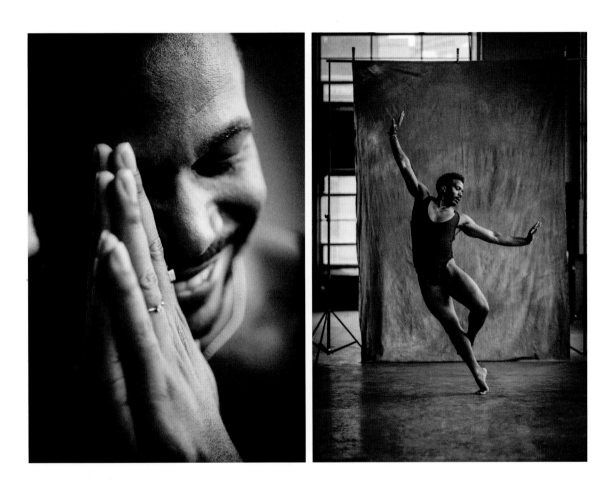

MICHAEL JACKSON JR. Modern

OVERLEAF: **LLOYD KNIGHT** Modern

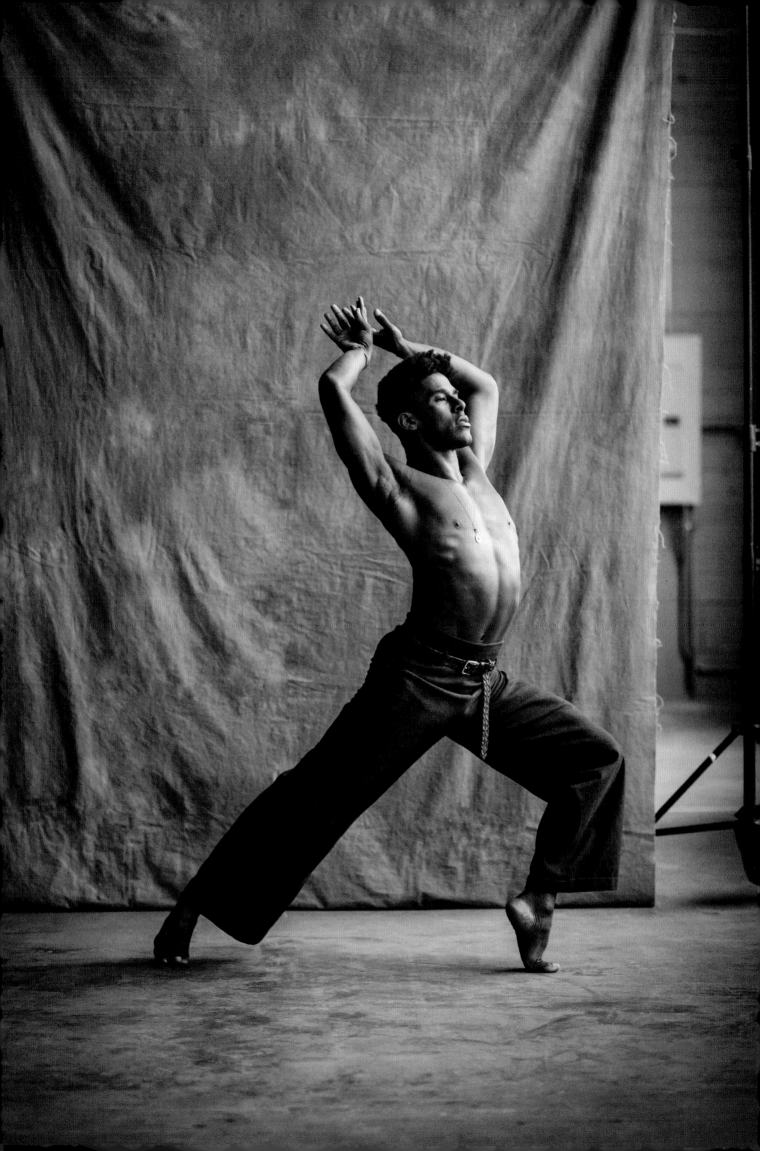

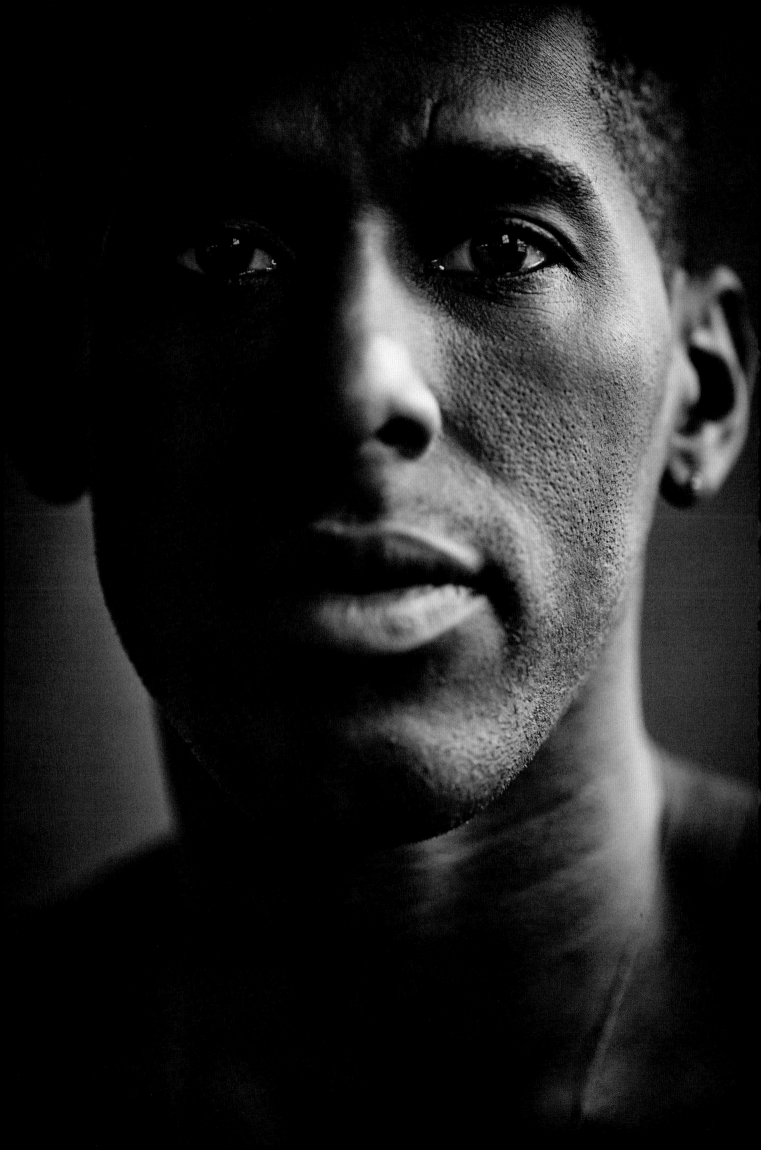

JACQULYN BUGLISI Dance Theater

I believe that movement is a basic element of human expression and that joy and inspiration flow from its wellspring. Using images, literature, poetry, heroic archetypes, and a consuming physicality, I craft dances that explore human relationships, revealing the bold visceral strengths, humor, and exquisite vulnerabilities of the individual.

The biggest challenge for me as a choreographer is always the birthing of the dance that is before me. Through a language that is timeless and universal, I am committed to creating theatrical dance works that allow us to pause, to consider issues of peaceful coexistence, environmental conservation, empowerment of women, and social justice.

I believe that dance transcends all boundaries, touching with wonder and inspiration the heart of the heart; its images allow us to recognize within ourselves each other, our ancestors, and the natural world. From this awareness rises meaning, compassion, and ways of knowing the indomitable spirt of man.

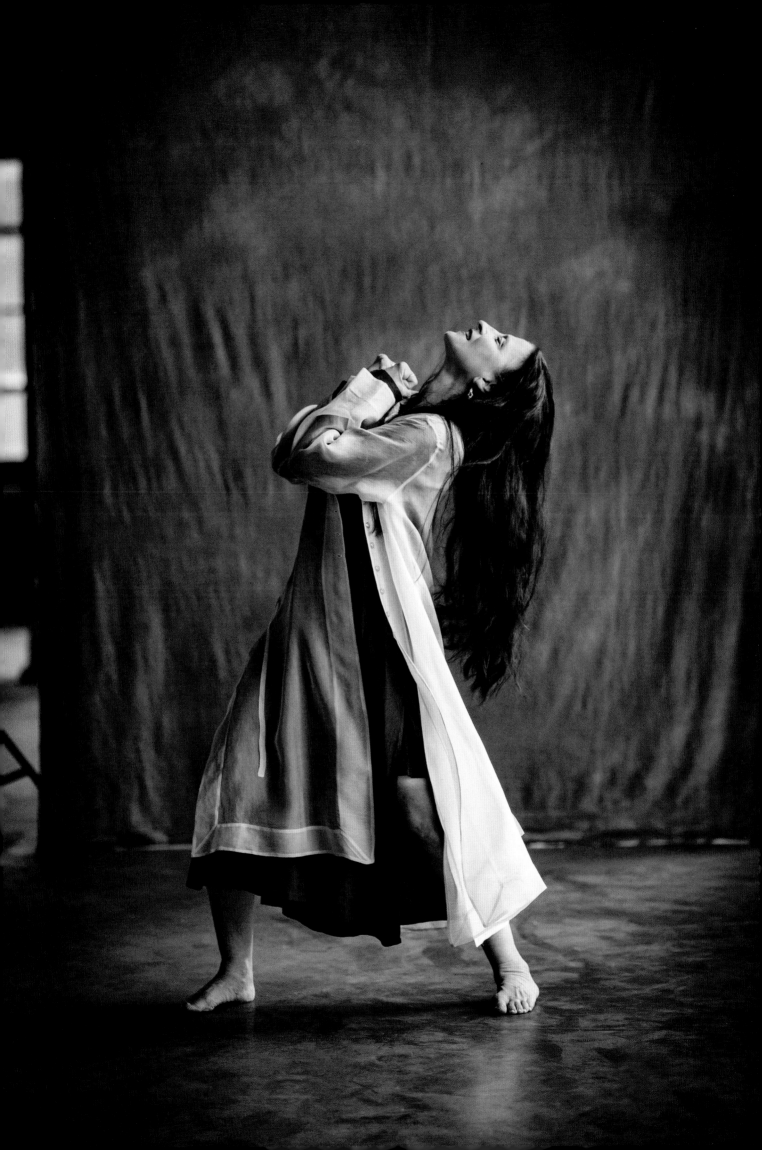

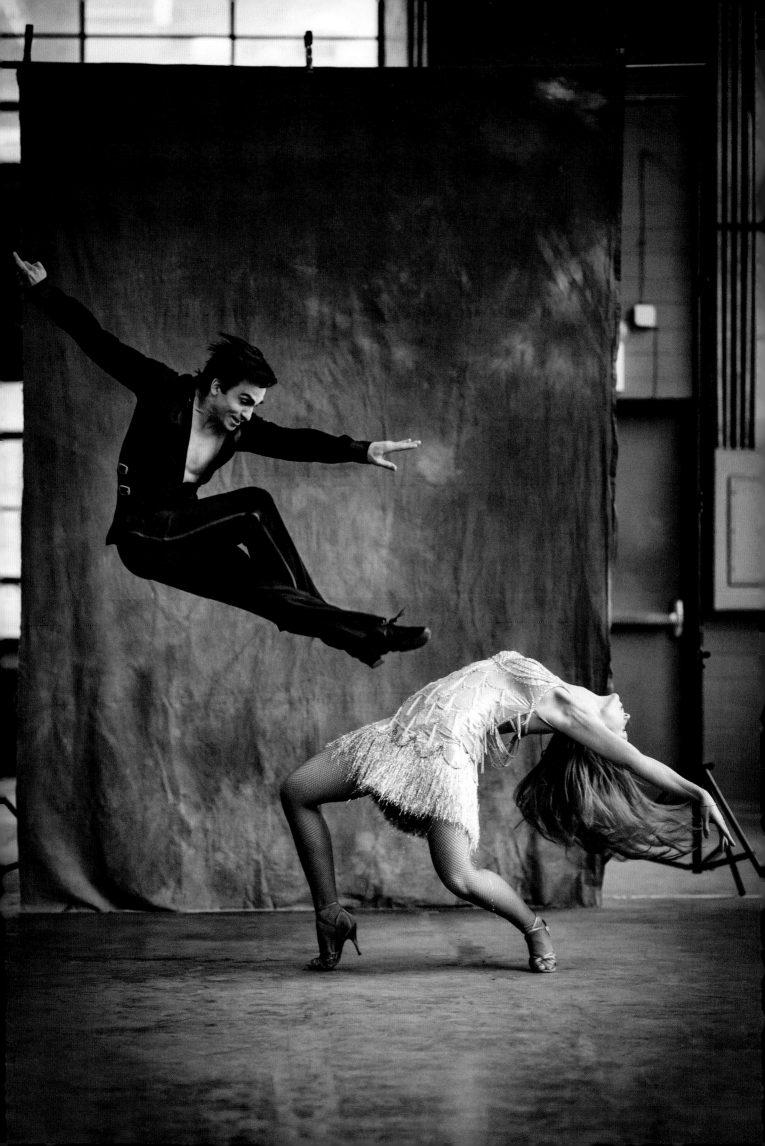

DENYS DROZDYUK and ANTONINA SKOBINA Ballroom

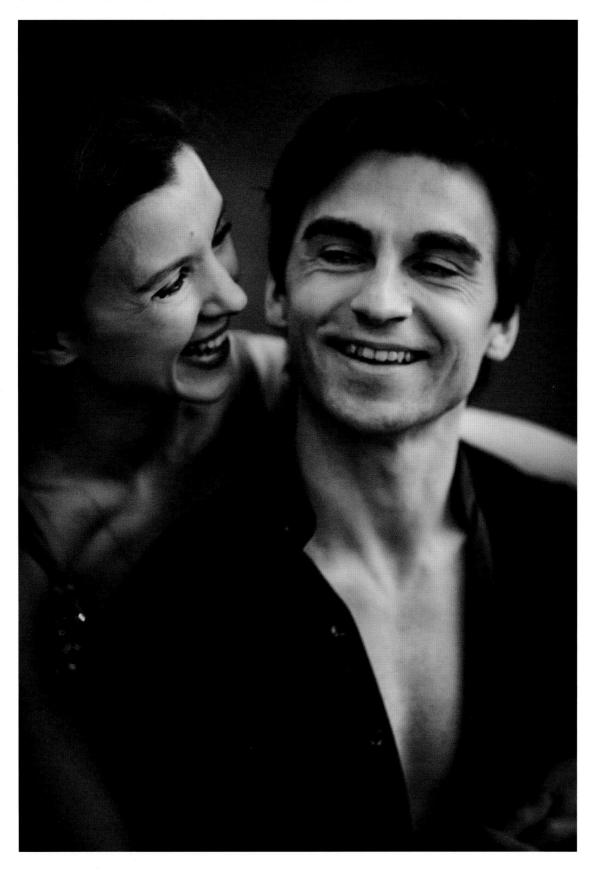

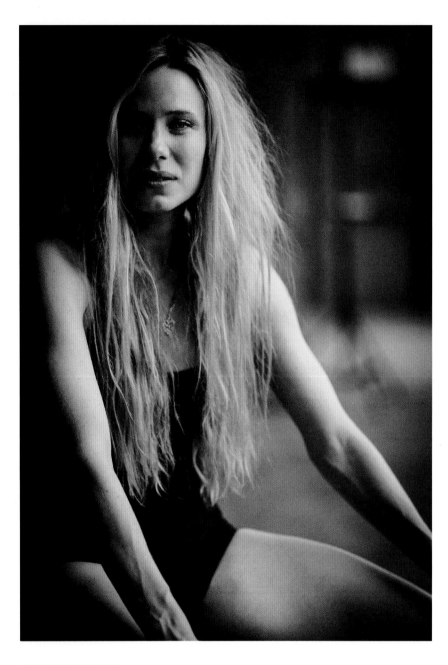

SARA MEARNS Ballet

I started dancing when I was three. It became everything to me from a very young age. It requires a certain level—a very high level—of discipline, commitment, love, passion, dedication, and skill to do it. But I don't see it as demanding; it's an honor for me to be dancing, to be able to live this life.

Every dancer has a passion for this art form. The life is too hard to live if the passion is not there.

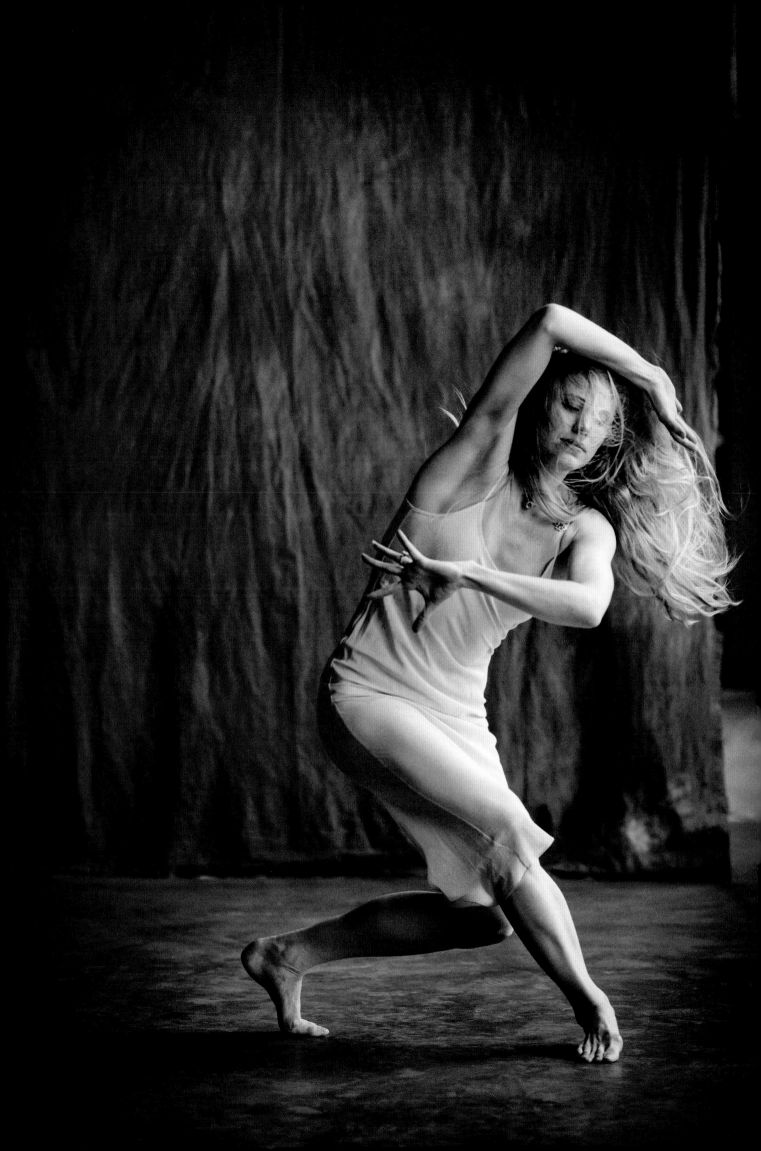

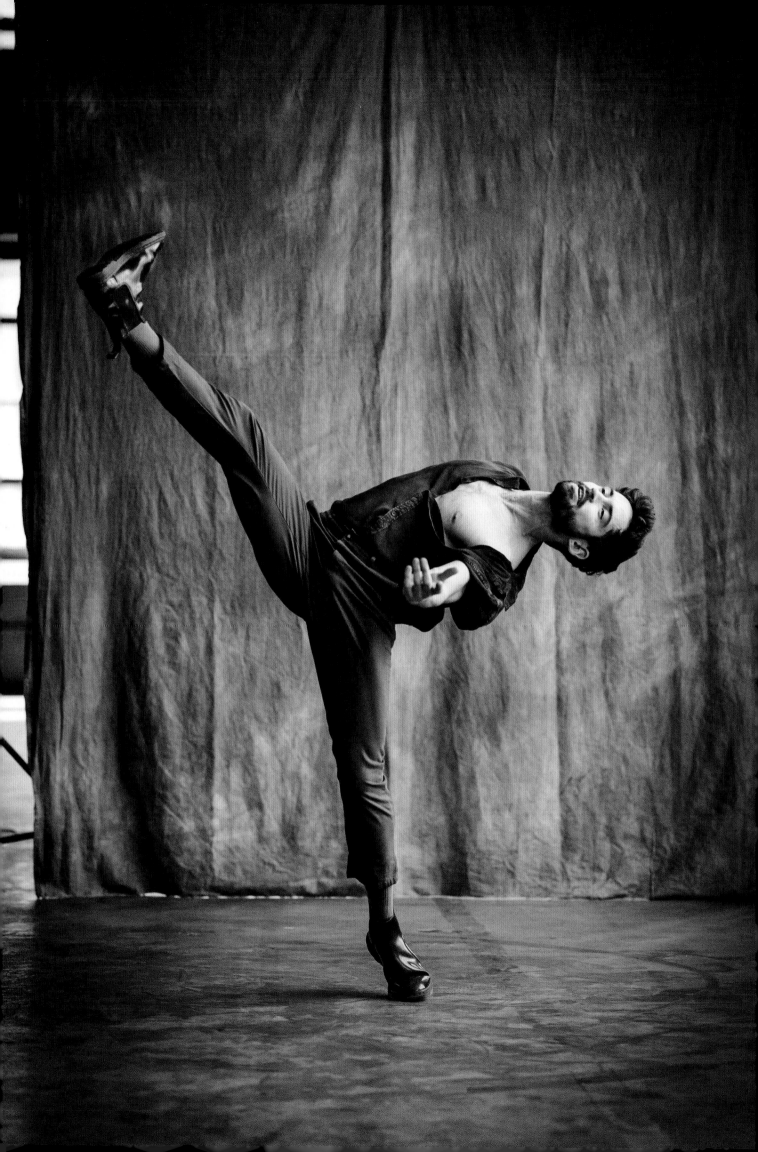

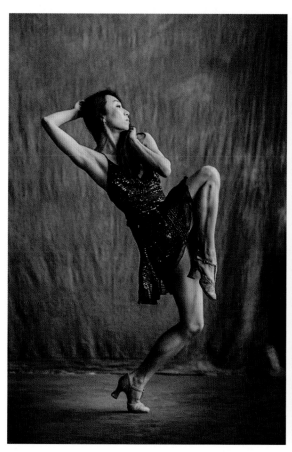

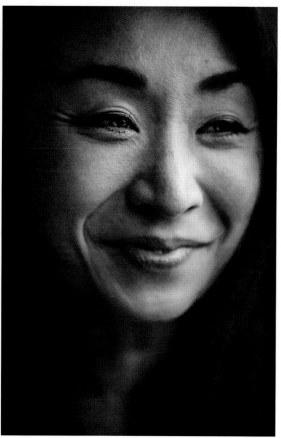

ARISA ODAKA Broadway

STEPHEN HERNANDEZ Broadway

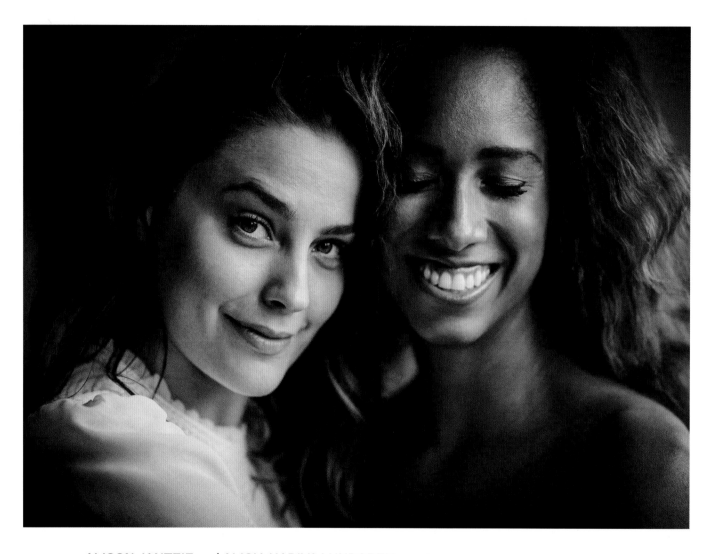

ALISON JANTZIE and ALICIA HADIYA LUNDGREN Broadway

The lived experience of each contributor in the dance community is what makes this collective so vibrant. It creates an empathetic, thoughtful, and joyful community that values and celebrates the talents and contributions of its members to the art form and industry. —*AJ*

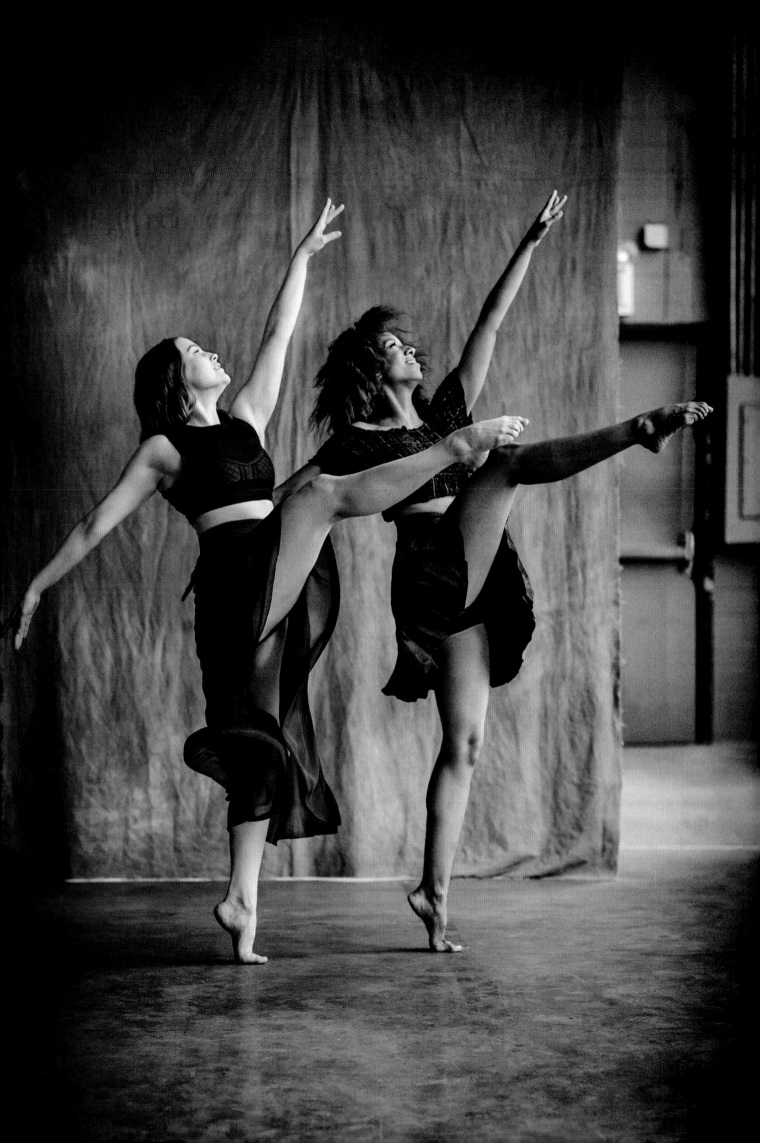

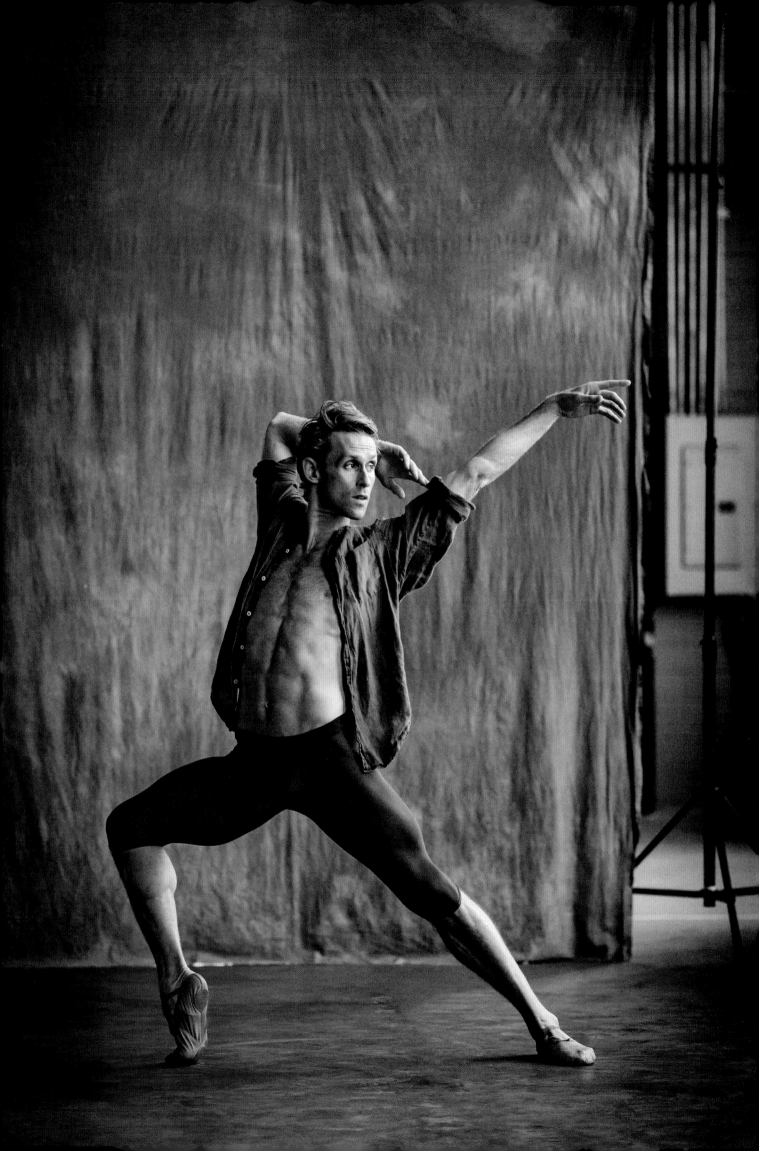

ADRIAN DANCHIG-WARING Ballet

OVERLEAF: **DESMOND S. RICHARDSON** Contemporary

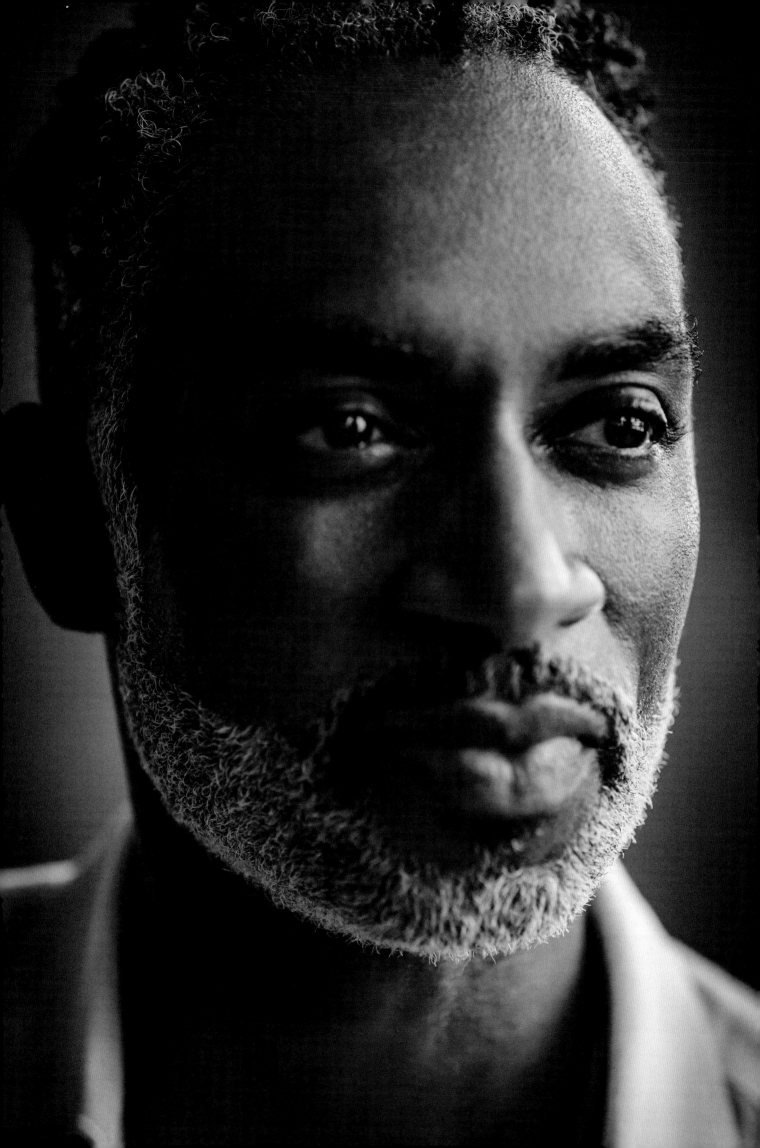

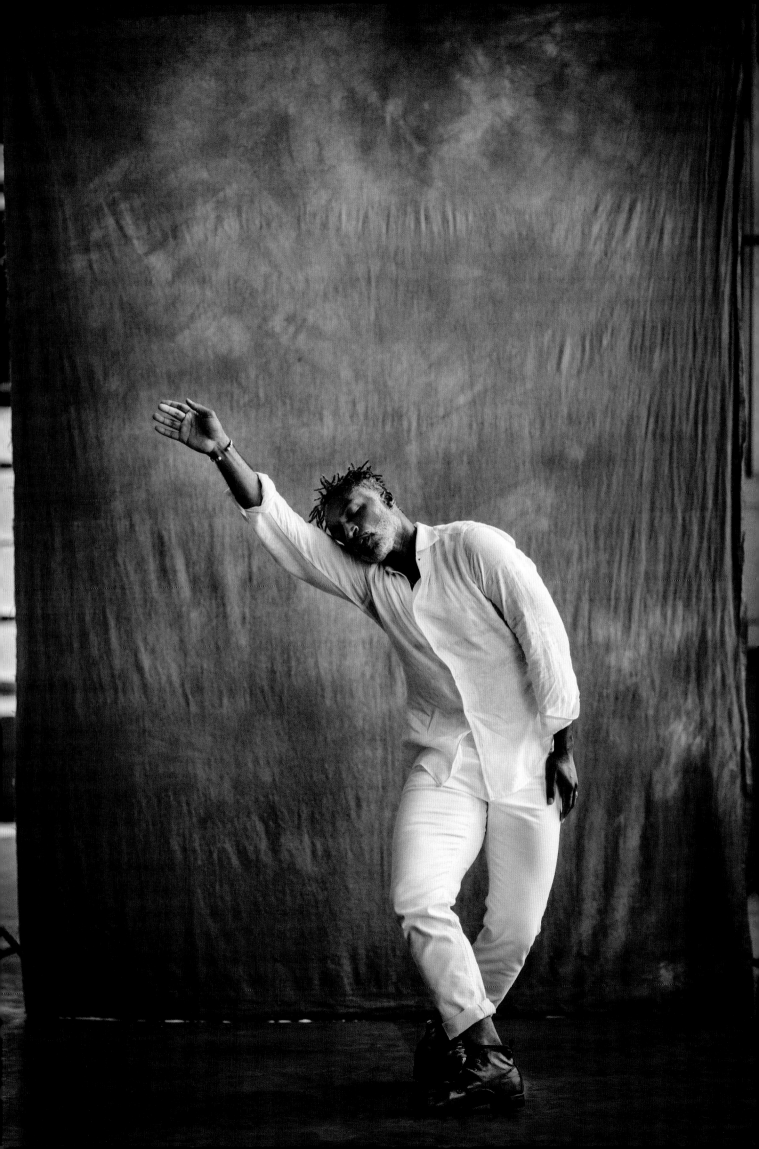

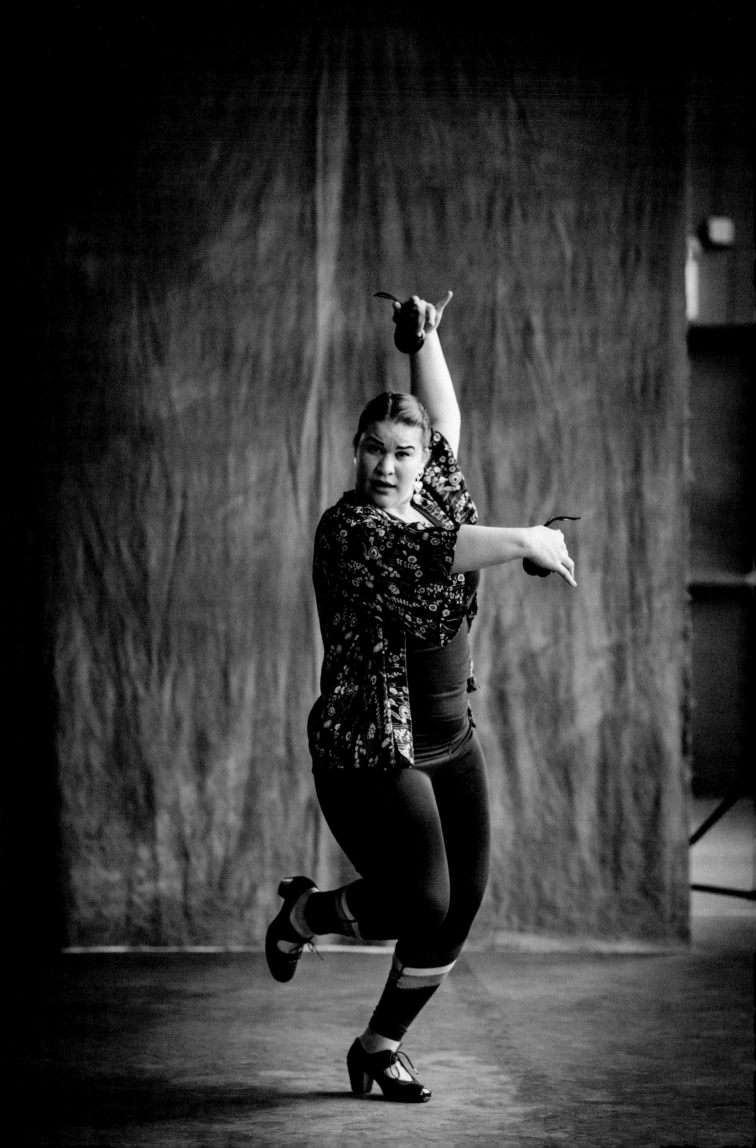

ARIELLE ROSALES Flamenco

In percussive dancing, the experience is based on receiving and responding to vibrations. It requires being entirely present in the moment so that you can respond to the vibrations even in silence and in breath. That flow of energy is the impetus of the movement and the rhythms that flow through the body, and in turn becomes art. In flamenco, this flow of creative energy is referred to as *duende*. Duende is a state of flow where you are a vessel for energies bigger than yourself, and Ego no longer exists. It is the most liberating sensation one can experience.

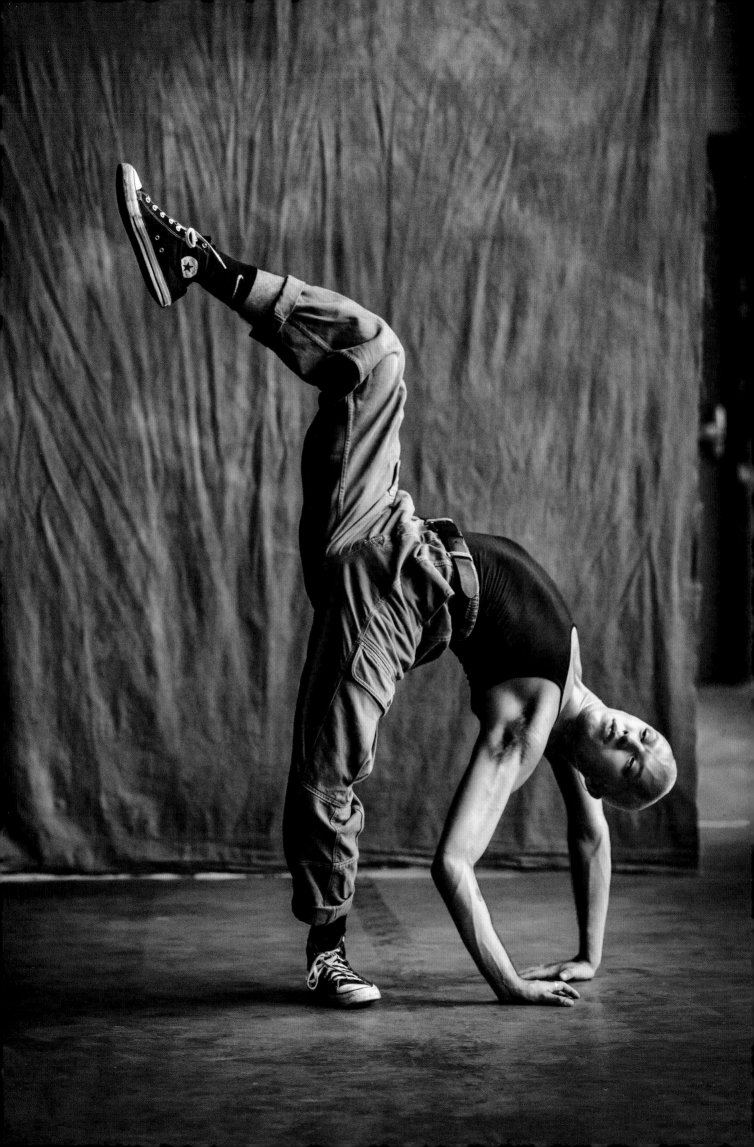

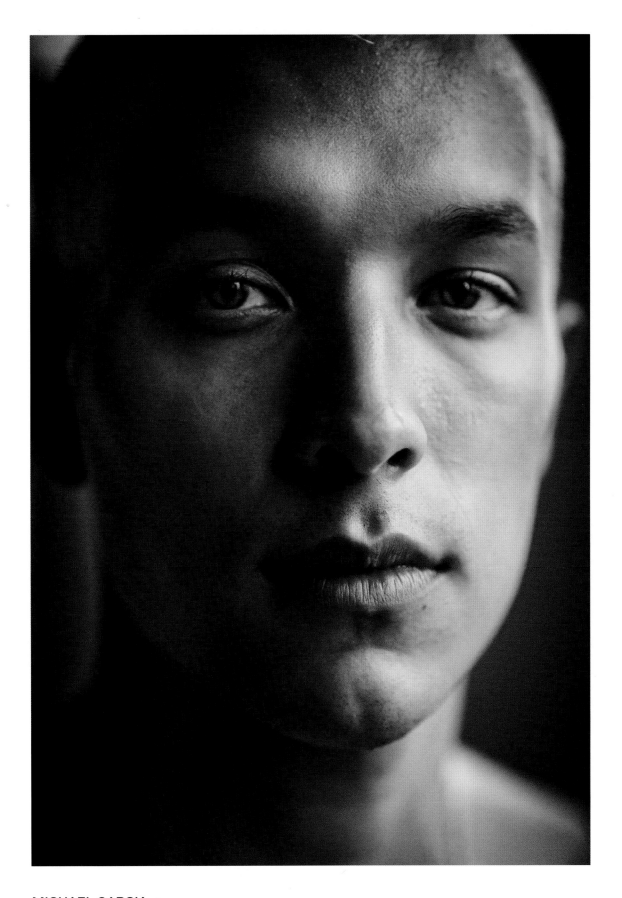

MICHAEL GARCIA Contemporary

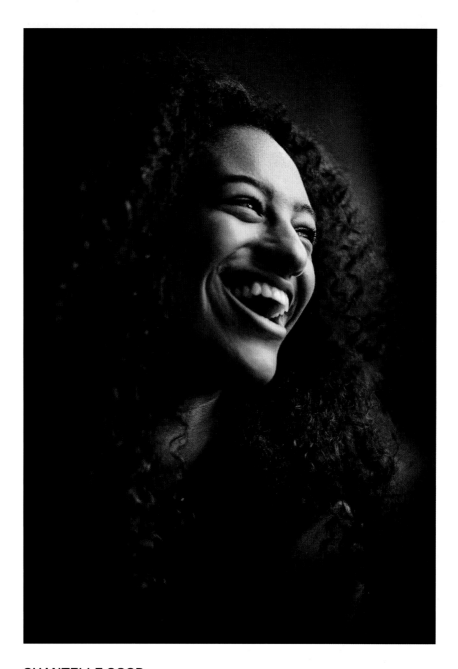

CHANTELLE GOOD Contemporary

I think there is a common understanding amongst dancers that to make a career out of this thing that we love is not easy; there are countless power structures in place that make it much more challenging than it should be. Being able to see people in the community thrive and achieve success (whatever that may look like) is a testament to the strength and tenacity artists possess. The resilience and adaptability this community shows in moments of adversity is like nothing I've ever witnessed or experienced. To look at a fellow dancer and know that you have some form of shared experience is both comforting and empowering.

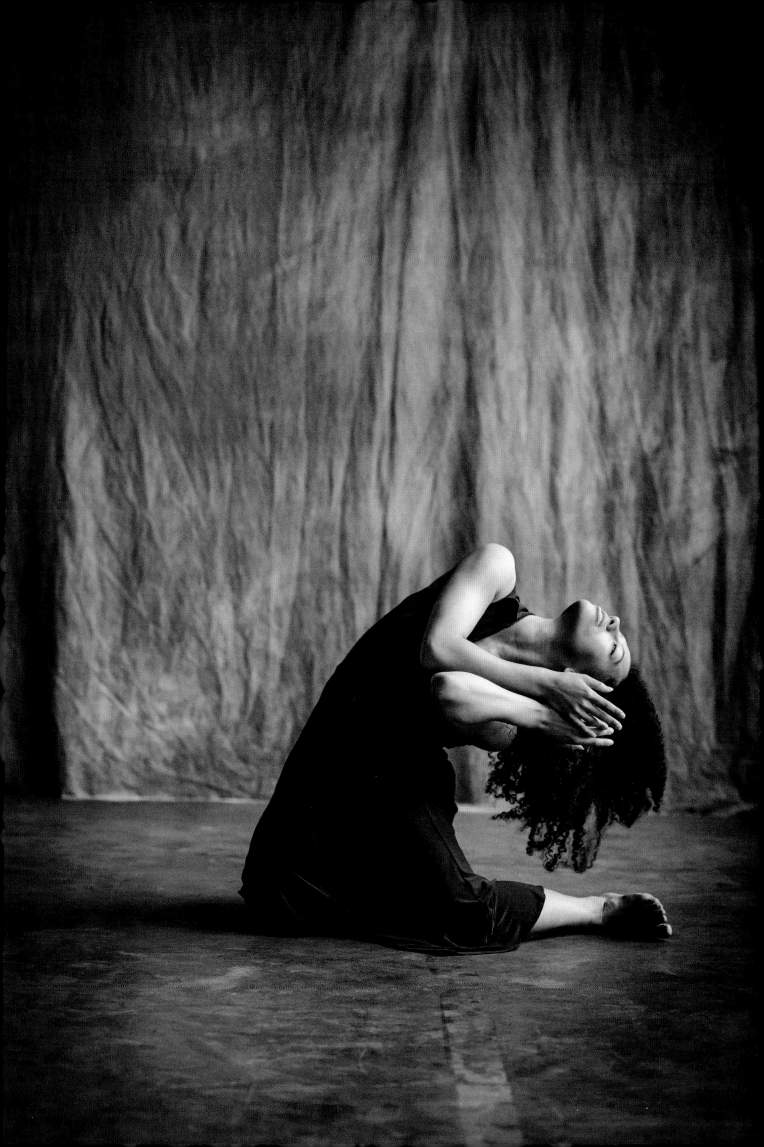

ROMAN MEJIA Ballet

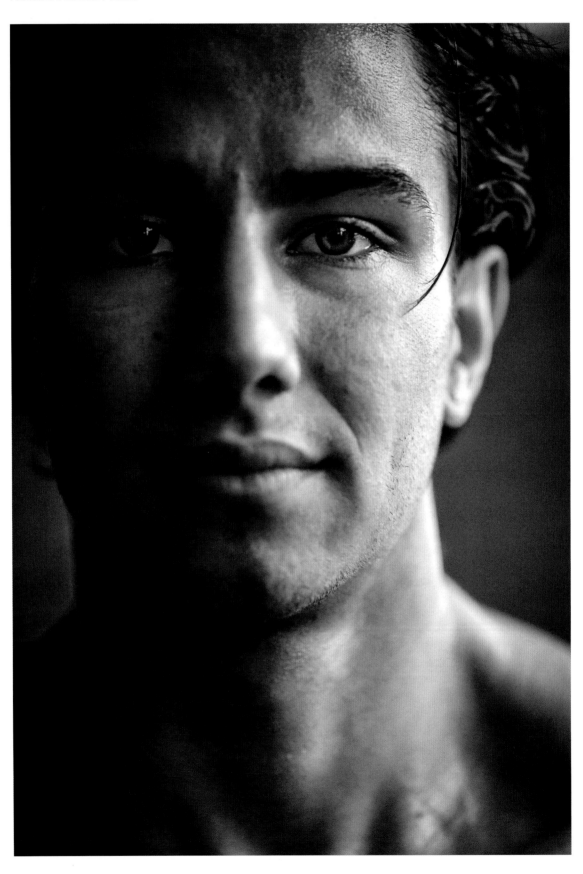

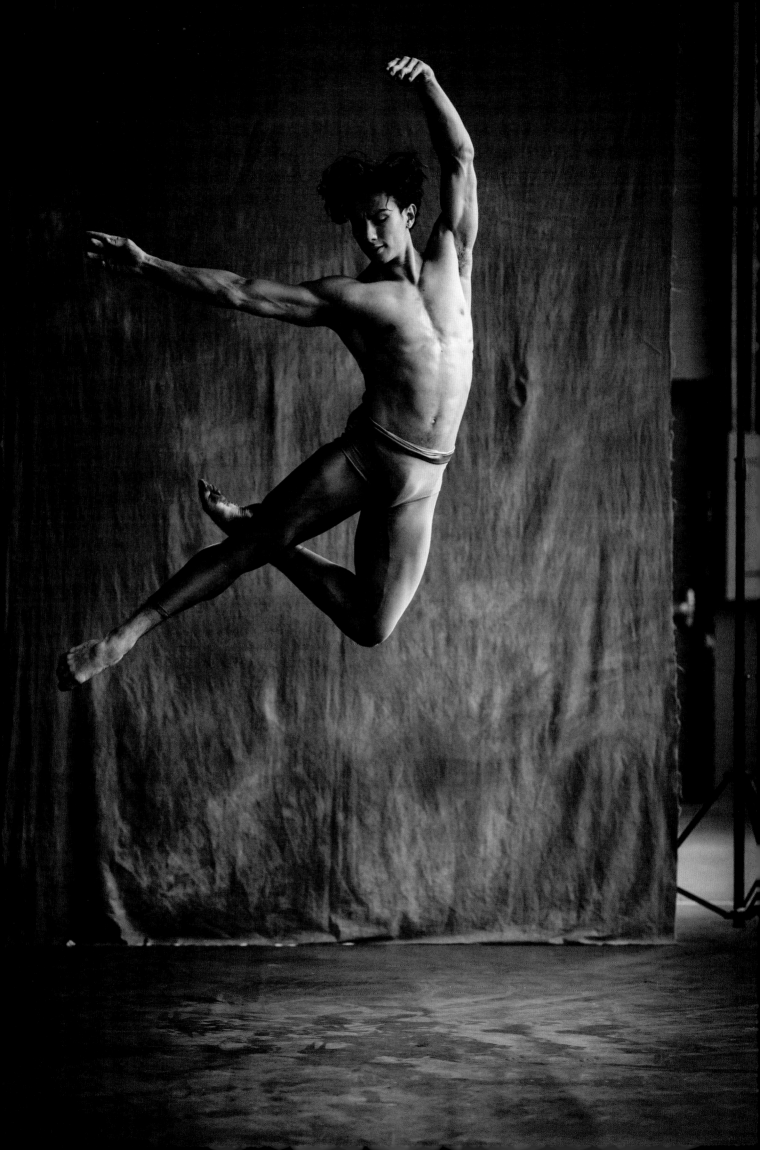

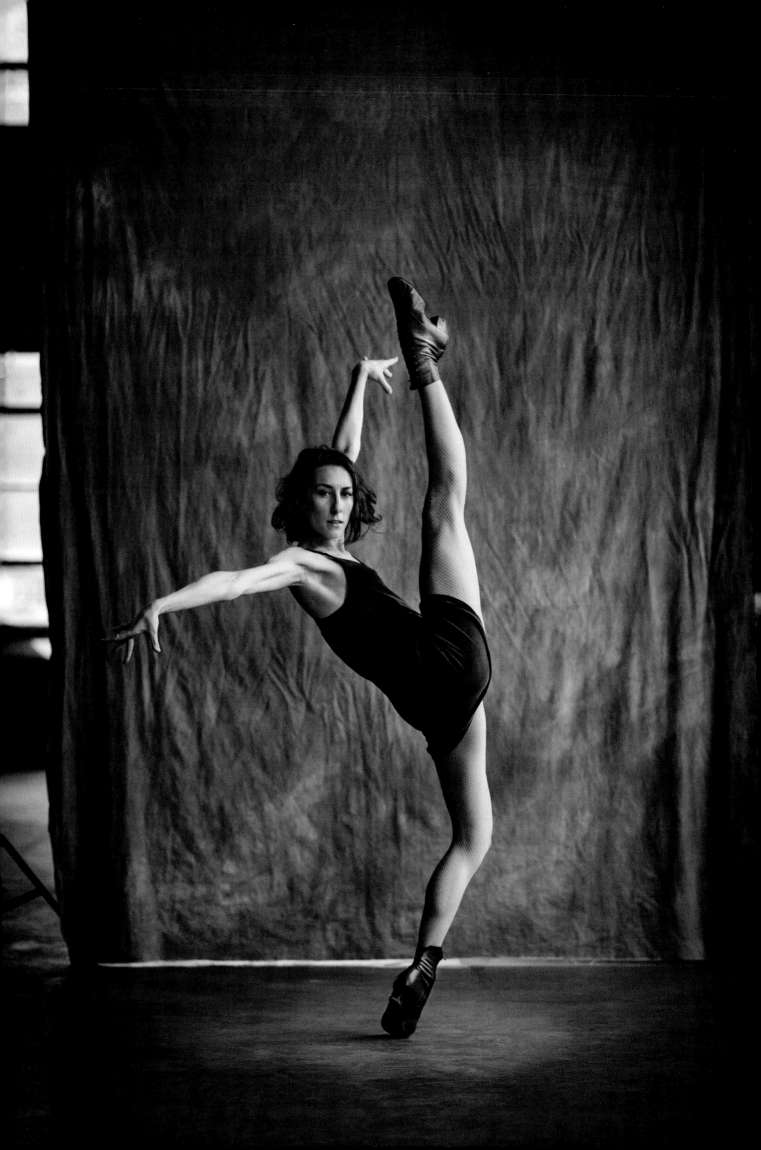

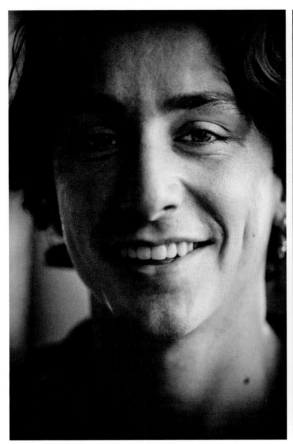 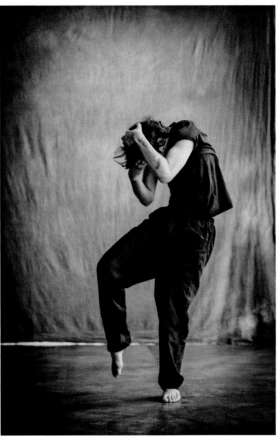

ETHAN COLANGELO Contemporary

SKYE MATTOX Broadway

As humans, I think we try to temper our emotions on a daily basis—whether it's to make sure people feel comfortable or to compartmentalize things for ourselves that might be too hard to think about. And when we give ourselves permission to be unabashedly emotional, like with dancing, it's incredibly cathartic. That's why I feel so good after class or a performance.

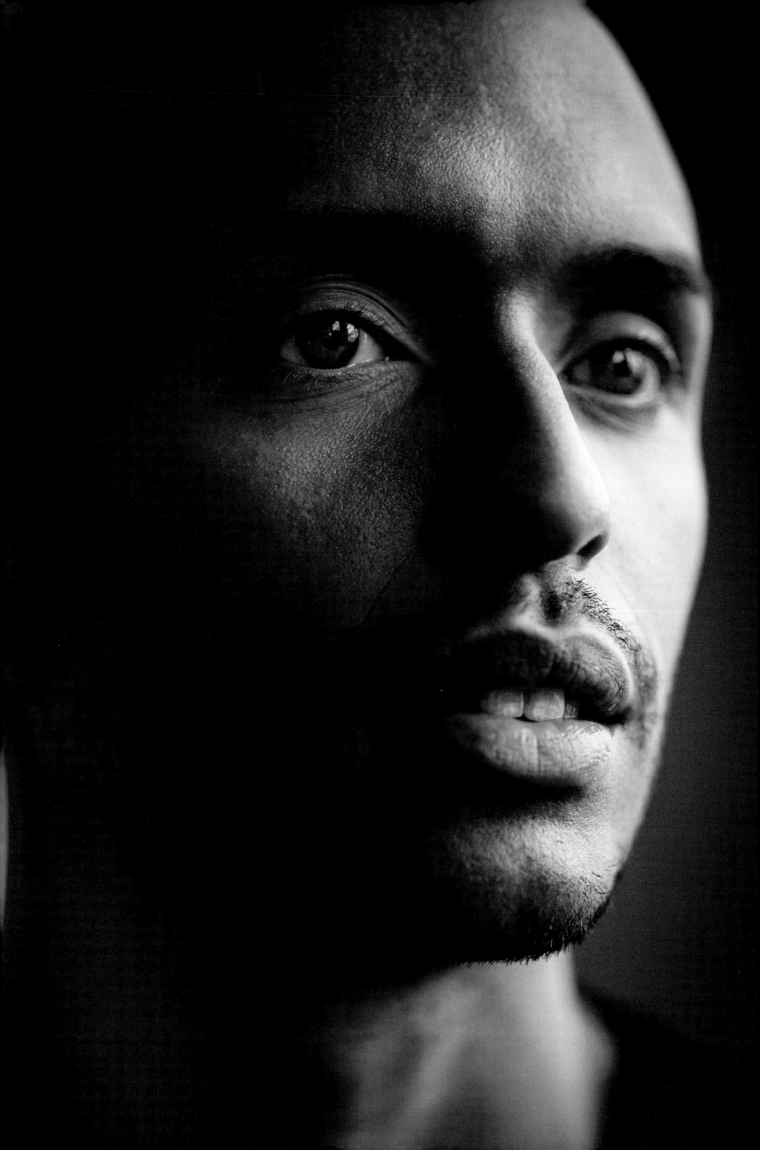

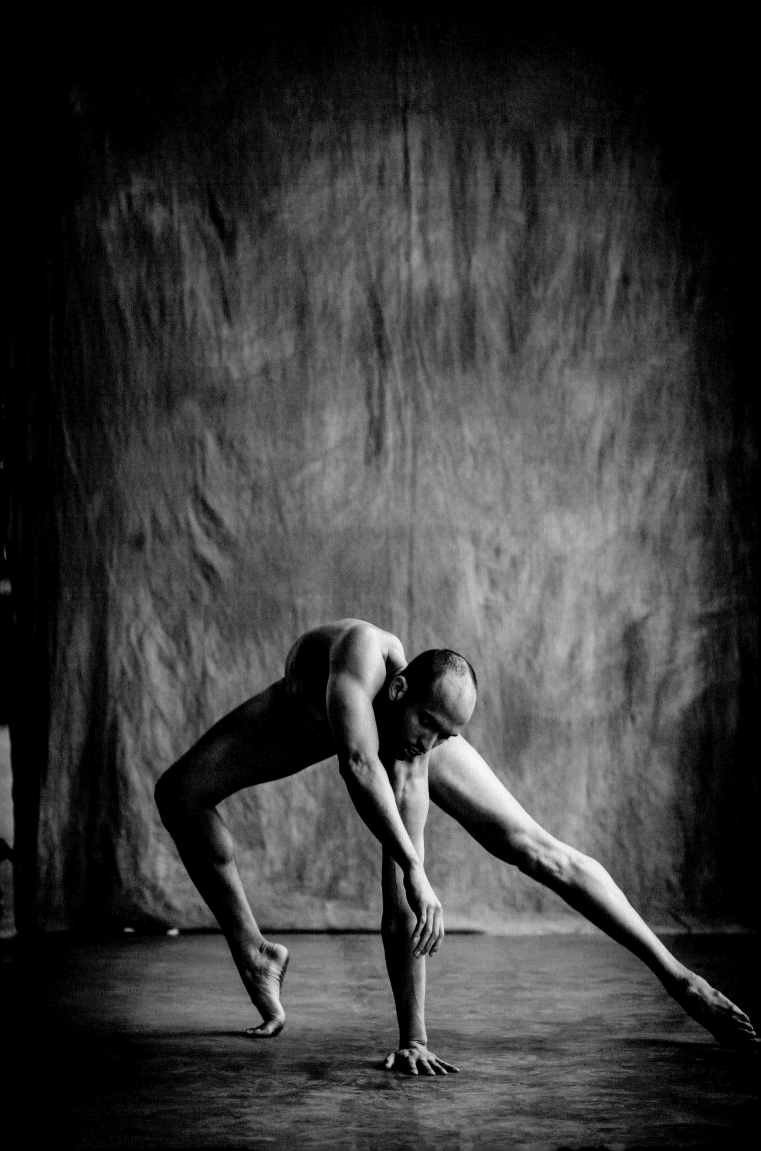

ELISA CLARK Modern and Contemporary

When your heart is fullest because of dance, it demands discipline and dedication. To live freely within one's purpose is the ultimate way of life.

The dance community is as diverse as the world we live in. Certainly, our individuality and self-expression contribute to this. There are dancers and dances that provide entertainment for entertainment's sake, and then there are dancers or dance makers whose only mission is to elevate and explore the craft itself. The range is part of what makes the industry brilliant! Chances are, however, if you identify as part of the "dance community" and have persevered to make this your profession, you have felt that you didn't choose dance, but that dance chose you; despite the challenges and never-ending hard work, being a dance artist makes your life fuller or better or more realized than if you were without dance, and I trust that is something that we have in common.

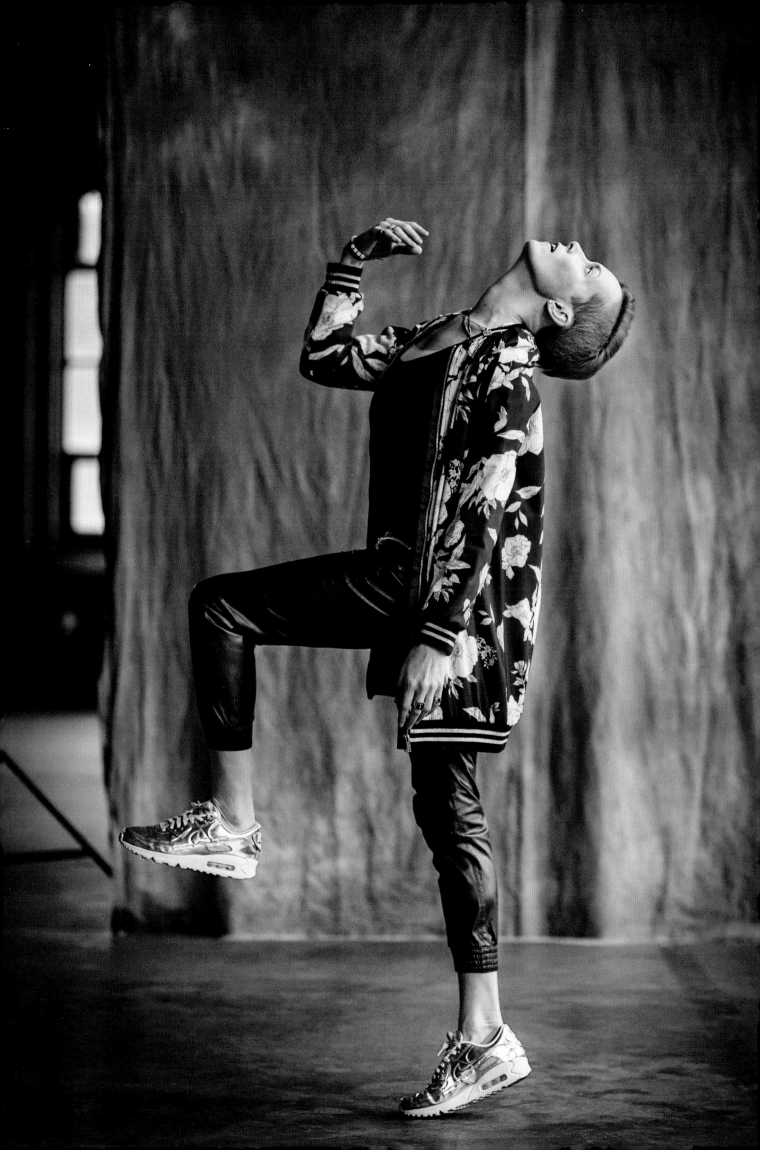

BRANDON T. GRAY Contemporary

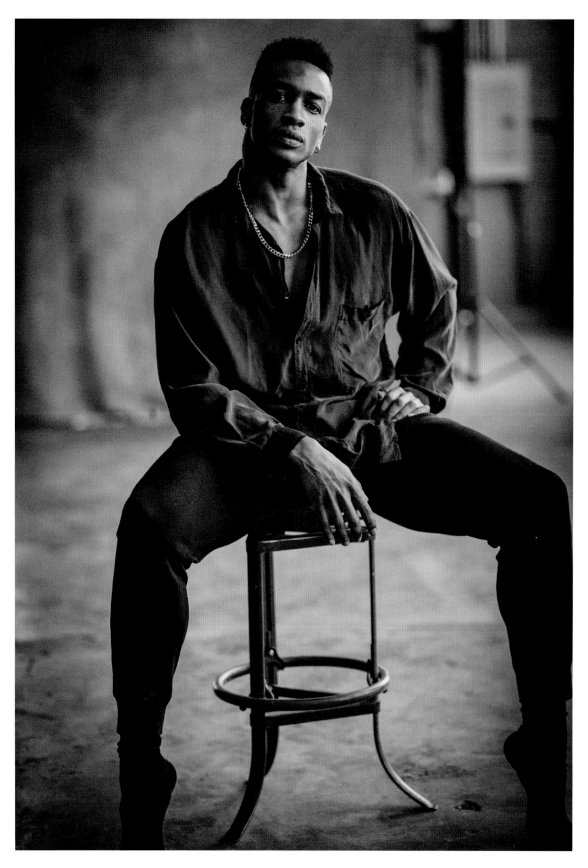

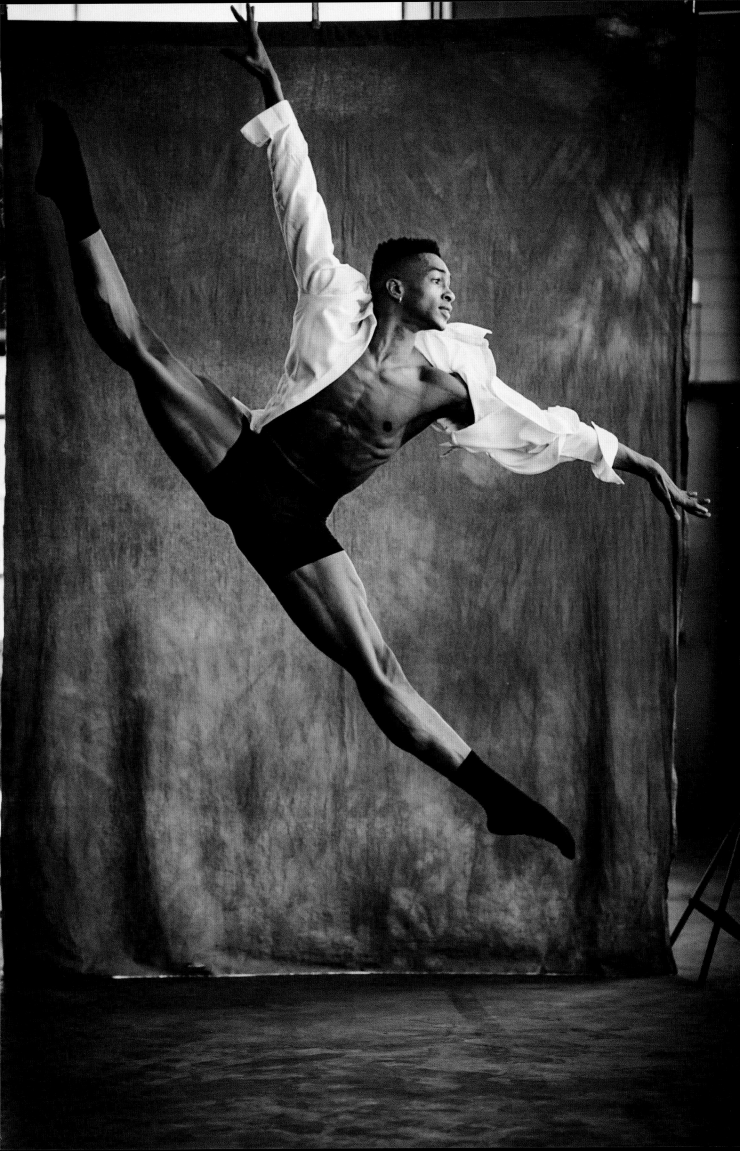

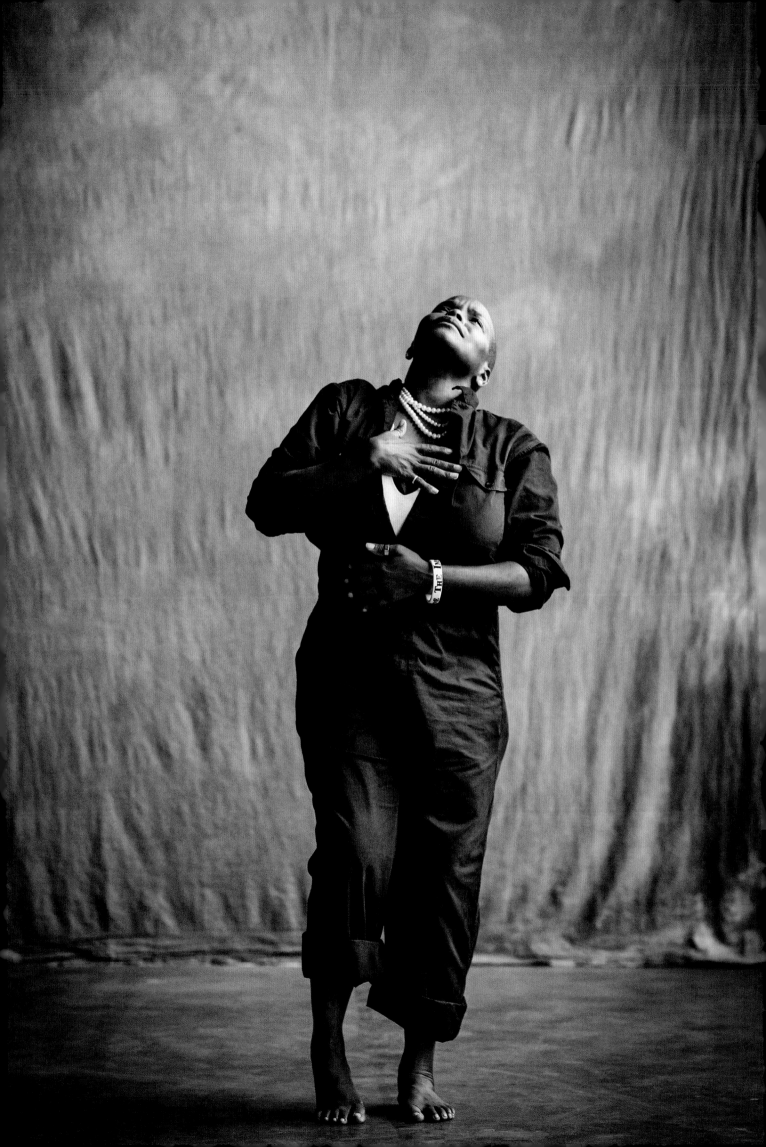

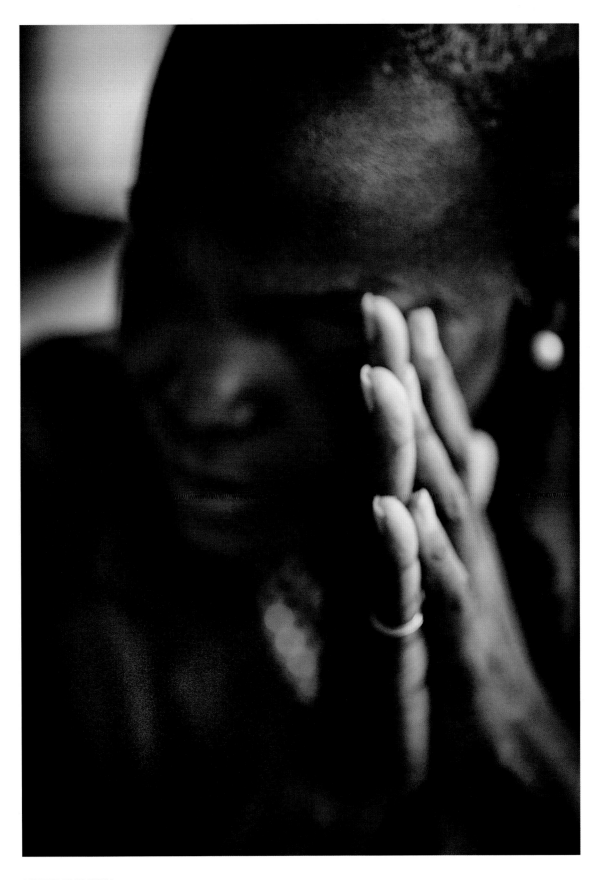

HOPE BOYKIN Modern

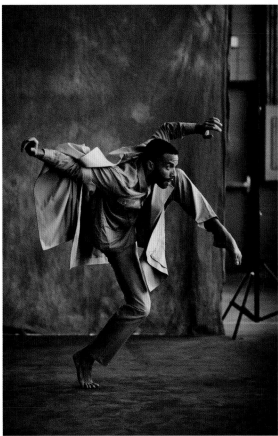 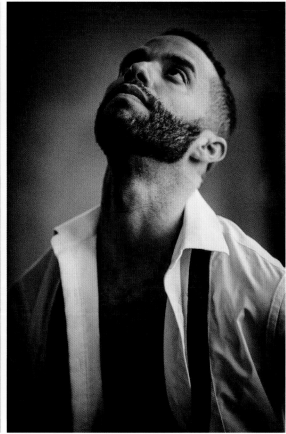

RICARDO A. ZAYAS Contemporary and Broadway

I had a total revelation when I realized art was going to be my life's work. It's sad to think the possibility may have never even occurred to me. That's why representation matters—to know our possibilities are endless.

Sometimes dance is worship for me, while other times some sort of exorcism occurs. It's deeply spiritual, and not of this world.

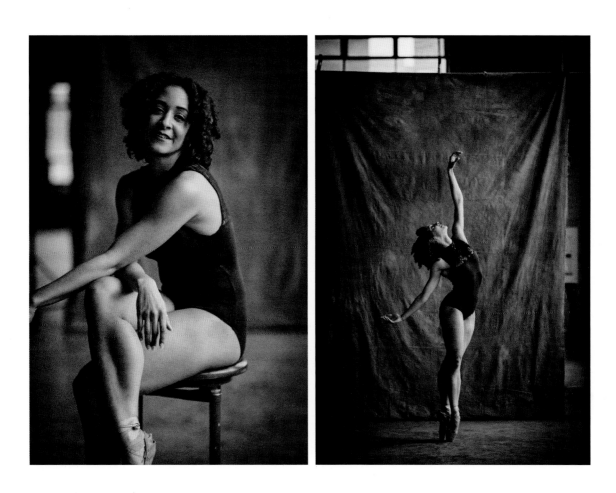

LARISSA GERSZKE Contemporary

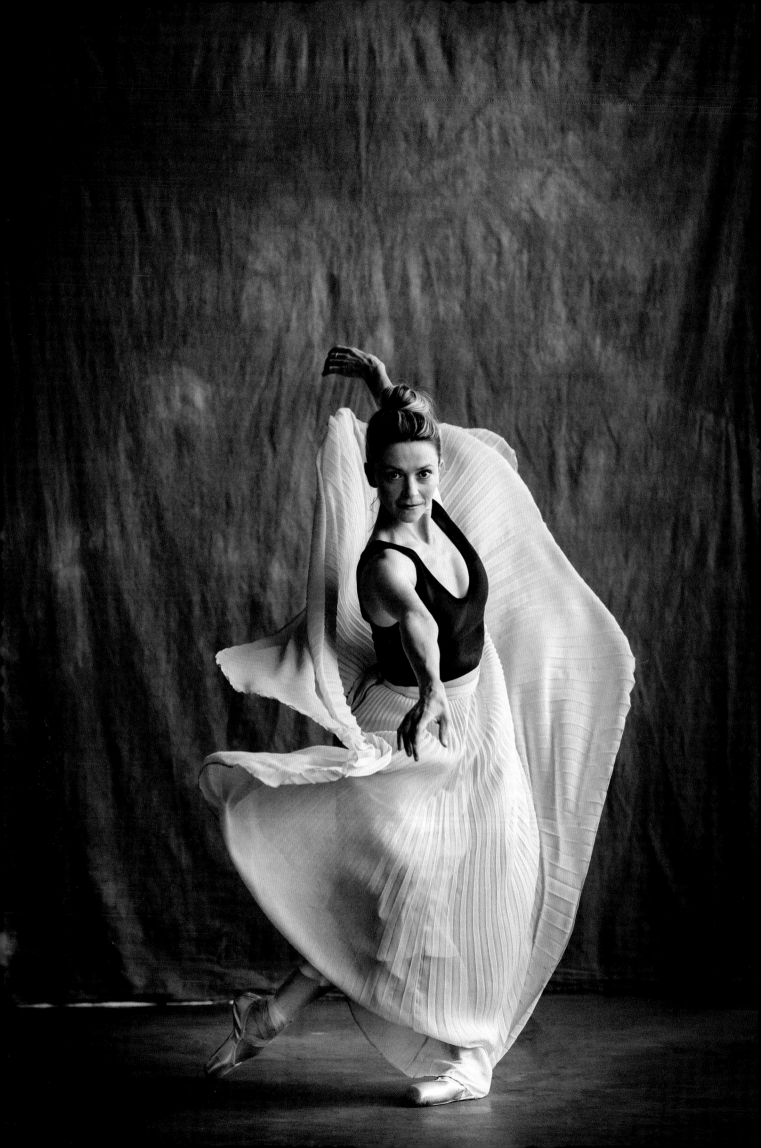

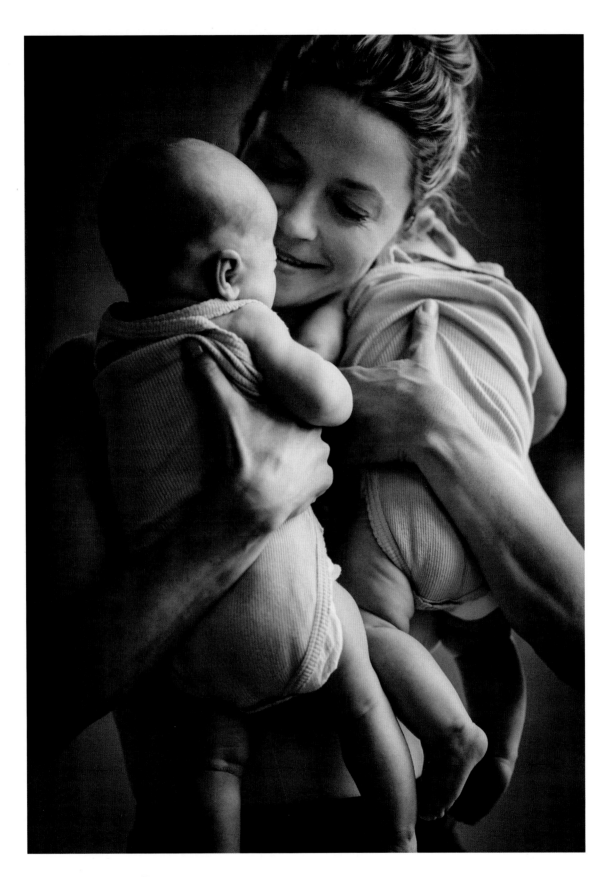

MEGAN FAIRCHILD Ballet

There is nothing more therapeutic than dancing your heart out to glorious music. It is like a meditation. Thoughts stop. Time stops. And you just exist in the movement to the music.

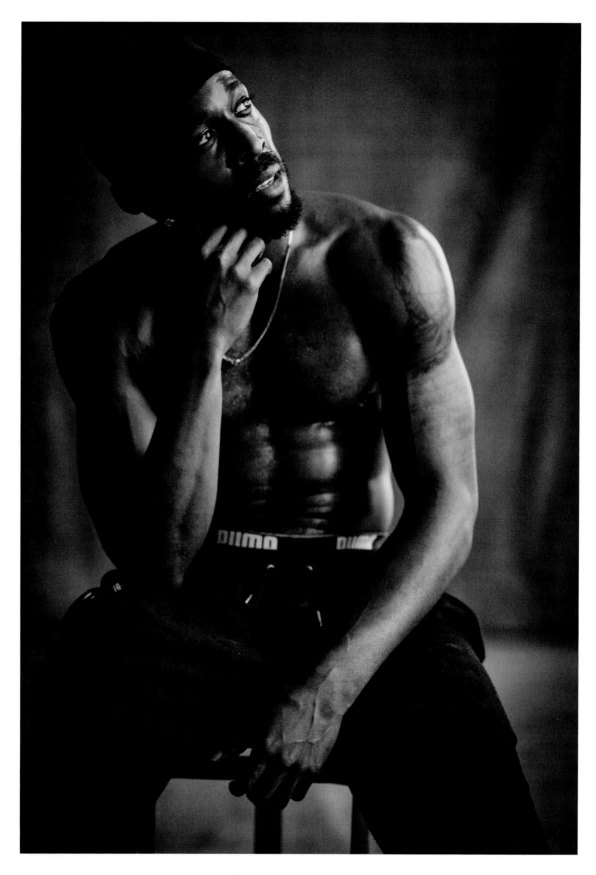

HUWER "KING HAVOC" MARCHE JR. Flexn

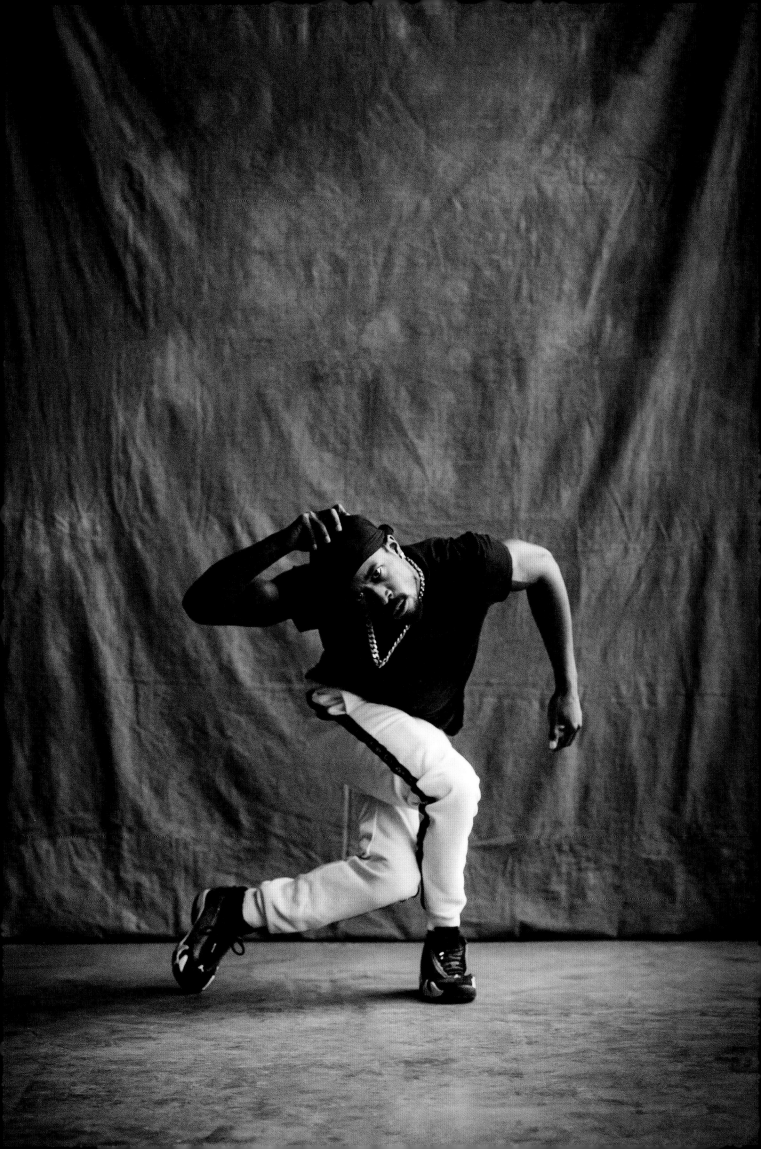

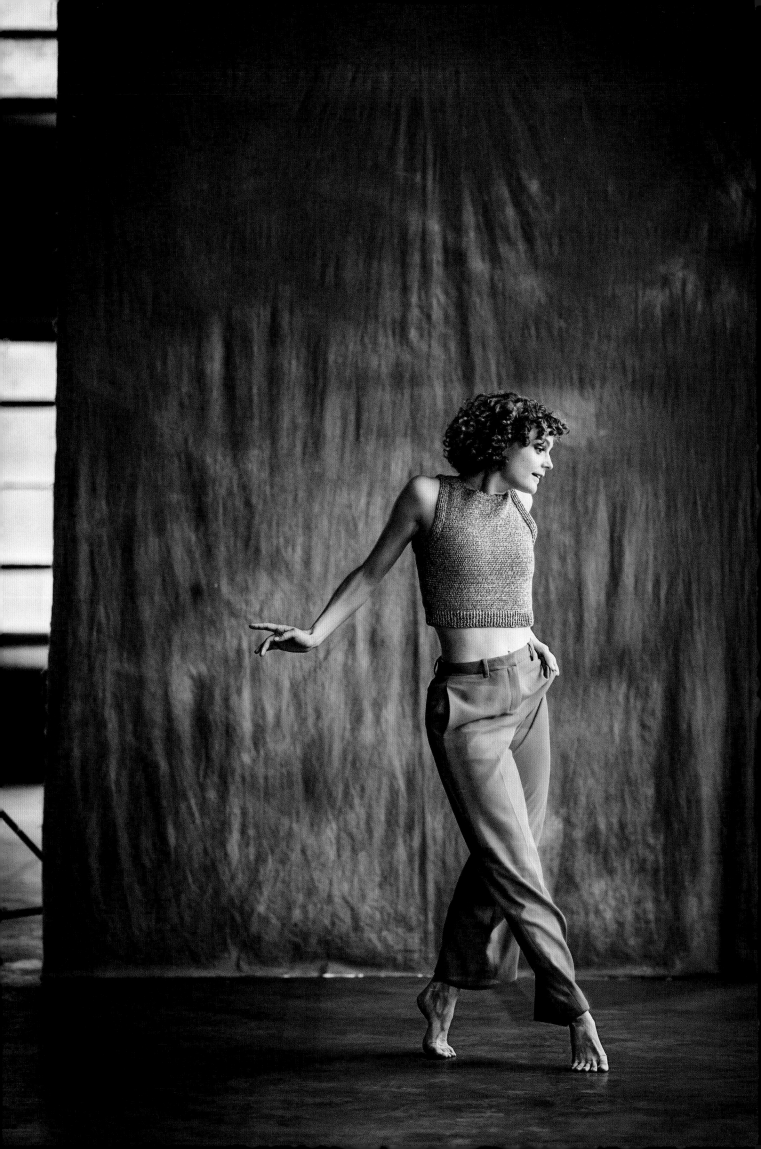

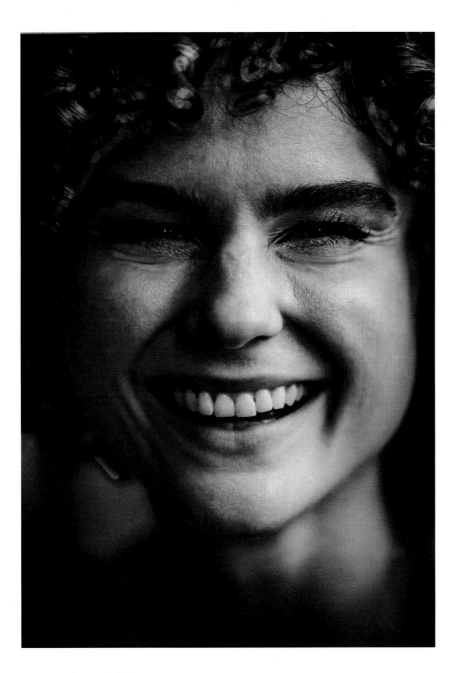

MELANIE MOORE Contemporary

Expectation has been the biggest challenge of my career. Careers are long and take unexpected twists and turns, and they don't always look the way you think they are going to. Once I let go of my expectation of what my dance career should look like and started being open to where dance was actually taking me, a whole new path opened up for me that I could never have imagined. My dance career doesn't look the way I thought and hoped it would when I was younger, but it has been more beautiful and fulfilling than I could've ever dreamed of. I can't wait to see where it leads me next.

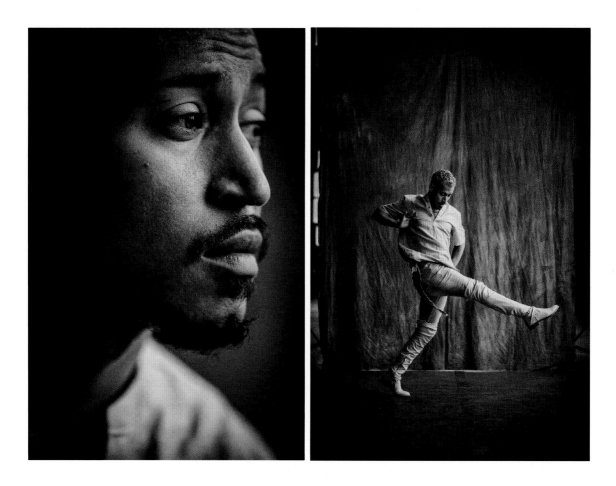

AMADEO "REMY" MANGANO Vogue

It is a blessing to be a part of such a strong community of individuals who are accepting yet harsh. Not everyone is built to be a dancer, or can understand that movement is more than just movement. But when you are in a room of dancers and that beat is playing, no matter what type of dancer you are or who you know, you will all be able to communicate, because your dance is your language. It's all about being able to have unspoken communication. That's what makes you a dancer, being able to understand the language of dance.

SIDRA BELL Contemporary

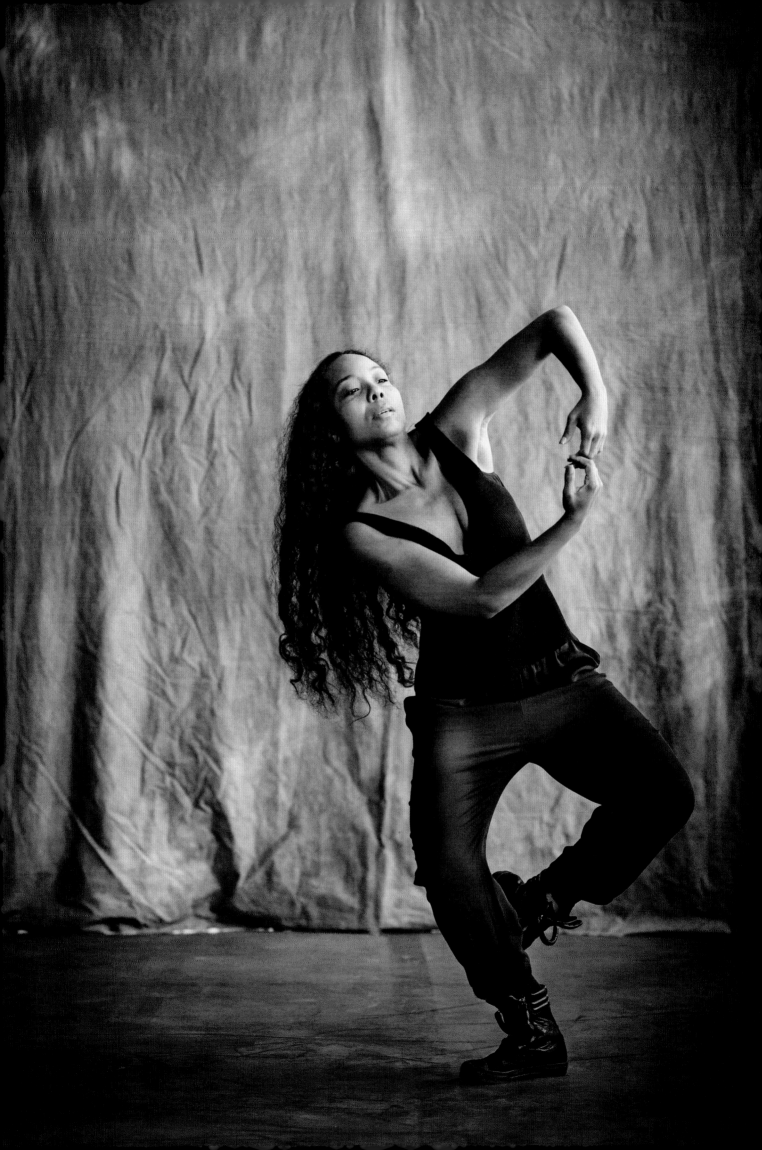

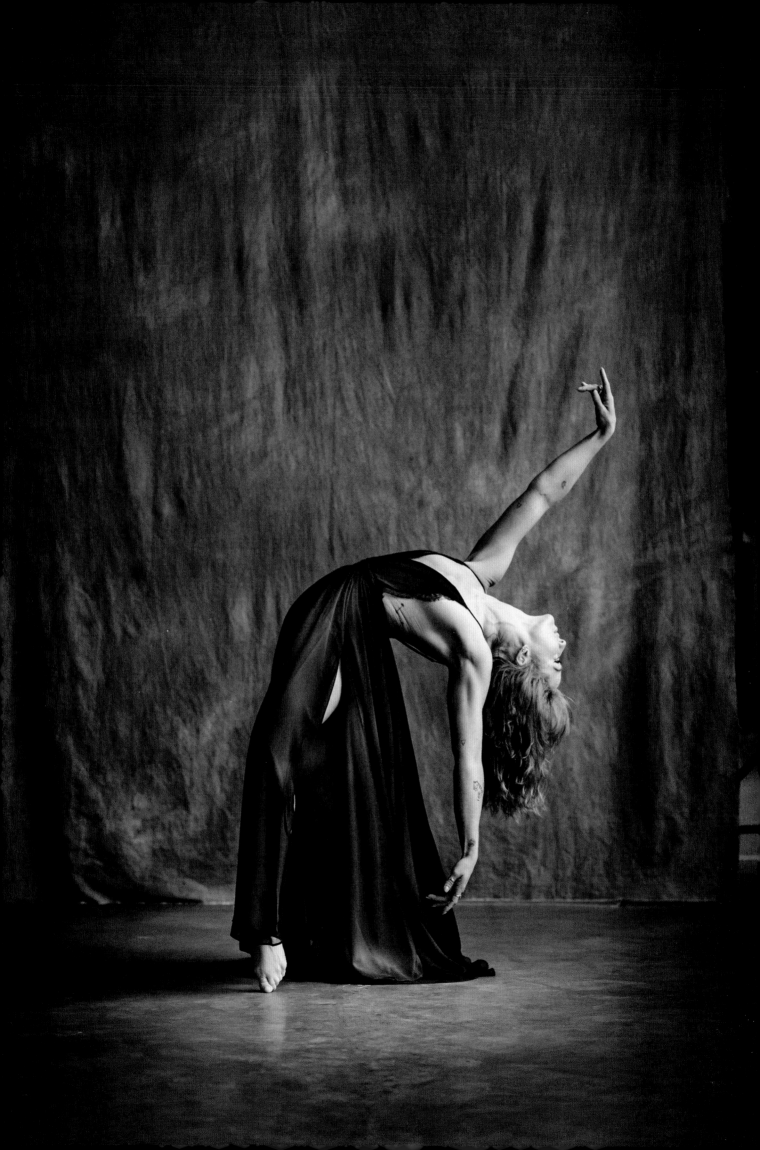

KAITLIN MESH Broadway

My mom used to say, "When you dance, it's like you're praying," and that's sort of what it feels like. It's the only time the chatter in my mind quiets and I can connect wholly with my body, in the here and now. I feel completely present—connected to breath, my body, and my dance partner. Enveloped in the current moment. The now.

My biggest challenge was overcoming an ACL injury. Dancers are athletes, we use our bodies in the most extreme ways. It took about two years for me to get back to full strength and power. It was a daily challenge, and it took intense discipline of the mind, but I'm back and stronger than ever.

OVERLEAF: **RICARDO HARTLEY III** Contemporary
(pictured with **Allison McGuire** on page 187)

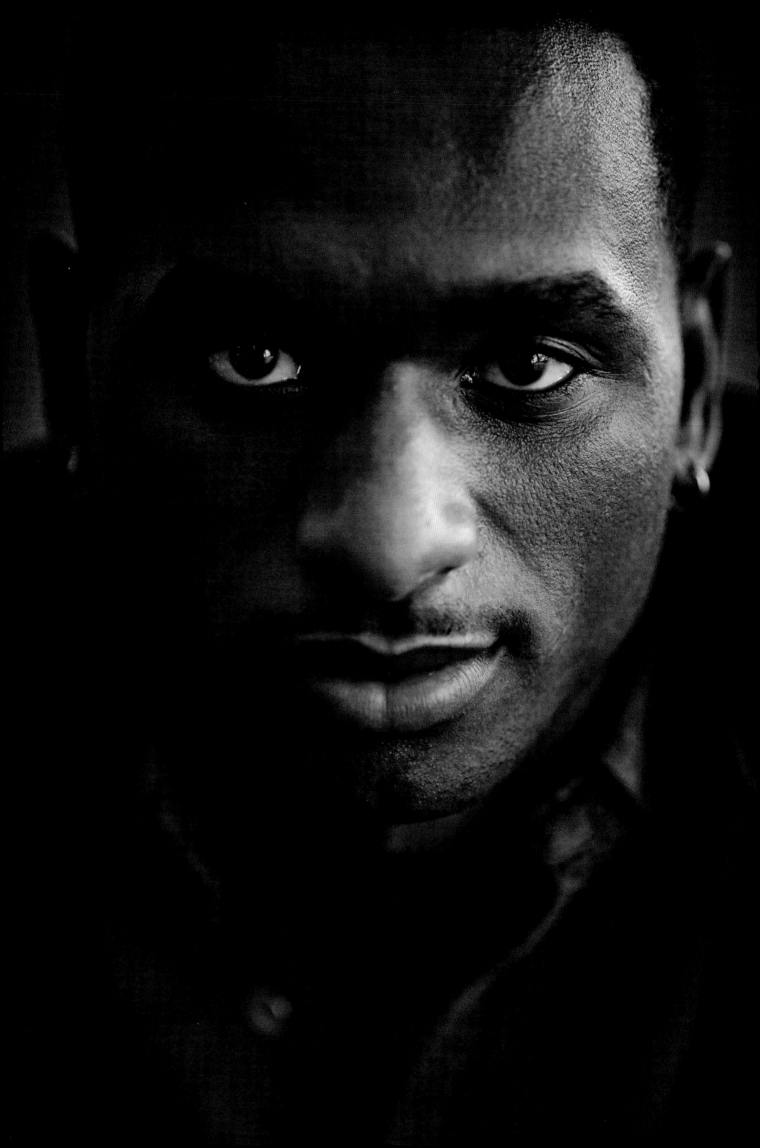

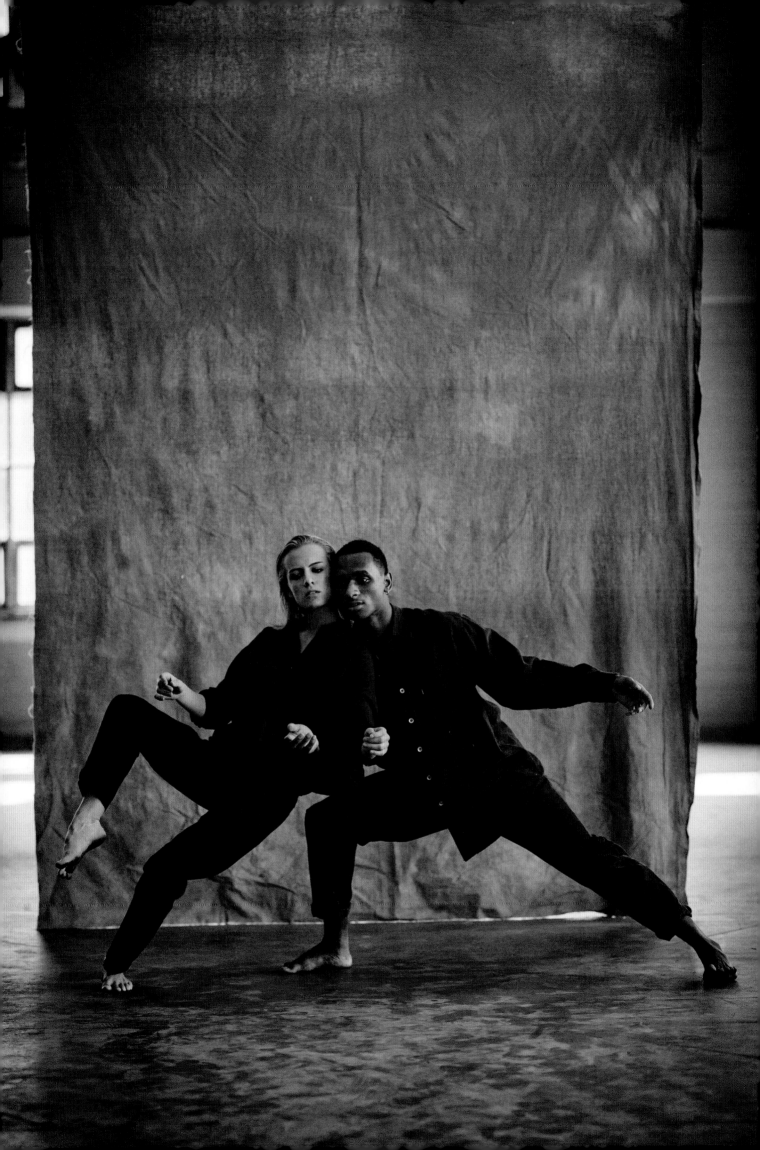

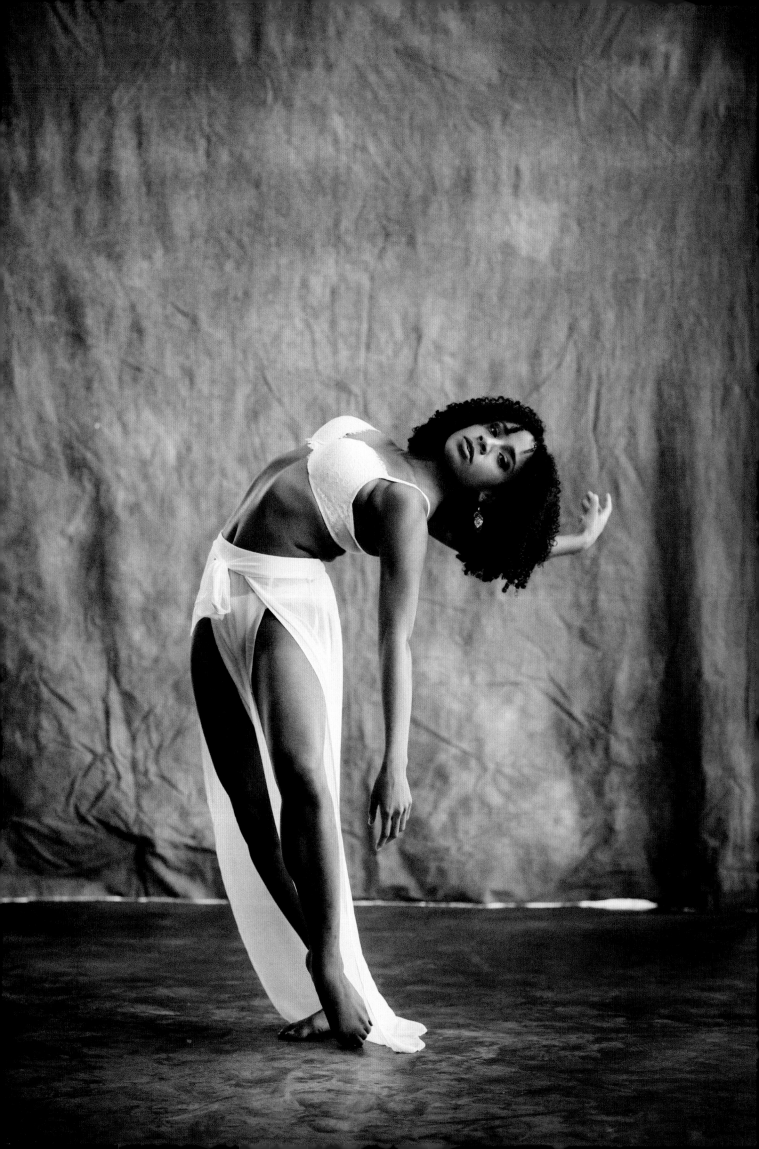

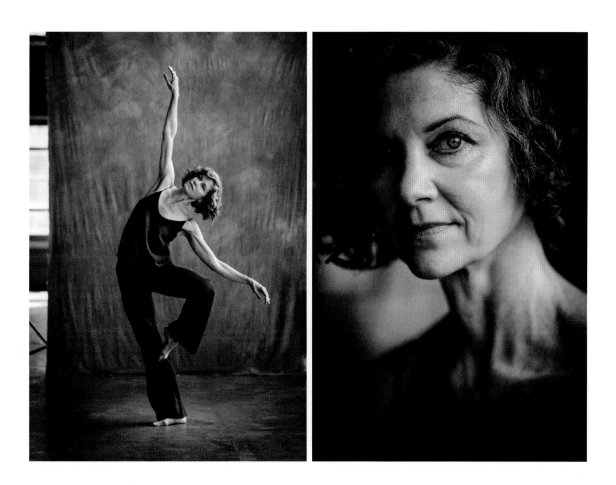

LISA BOUDREAU Modern

From a very young age, I became hooked on the repetitive nature of a practice toward hypothetical perfection and the pursuit of executing what I thought was impossible. The sensation of committing 100 percent to the task at hand, while being openly vulnerable enough to share that moment with an audience, is surprisingly liberating.

JUSTICE MOORE Broadway

IRÉNE HULTMAN Contemporary

A female jockey was once asked if riding was her passion—she paused a moment then answered: No, it is not passion, it's deeper than passion.

I think that is dancing for me.

There is a oneness that happens while dancing—an interconnection with oneself and a larger universe, both human and nonhuman manifestations, that connects with others and otherness. It's beautifully explorative and satisfying.

Dance is a communal social experience like theater or film; it mostly requires a group, a team, and with that comes a certain belonging—that belonging is different for different dancers and performers. Perhaps, as in any art form, there are overall shared traits that make certain understanding easier—a recognition of sorts.

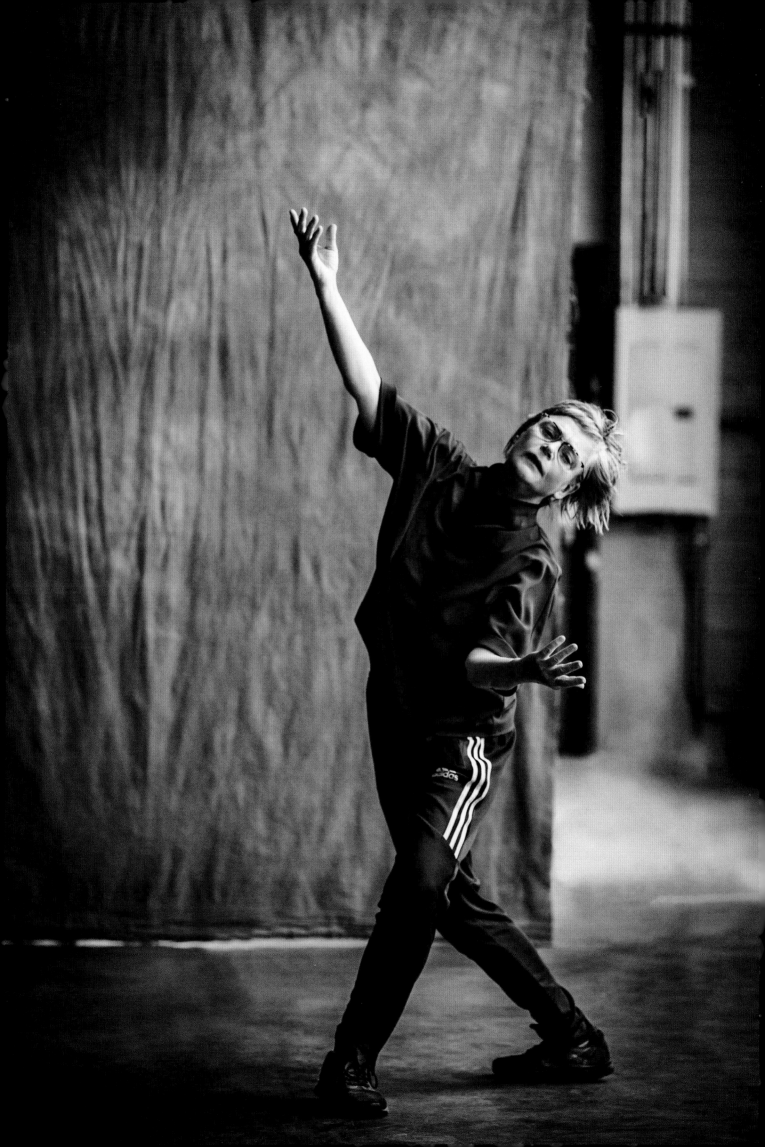

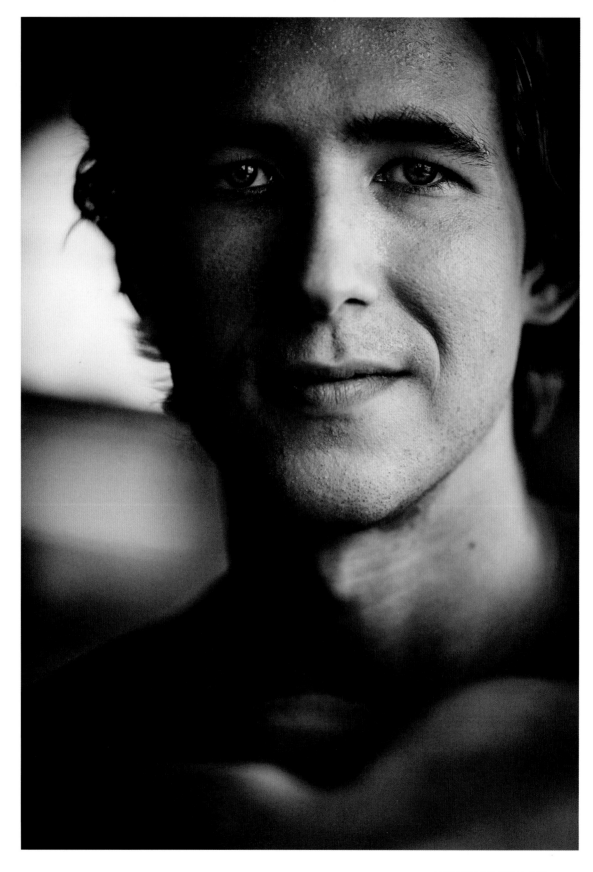

JOSEPH GORDON Ballet

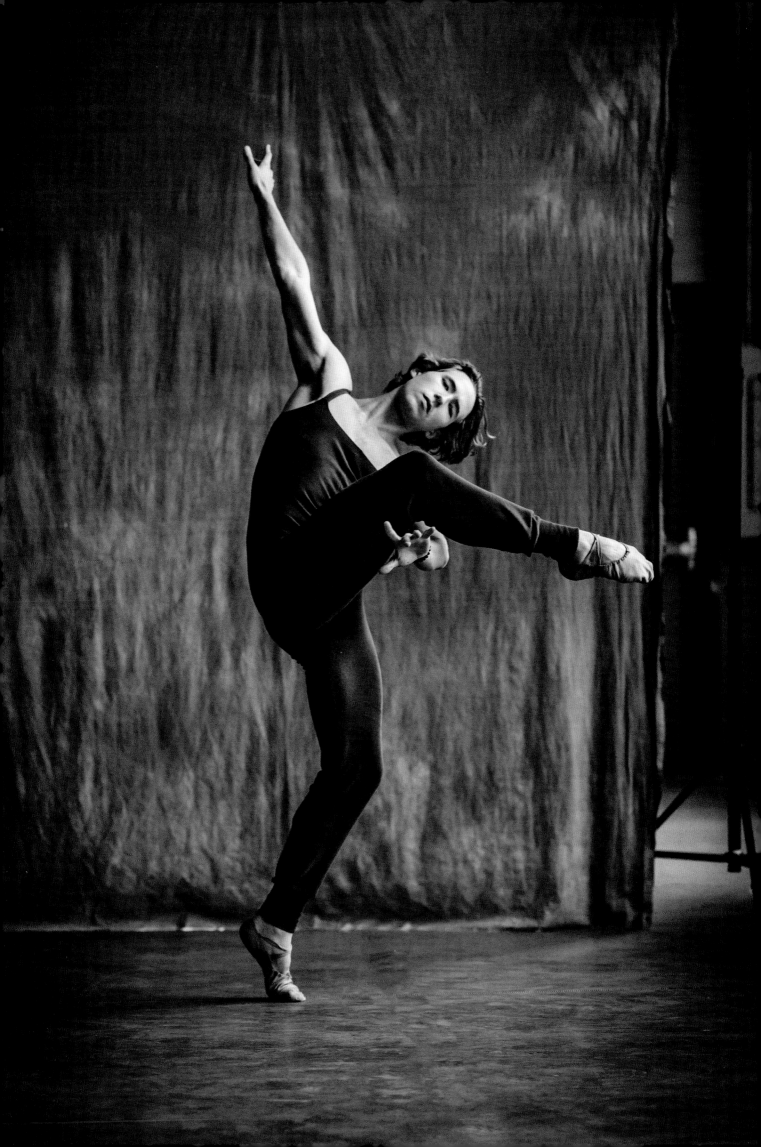

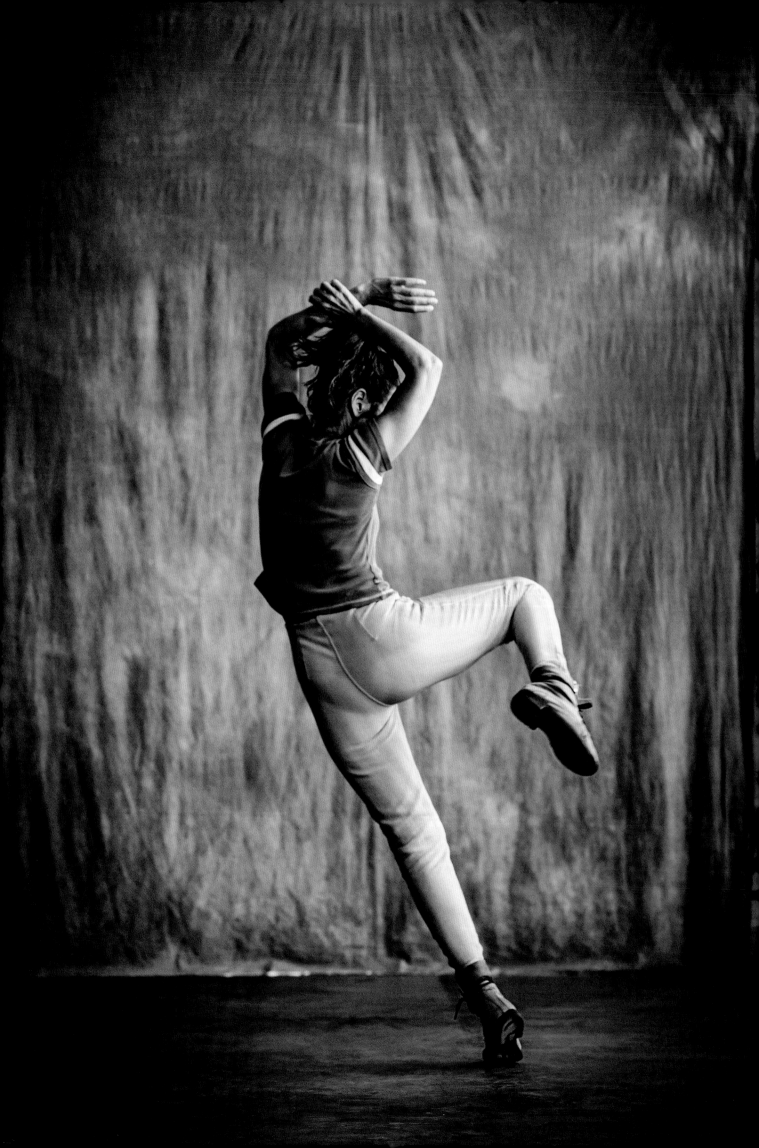

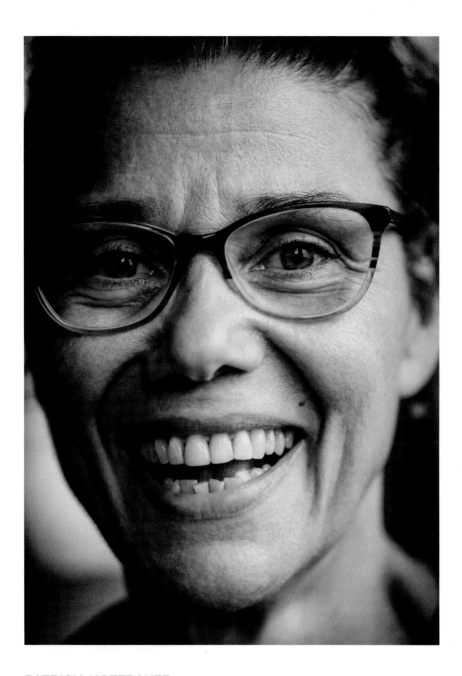

PATRICIA HOFFBAUER Contemporary

I like figuring things out in motion. I like to figure out how not to fall, not to stop, not to interrupt motion or the thought process, how to juxtapose movement with other movements, how to make the impossible a possibility . . . dancing is like thinking, for me. One movement after another, one thought after another, even if the rhythm is constantly in flux. Exploring my way around a movement or a series of movements gives me the deepest satisfaction as well as profound anxiety, fear of my inability. All is revealed in that moment: my courage and my weaknesses.

 Working physically with other people is like nothing else. You become immediately intimate with that person, with a group of people. And that closeness is not found in any other way. Dancing with someone creates a bond that is hard to break even if you go separate ways. If you see someone you danced with in some moment far away, you will feel a certain bond with that person even if you disagreed with most things they represented.

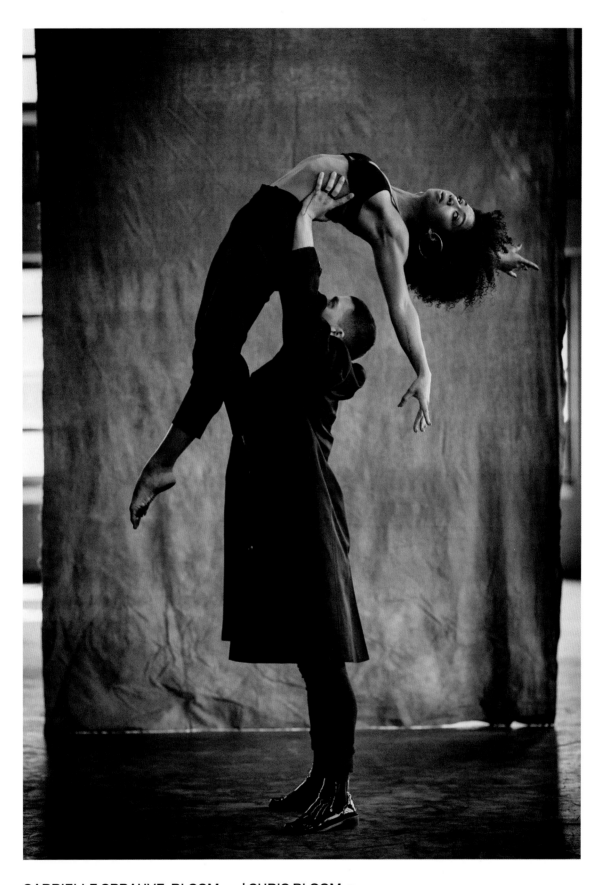

GABRIELLE SPRAUVE–BLOOM and CHRIS BLOOM Contemporary

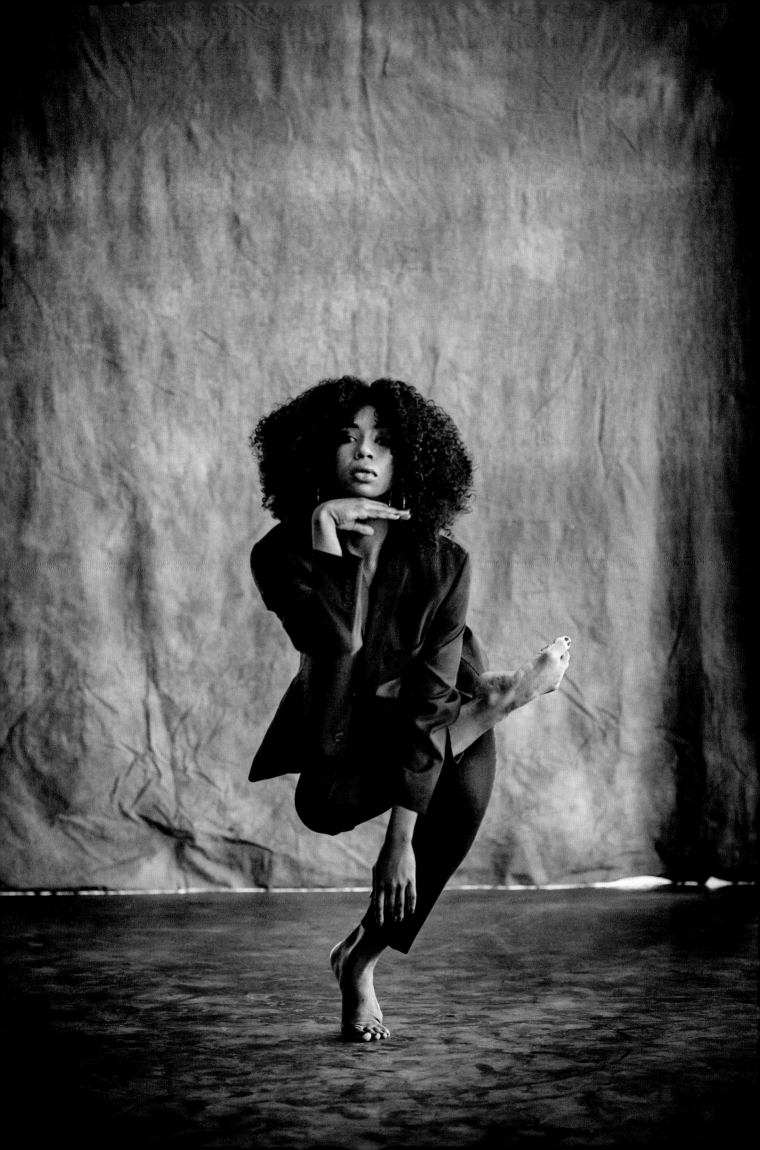

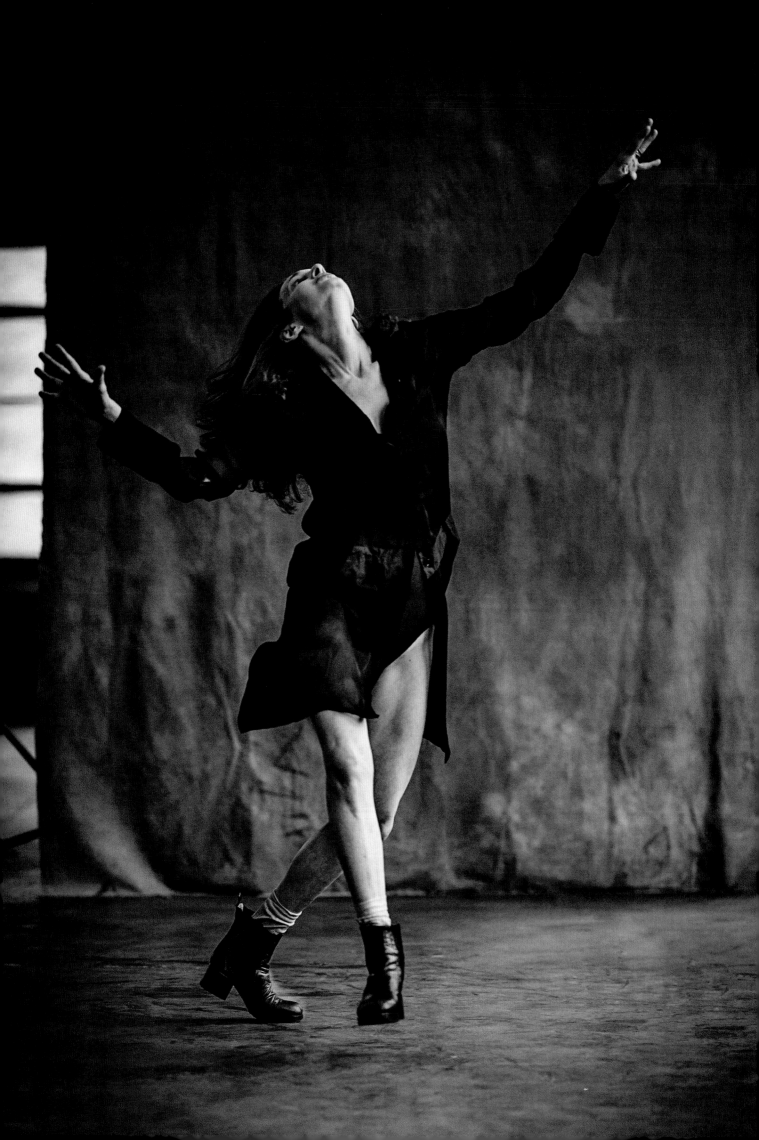

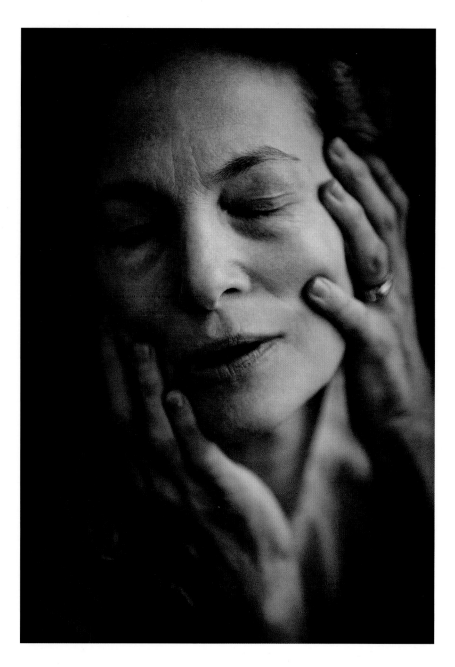

JODI MELNICK Contemporary

The body just can take so much physical rigor; injury is just a part of the life of a dance artist. Age has also been the great gift of being a dancer. The connection with my body, with others in space, with the things I can no longer do or want to do, that has been a constant discovery of being a more mature dancer.

BRIGITTE MADERA Vogue

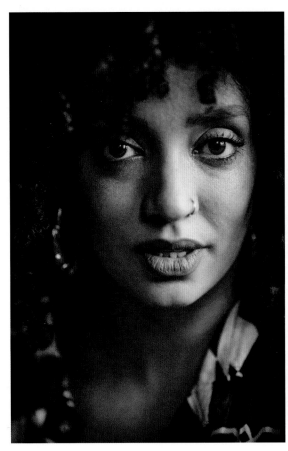

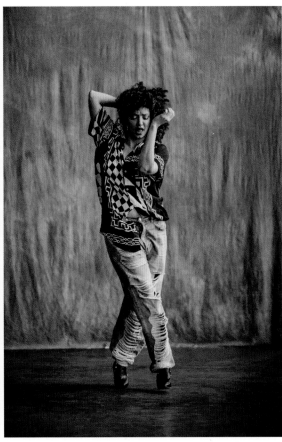

EMILY HAYES Ballet

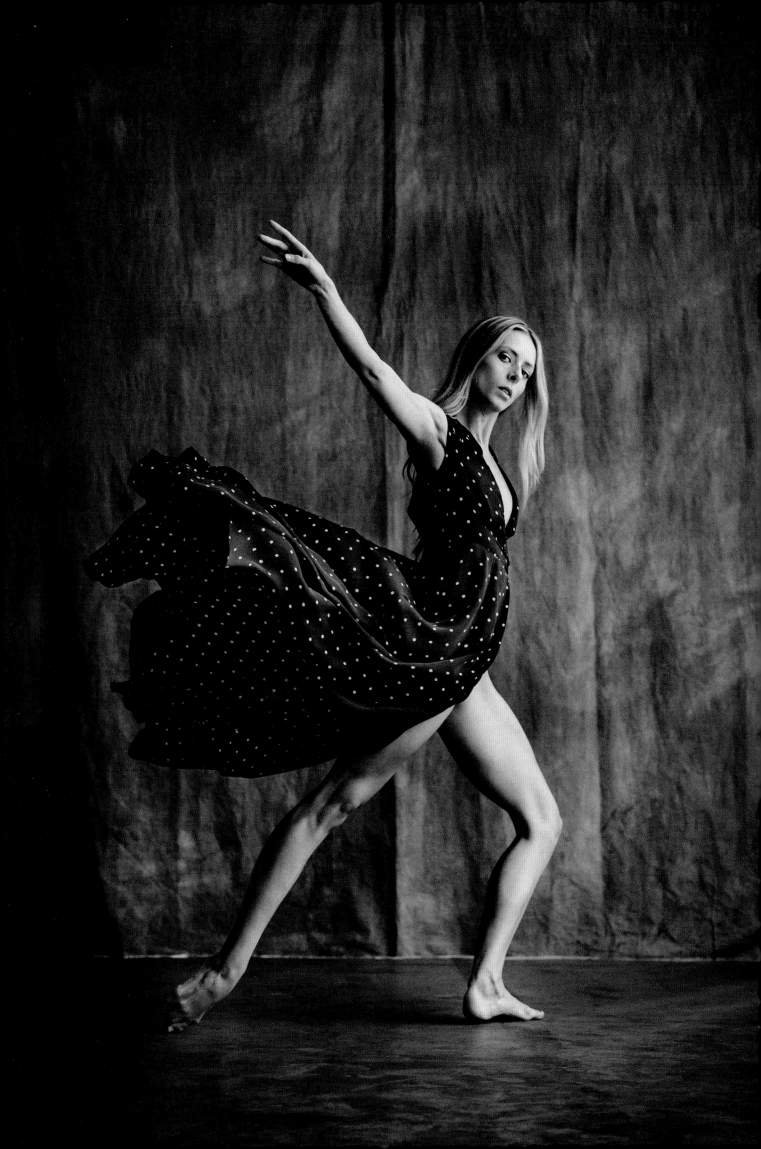

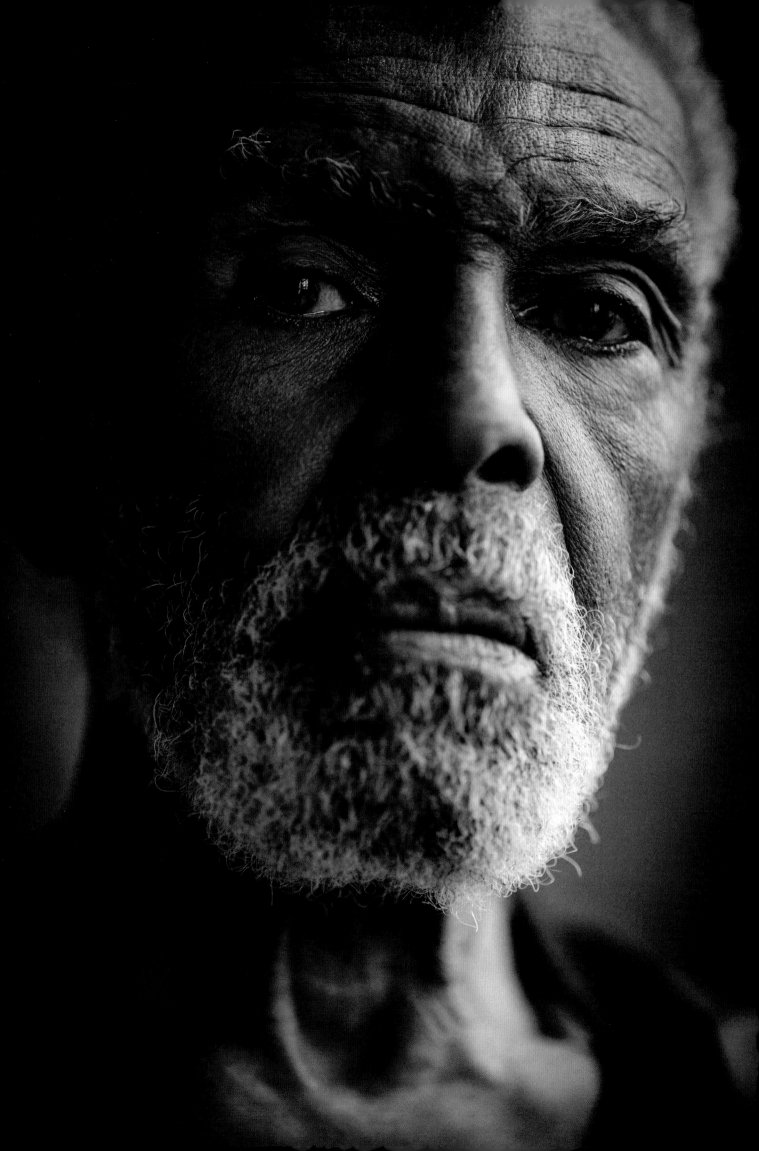

GUS SOLOMONS jr Modern

I loved dance from the moment I first did it. It wasn't till later, when I actually studied, that I knew what I was doing. Earlier in my dancing, I enjoyed the feeling of controlling my body however I wanted. I was largely unaware of physical obstacles, because I didn't acknowledge them until my instrument began rebelling with injury. Nowadays, at age 83, dancing momentarily suspends the pain I know I will feel afterward. I remain focused on the things I can still do, not the ones I no longer can.

My biggest career obstacle, in retrospect, was not getting cast on Broadway, because choreographers and producers in the '60s wouldn't mix casts racially. Now that casting has become more color-blind, that might be less of a problem—but nowadays, I can't do eight shows a week!

Ultimately, dancing is a sharing of community with your colleagues, an offering to the watchers, and an act of generosity.

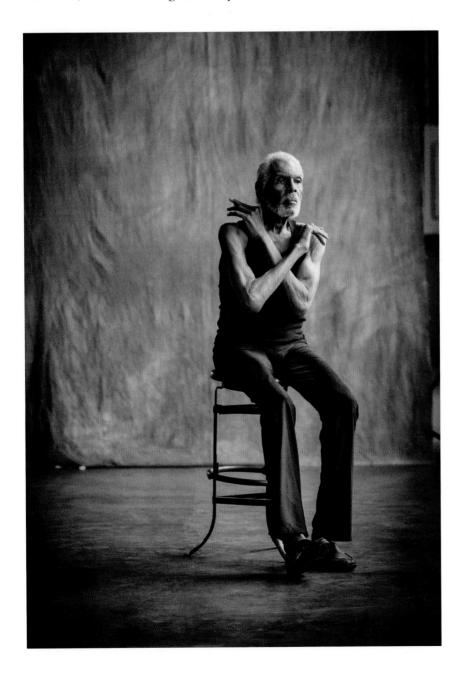

SHOBA NARAYAN Bharatanatyam and Broadway

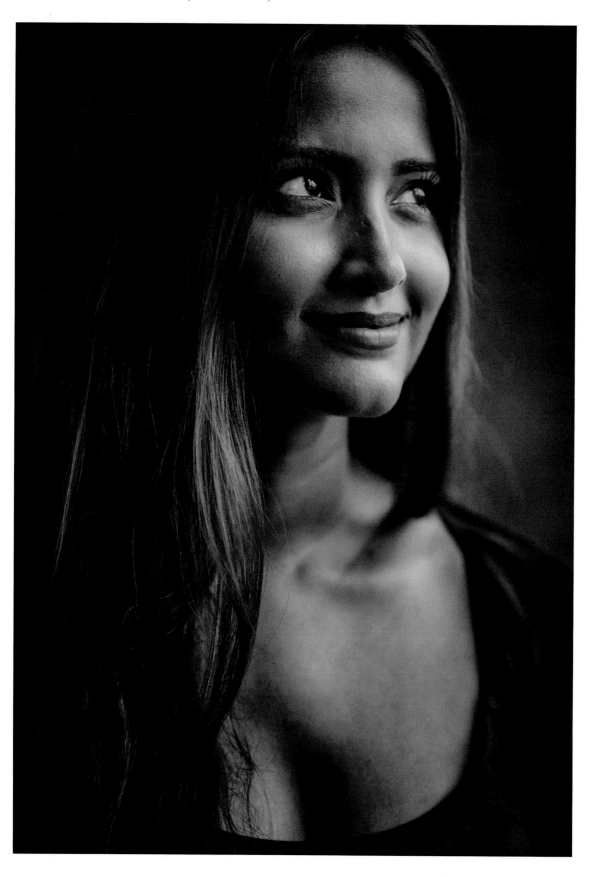

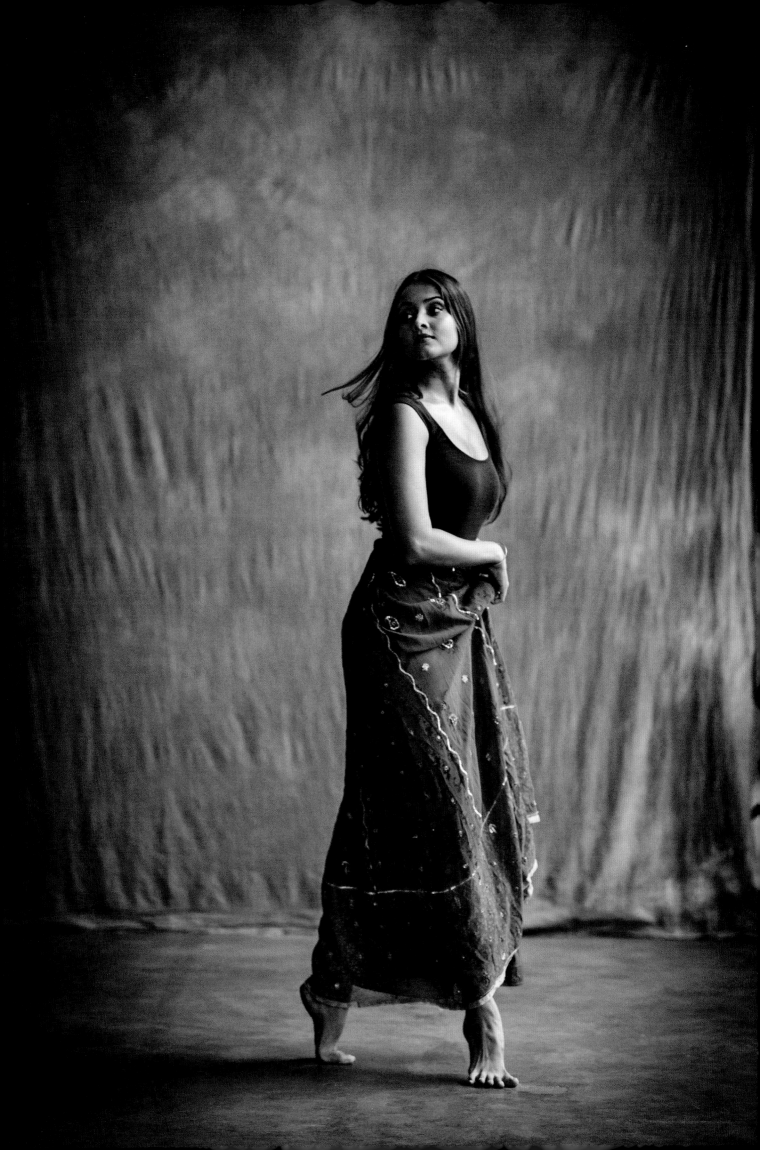

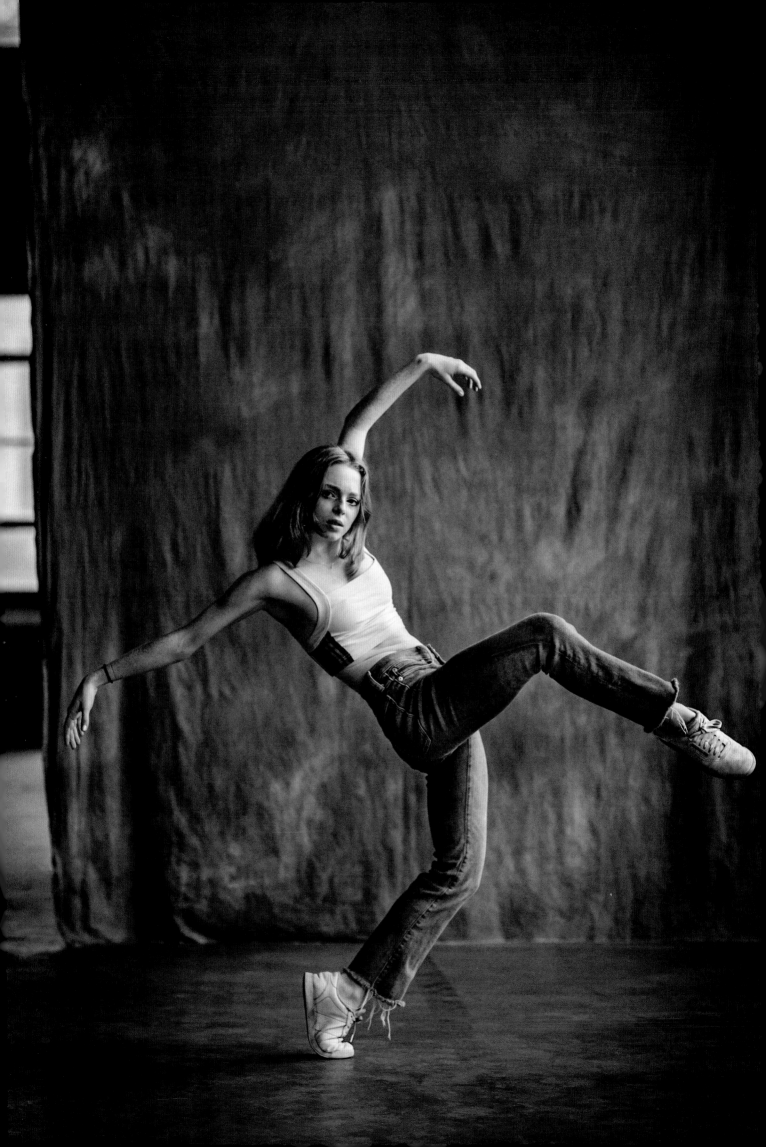

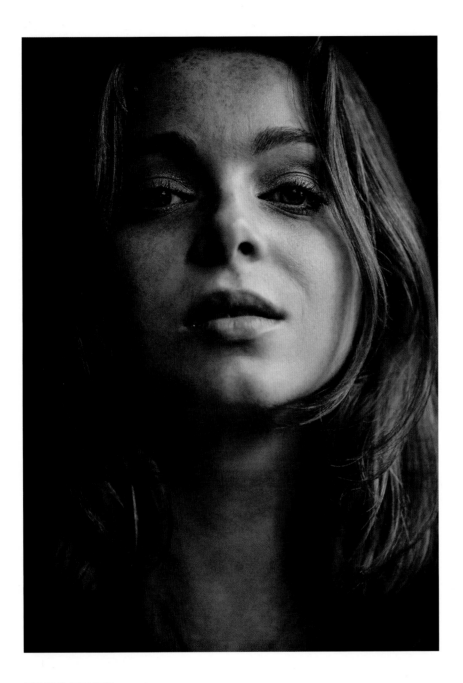

ZIMMI COKER Ballet

Every dancer hits a peak of adrenaline onstage, and when you reach that peak, the feeling is second to none. This overwhelming sensation is the reason why I am continually driven to put my full heart into this craft every day.

When I dance, whether that be in the studio or onstage, I find that all of my physical sensations are heightened. My vision becomes clearer, my ears are more open (to hear musical cues), my mouth starts salivating, and then every muscle activates. Emotionally, I feel happy, nervous, and excited. Combine the two, and you have this natural high that is the guiding force to your performance. Afterward, you feel so physically drained, but so mentally fulfilled that you can't help but have a smile plastered to your face.

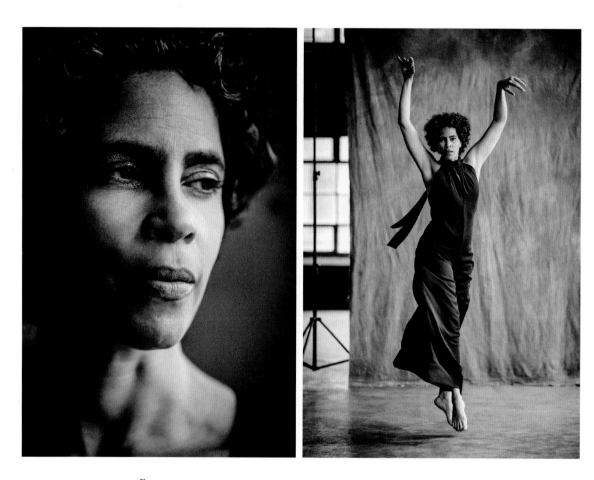

LAKEY EVANS-PEÑA Modern and Contemporary Movement

The ability to embody and fully express myself has always been most resonant through the language of movement. Creating, collaborating, and sharing dance is my chosen way of living joyfully and celebrating life.

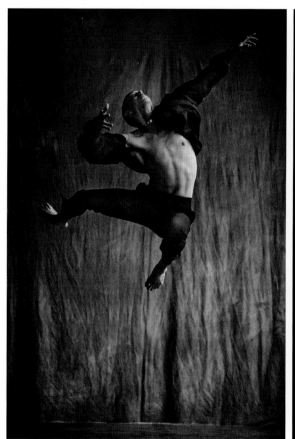 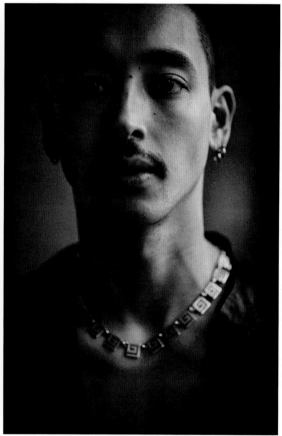

JACOB THOMAN Contemporary

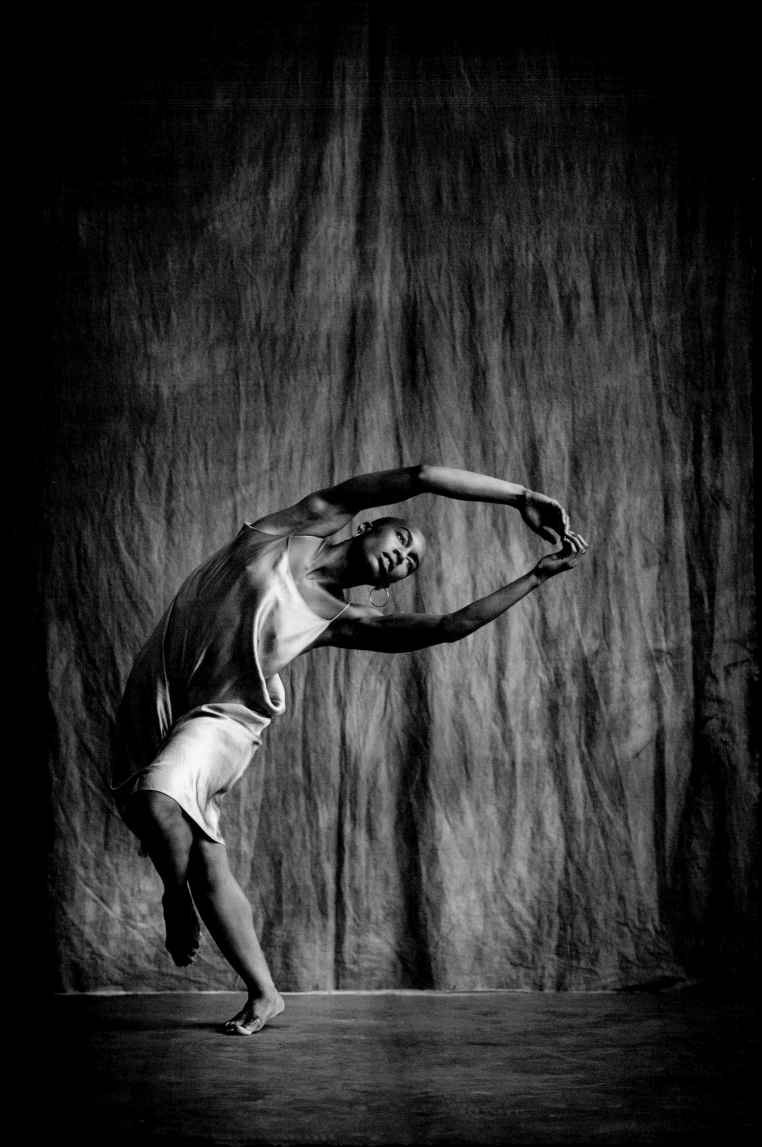

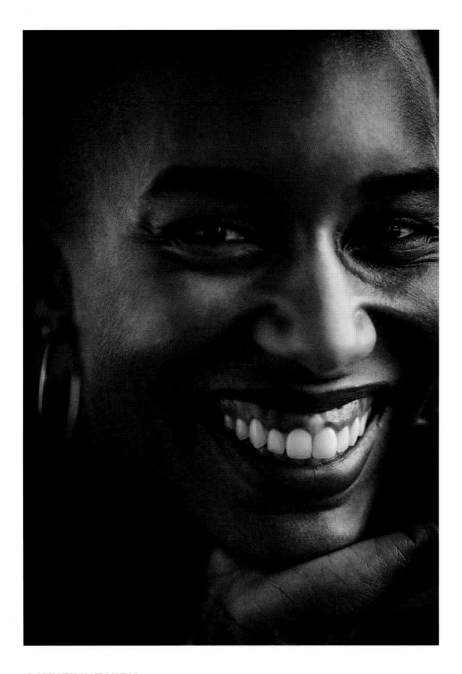

CATHERINE KIRK Contemporary

Dancing can feel ecstatic, euphoric, gut-wrenching, historic, revealing, grounding, and ancestral. Sometimes all at once, or not at all. But candidly, the true feeling I connect to when dancing is indescribable. And I truly think it can be this way for each and every one of us. Whether you're letting loose on a dance floor, grooving in the car to your favorite song, or getting lost improvising in a studio, dancing is an embodiment of freedom, expression, and honest humanity. And that feeling is beyond some of the greatest sights I've ever witnessed in life.

GEORGINA PAZCOGUIN "THE ROGUE BALLERINA" Ballet

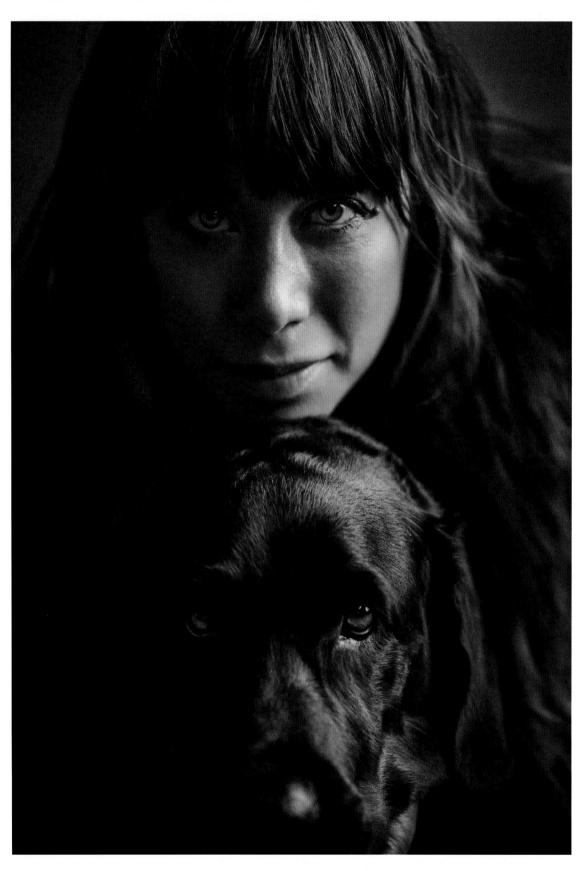

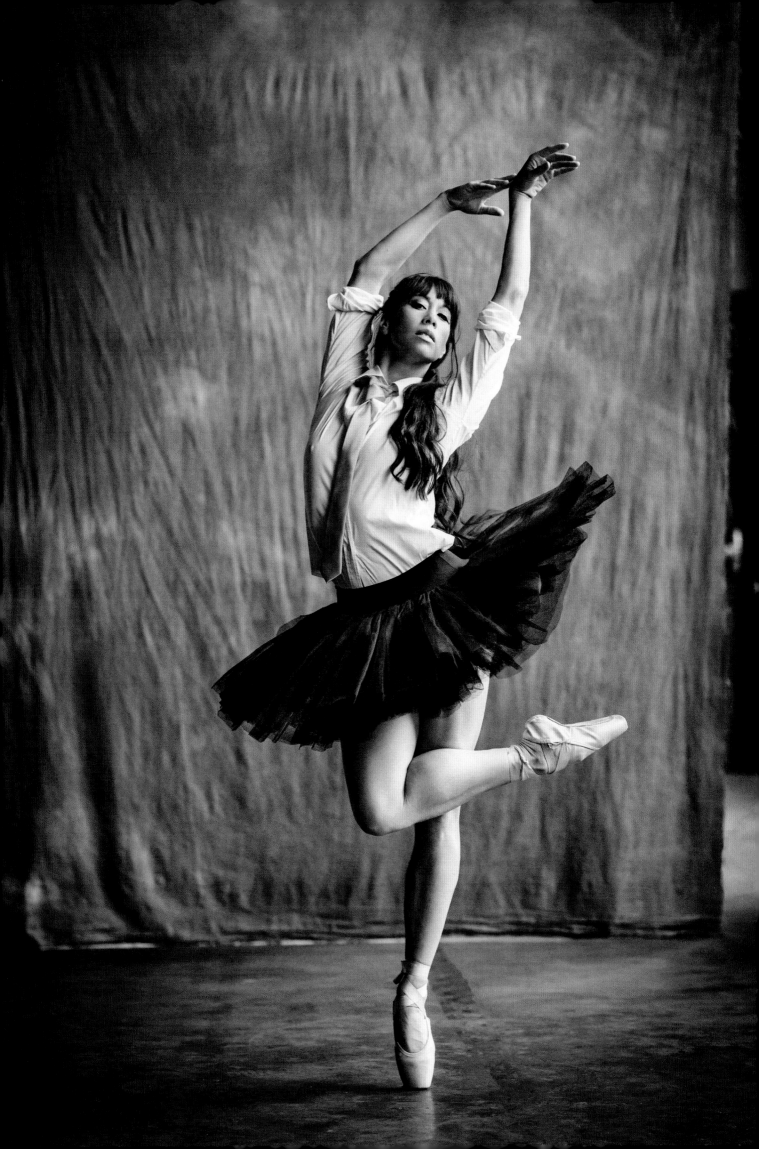

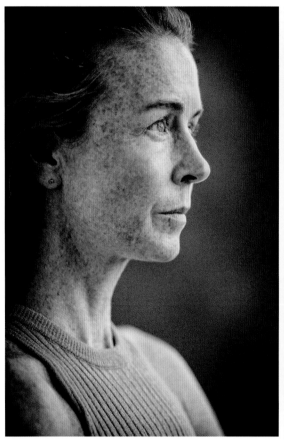
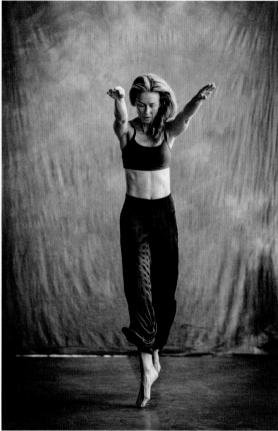

JEAN BUTLER Contemporary and Irish Dance

I used to think of my changing technical ability as a failing, as a death of some sort. As I dance into my fifties, I now see it as a creative opening into a whole new world of endless possibilities.

Dancers have an innate tenacity. To commit your life to dance, to moving in a moment which disappears forever and lives on only in the memory of others, takes a certain kind of temperament.

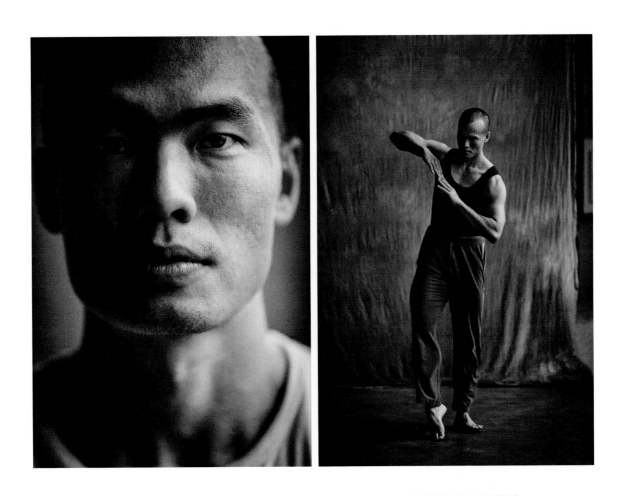

HUIWANG ZHANG Dance Theater

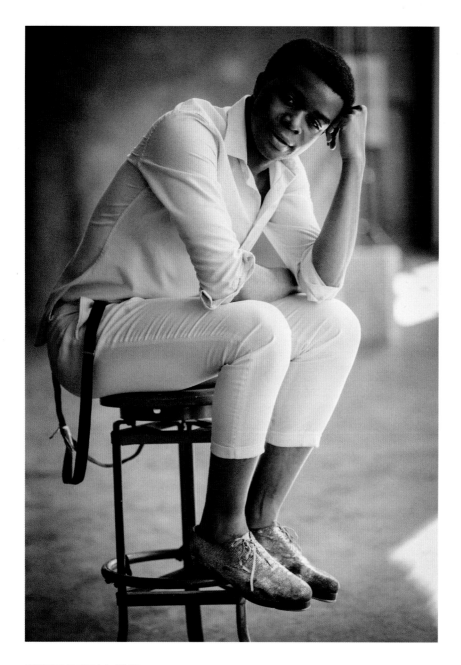

CURTIS HOLLAND Broadway

Physically, I try to feel my body as deeply as possible. I aim to stretch every muscle to its farthest point and reach for as much follow-through on each movement and intention as possible. Emotionally, I try to remove the noise of my head and listen to my intuition. I breathe through the anxiety of being watched by an audience and focus on the hard work that I have put in before this moment. When the purest form of this is achieved, dance feels easier than breathing. For how hard the activity itself is, being aligned physically and emotionally makes dance the closest sensation to flying a human could ever experience, void of regret and shame, and only filled with pride and peace.

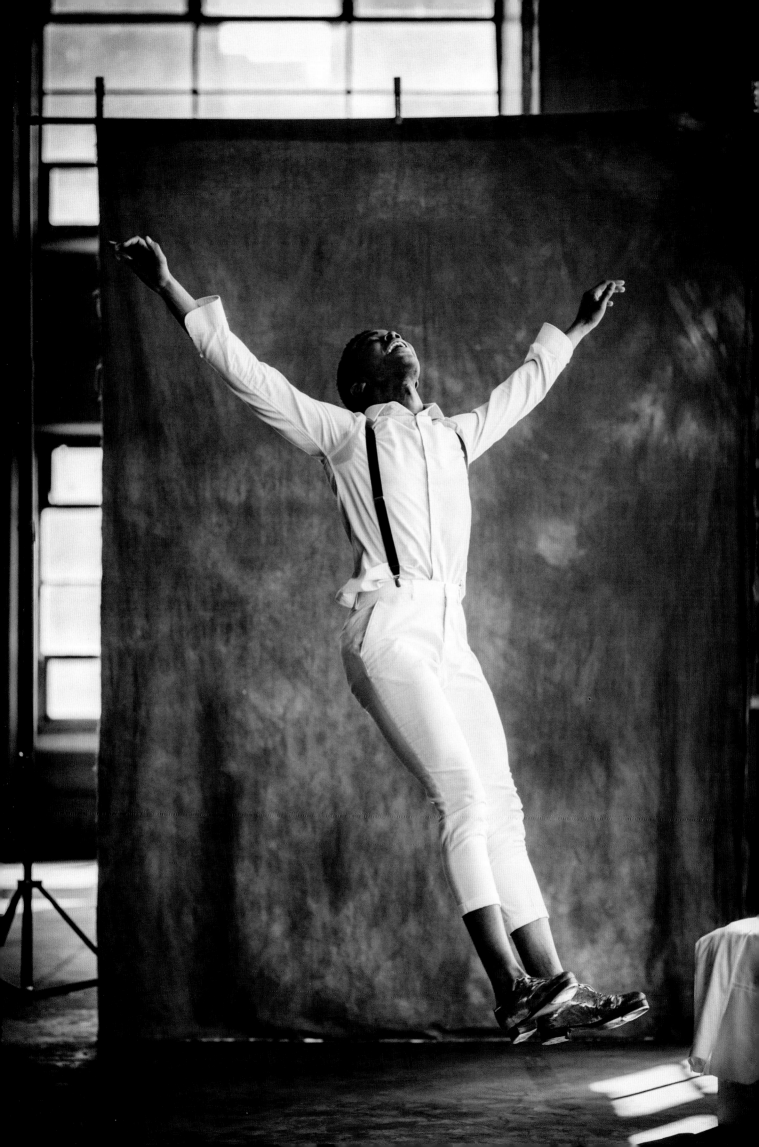

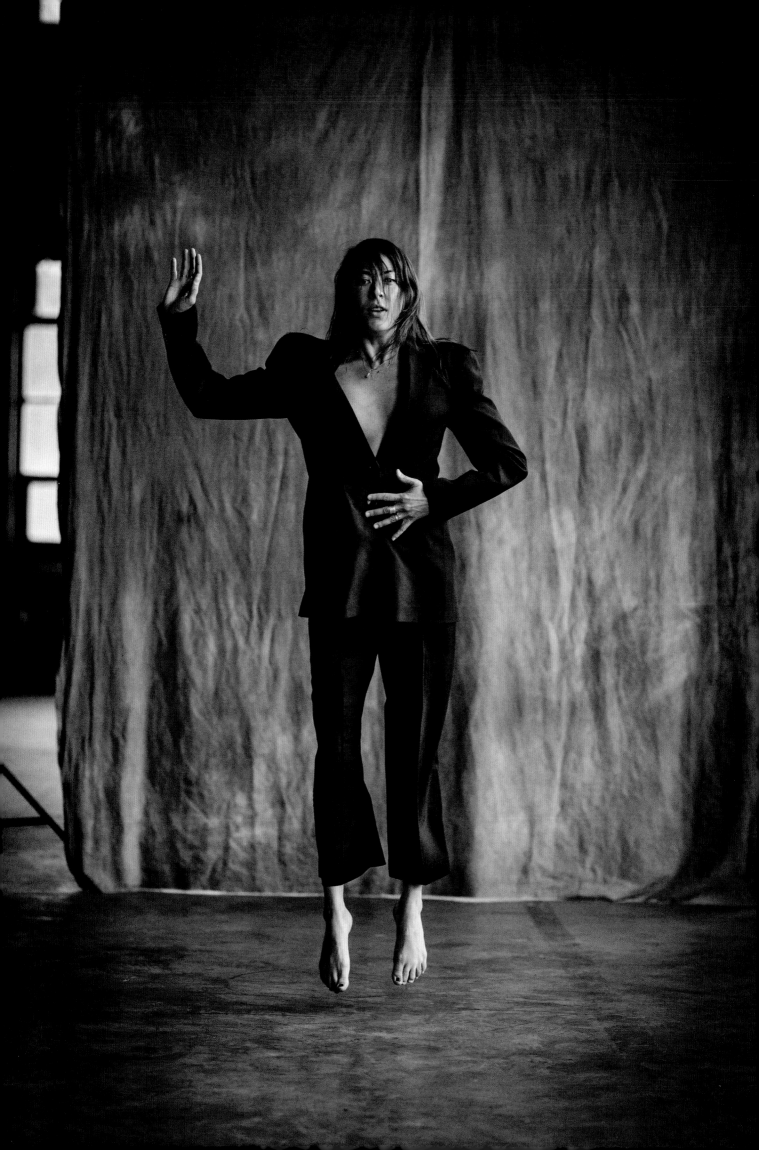

ELOISE DeLUCA Contemporary

Dance as a hobby just never felt like an option to me. I fell very hard for it at a young age and wanted to consume as much information as I could. I wanted to become an expert.

Movement is a dialogue that provides an opportunity to be hyperaware of the present. Whether you are using your own body, the environment, or sound to influence your choices, hopefully the conversation can be continuous and travel somewhere that feels good. Personally, it's the most freeing experience, and on a good day, I feel like a rock star. It's a balance of work and groove, a type of effort that makes me feel free, and alive.

OVERLEAF: **WENDY WHELAN** Ballet

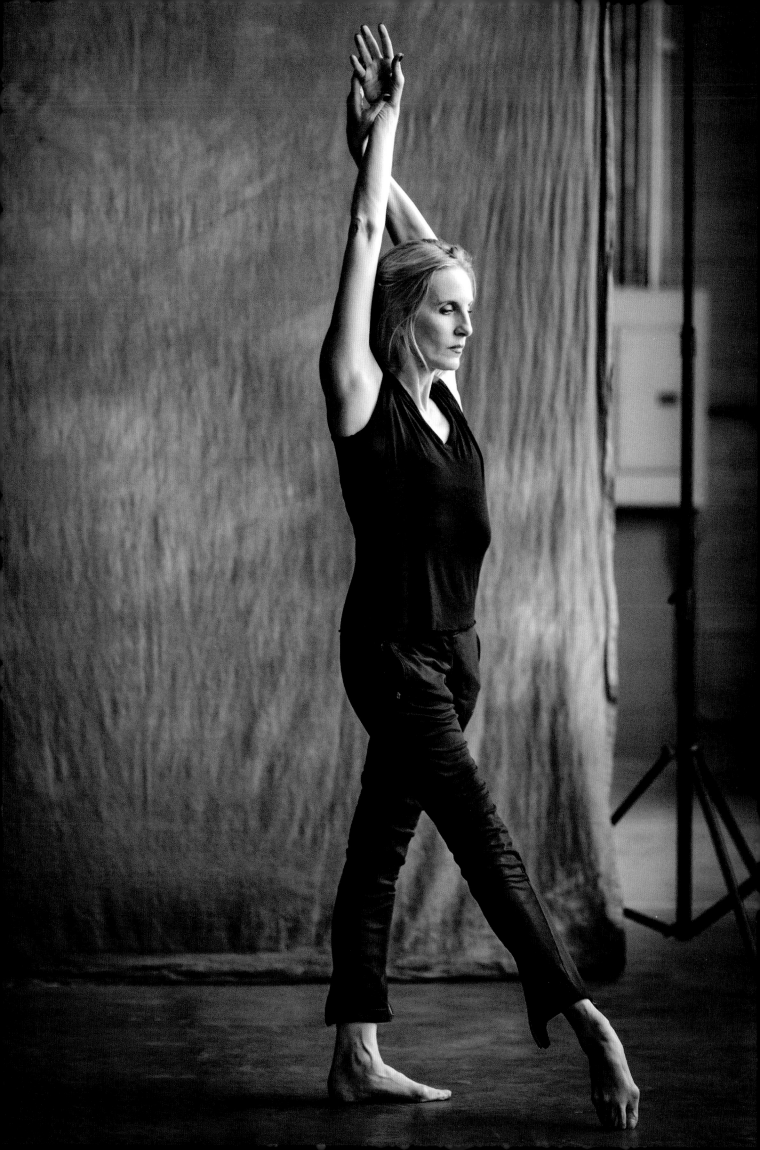

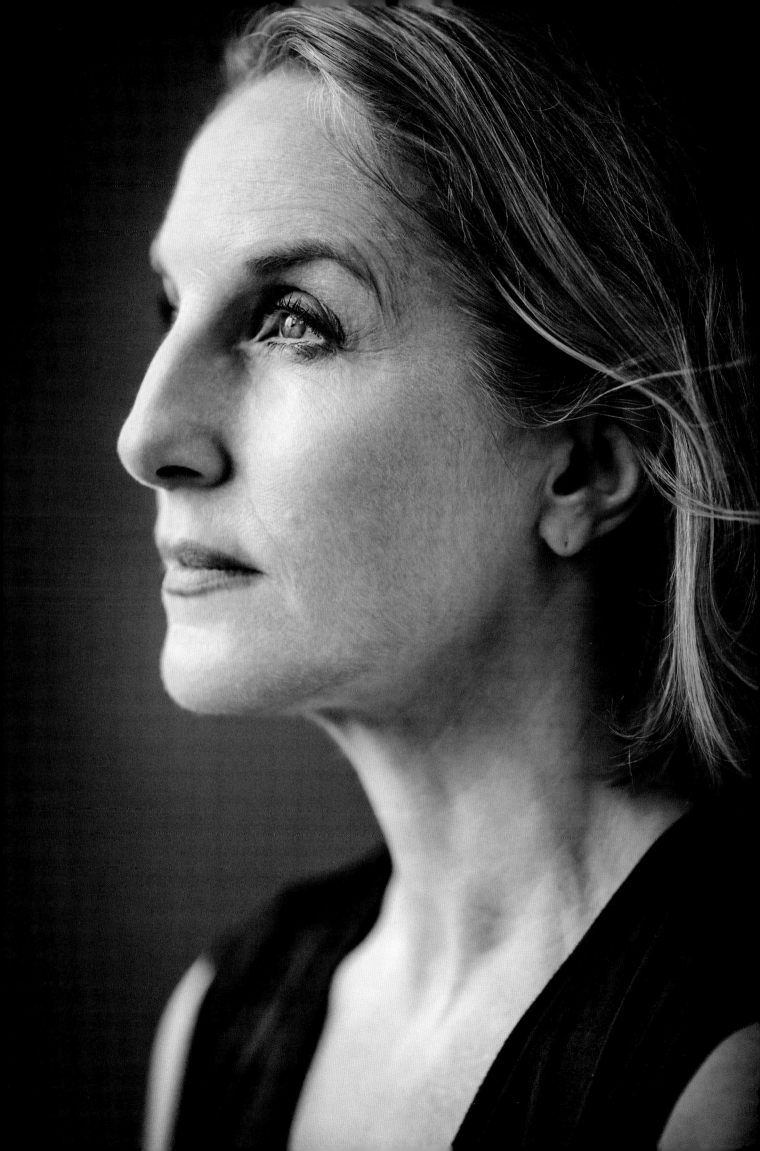

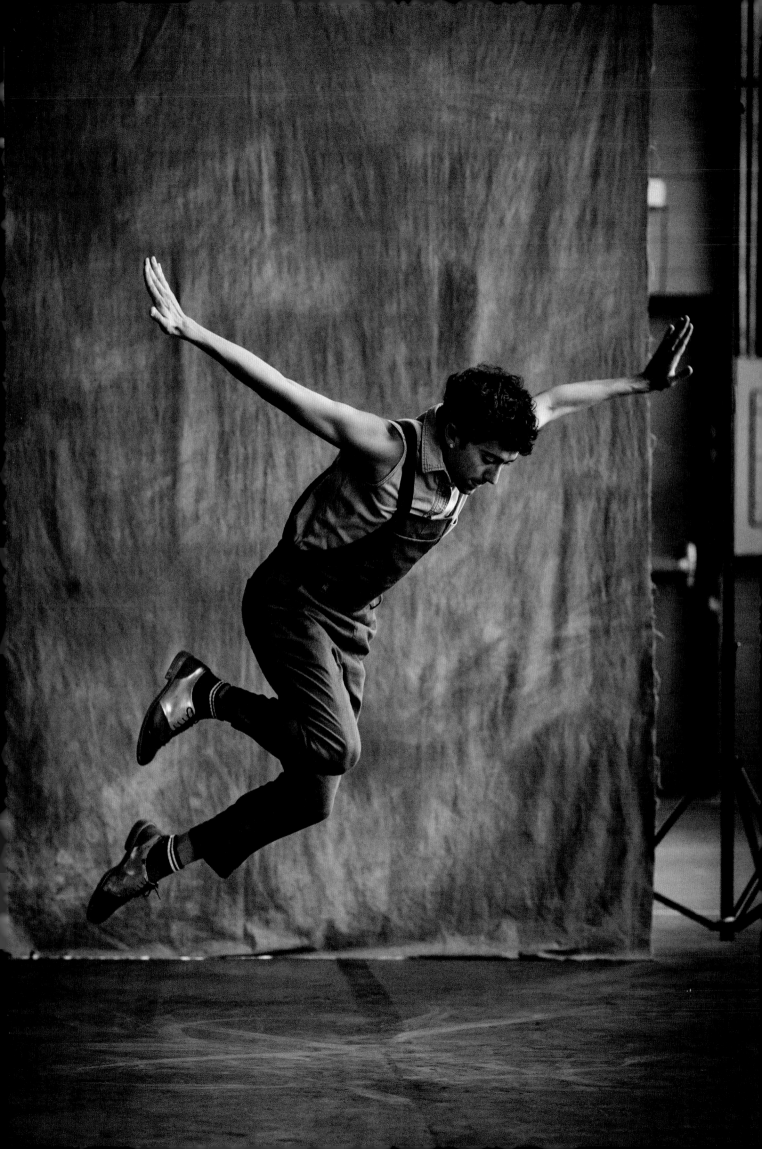

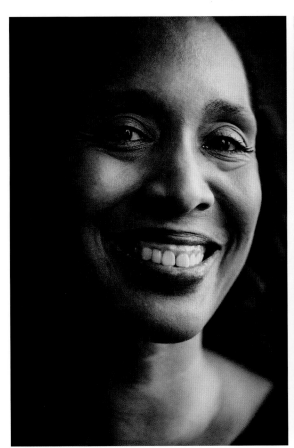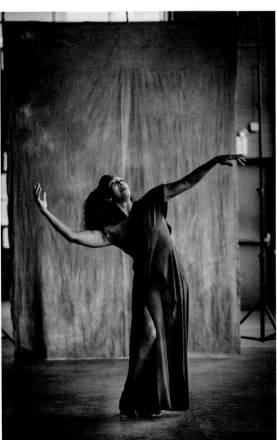

FRANCESCA HARPER Contemporary Ballet

CALEB TEICHER Tap

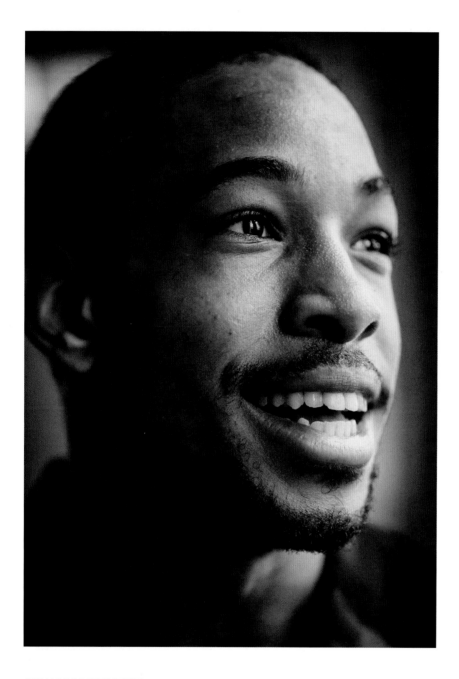

QUABA V. ERNEST Contemporary

I started dance as a child because my mother, who grew up in St. Lucia, always dreamed of being a ballerina. I began initially because I was told to, but before I knew it, I was fully immersed. It put me on a path that constantly pushed for my growth.

When I dance it feels like I can momentarily escape the physical constraints of the body. For a brief moment my mind becomes clear, focused on the sensation of movement. Dancing feels like a mental release that keeps me weightless while simultaneously grounded.

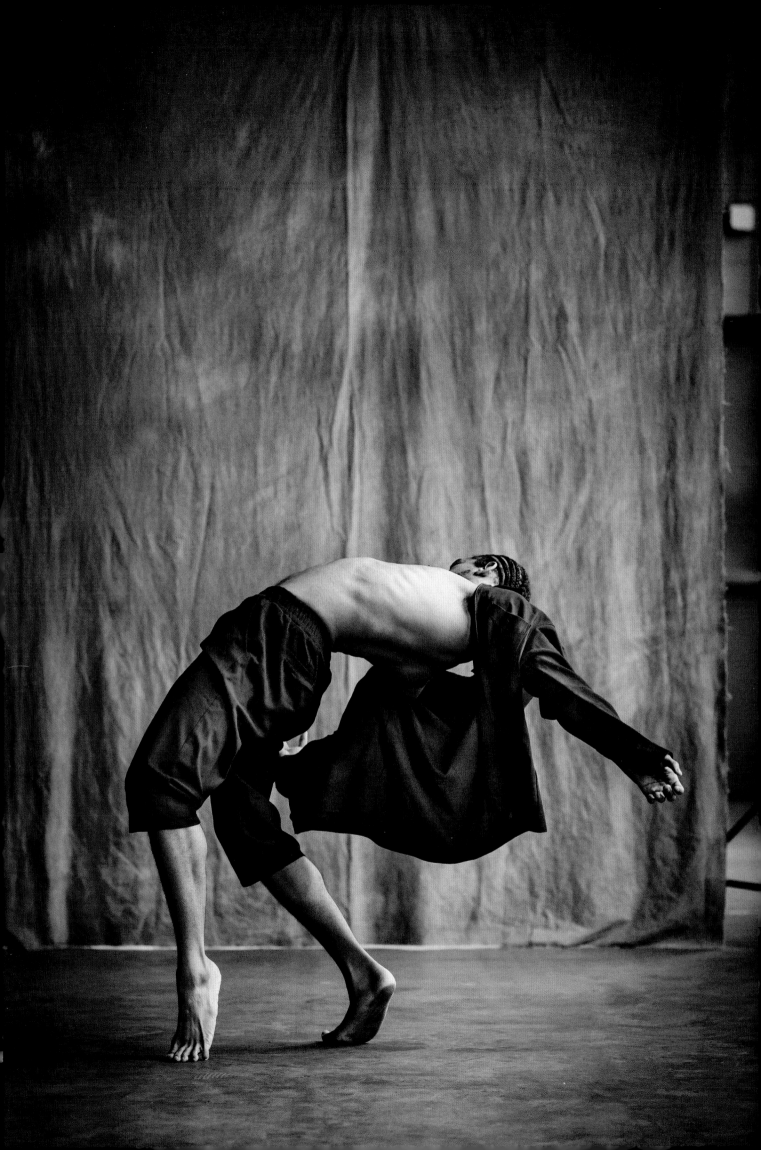

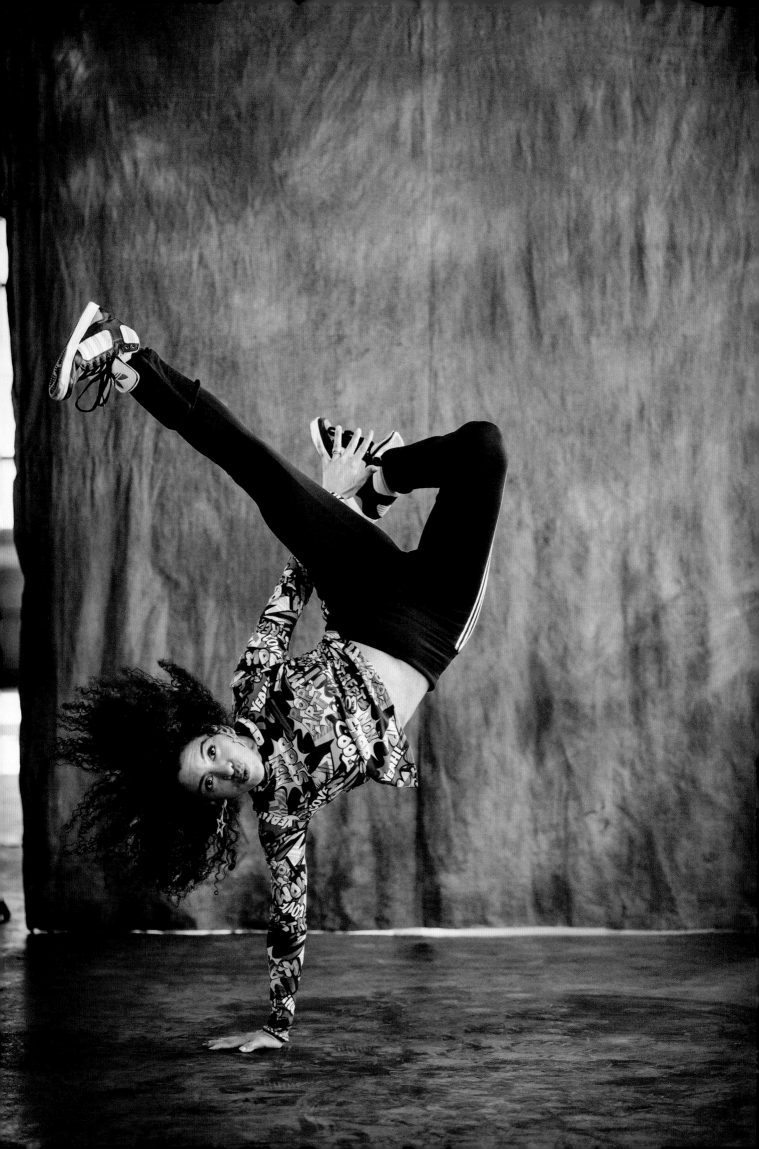

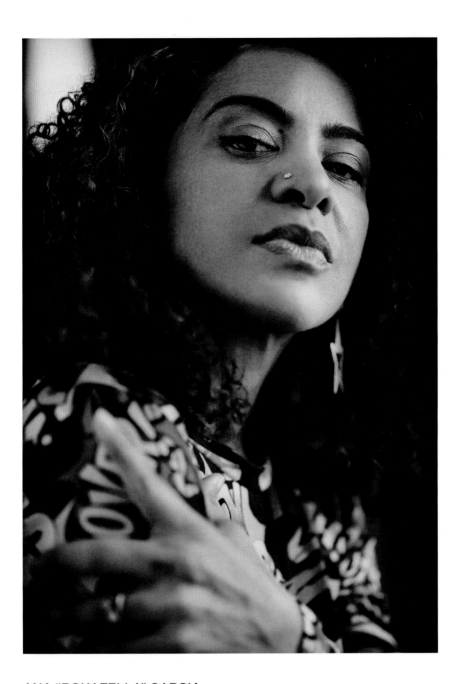

ANA "ROKAFELLA" GARCIA Break Dance

When I dance, I feel present in and creatively interactive with my environment. It is the only time I am in control of my destiny, even if I am being led by the DJ or the musicians. I go into a realm of spontaneity that allows me to turn off thoughts about my problems. Once I touch the floor, it is like tuning into a powerful channel of energy. I feel limitless in the ways to move with the drum/drummer.

As descendants of Africa, we have a base for the call-and-respond aspect of our music, art, and dance, and sharing it heals us and those watching. Each dancer has something unique to bring to the table so this has to be our focus because it balances the competitive nature of the streets and clubs. We are like a first nation tribe that, despite all the hard times, still comes together to uplift and celebrate life and be in the moment!

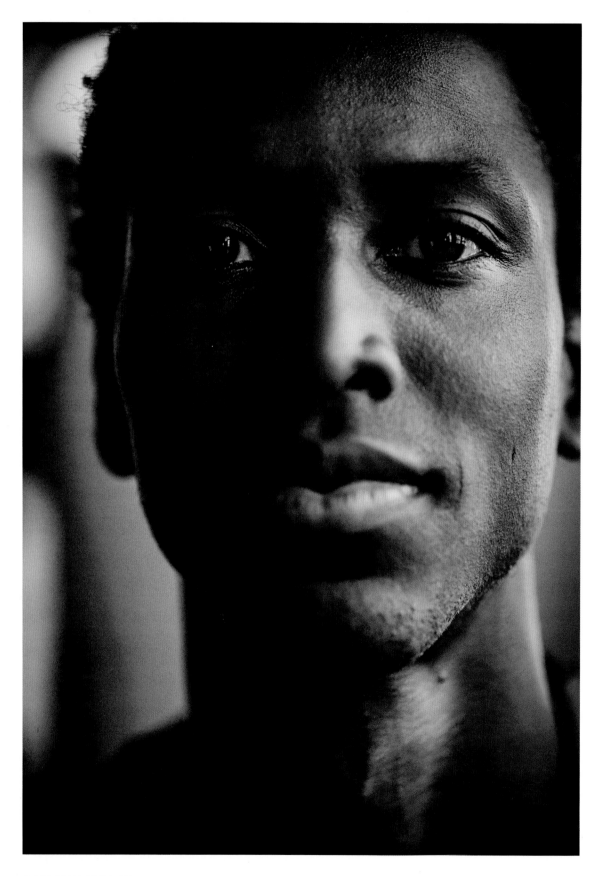

CALVIN ROYAL III Ballet

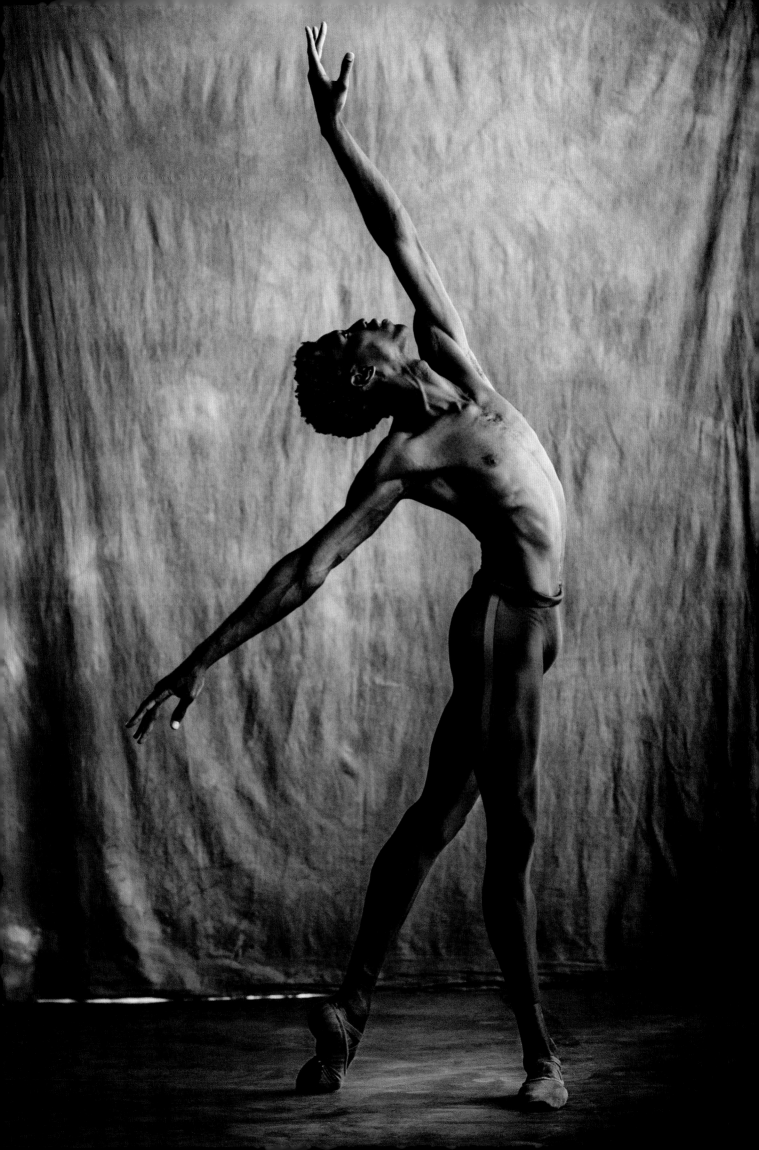

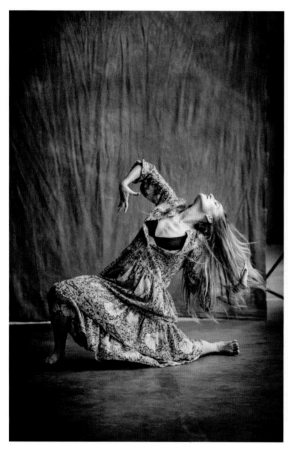

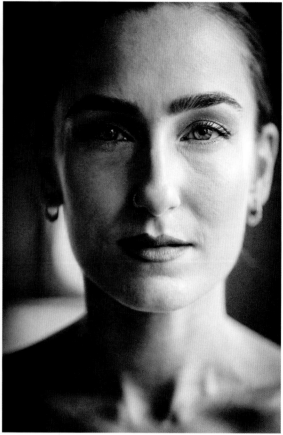

CAITLIN TAYLOR Contemporary

ISADORA LOYOLA Ballet

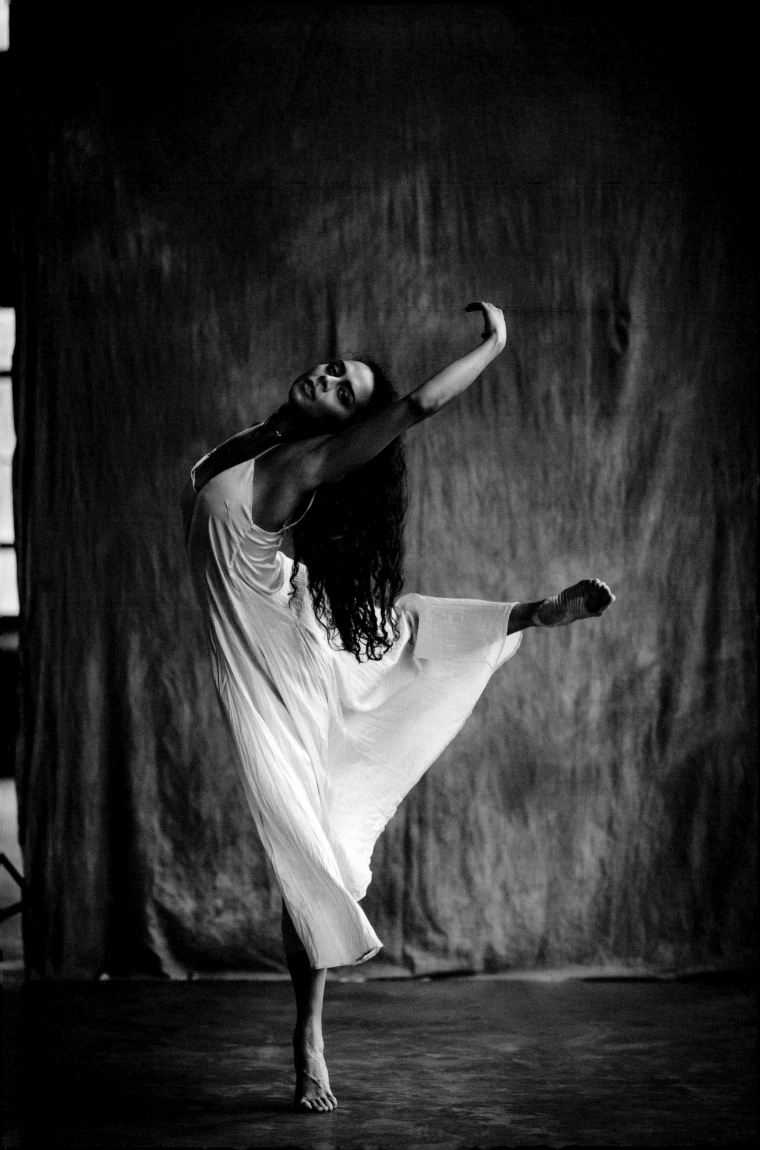

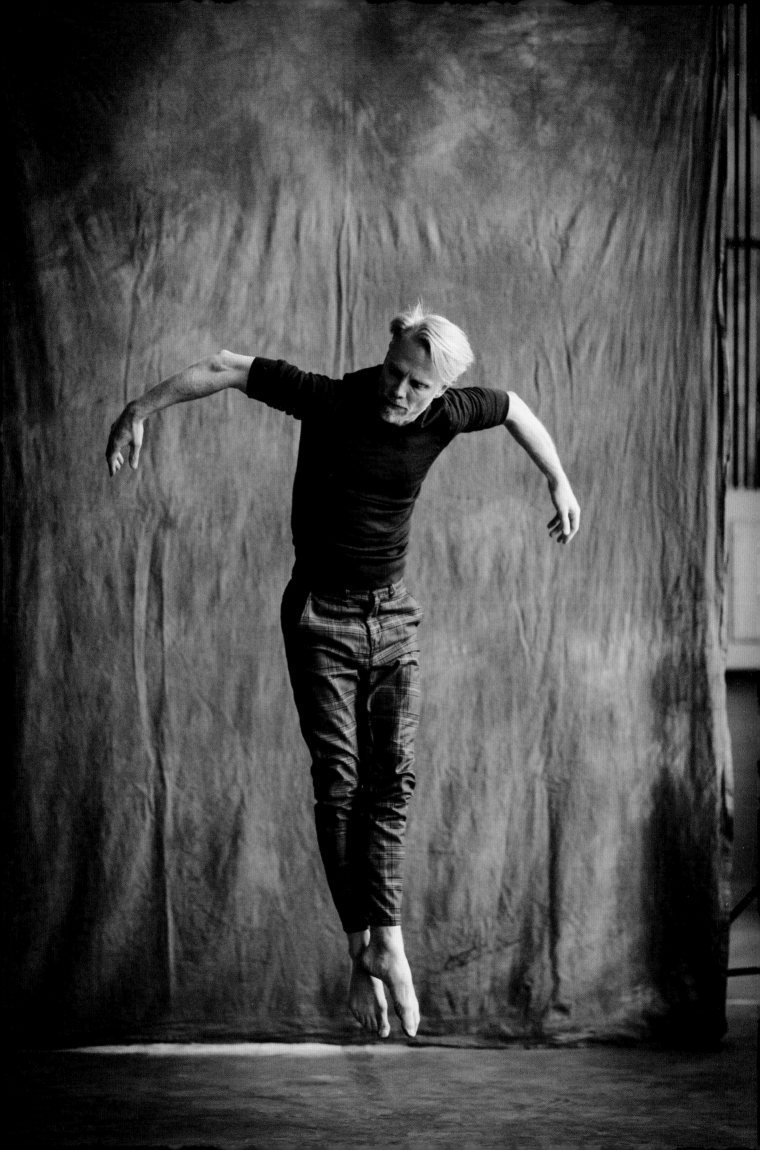

MICHAEL TRUSNOVEC Modern

I've never wondered why I am a dancer or how I could possibly have been drawn to such a uniquely demanding life in the arts. I've just always been moved to move. There has always been a clarity in my desire and drive to dance. That said, there is a great satisfaction when you find something early in life that you not only are challenged by and passionate about but also have a natural gift for—one you recognize can be honed with hard work and dedication.

People often talk of getting "lost" in what they're doing. For me, moving through space, engaged in and fully inhabiting my body and the music, deeply connecting with the other bodies I'm dancing with, is where I feel found. Dancing fills me and demands I am emotionally and physically present in a way that nothing else does. There is an electricity, my breath deepens, my focus becomes crystalline, all senses are heightened, and the audience fades away. Time seems to stretch and there is nowhere in the world I would rather be.

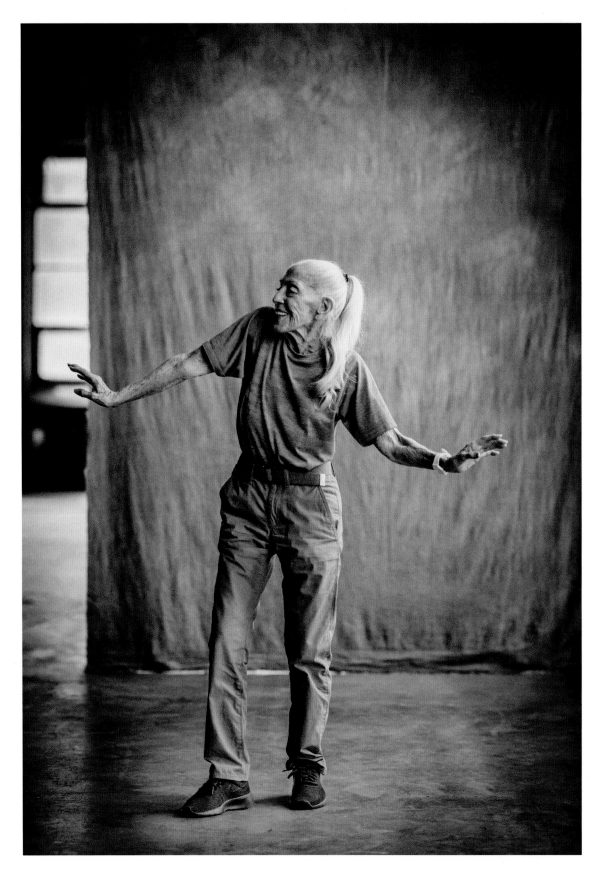

SONDRA LEE Ballet and Broadway

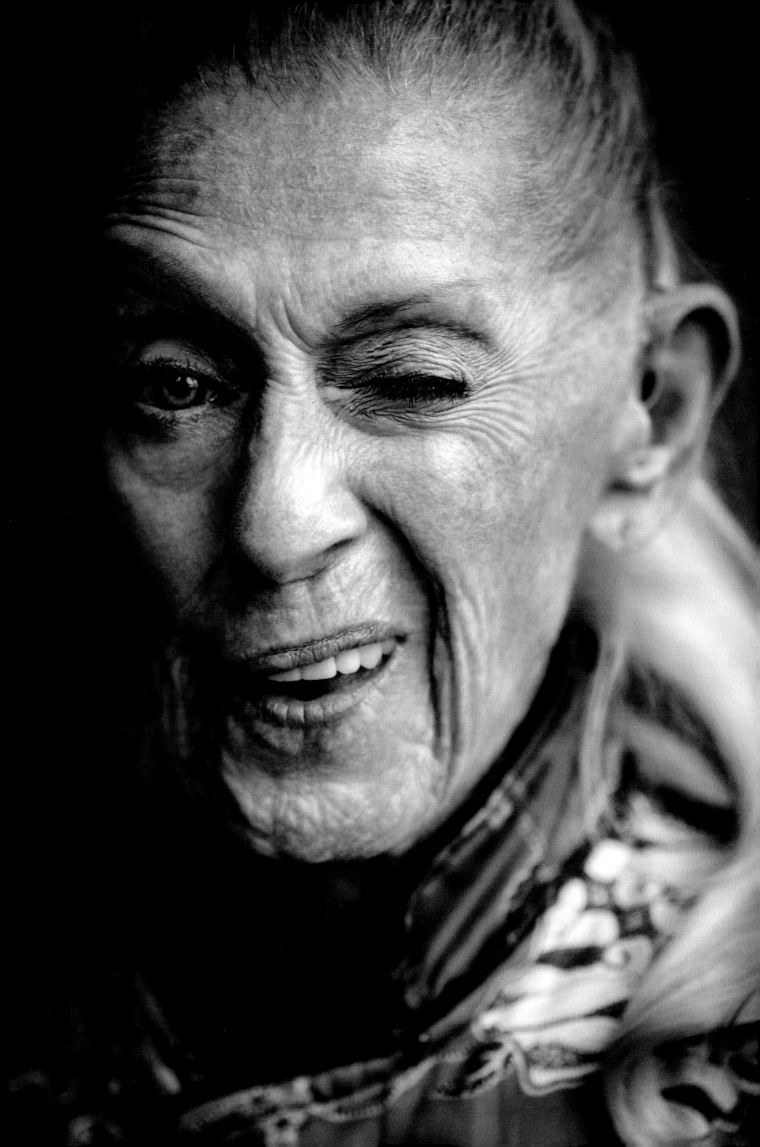

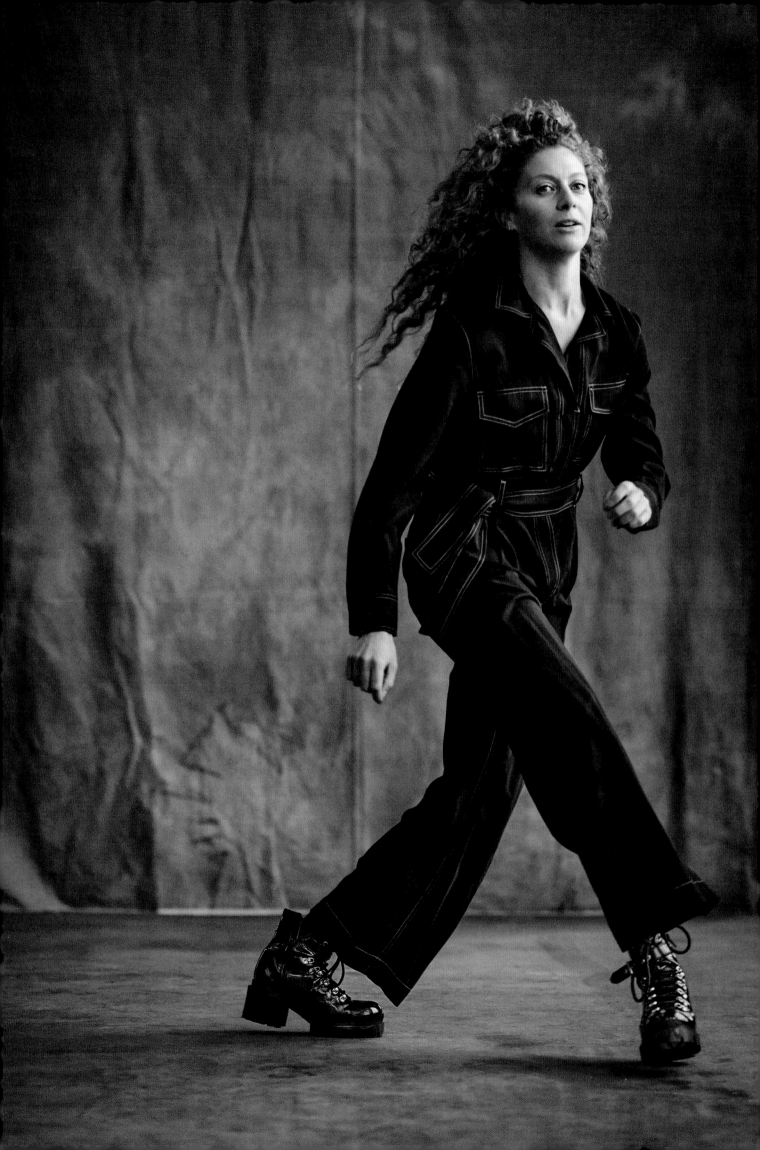

AFTERWORD
by Loni Landon

WHEN I LOOK BACK AT HOW THIS PROJECT STARTED—conversations at family gatherings between Mark and me about someday working together, then getting that opportunity during one of the strangest times of our lives—I am amazed. We were able to gather an extraordinary group of subjects, dancers from a broad range of genres, despite the discipline's tendency for little exchange between its various circles. In early 2021, I found myself—like many people—with extra time on my hands. This feeling was new for me, because I was used to living the life of a creative person in the city, in constant motion as a choreographer and dancer. The project on which Mark and I embarked started out with me texting a few of my friends in the dance community, asking if they wanted a photo session with Mark. I sent them his Instagram, and suddenly we had a few volunteers. Mark had never shot dancers before so I gave him some pointers and navigated the scheduling of the first few subjects. As soon as Mark started clicking his camera, I realized he was capturing the essence of these artists. He kept getting these "in-between" moments, which were more spontaneous and natural than a traditionally posed image.

During the shoots, we spoke to the dancers about identity. The pandemic challenged a lot of us in terms of facing our true selves in a moment when we had lost what defined us—the ritual of classes and performances, opportunities for creativity and personal interaction. Everyone figured out how to survive in their own way. It was astonishing to see perseverance paired with vulnerability—the resilience of these artists. The abundance of diversity in style, genre, age, race, and gender identity make the dance community in New York what it is—and we tried to reflect that wealth here. Aware that we captured a microcosm of this larger world, I am truly grateful to all of the exemplary dancers who contributed to this body of work.

Acknowledgments

I thank Jacob Levy, my favorite cousin named Jacob and a producer extraordinaire. Without his constant vigilance and noodging this book would never have been completed.

Loni Landon was indispensable in getting things moving when we were all still. I will be forever grateful for her trusting me enough to bring me into the dance community.

Philip Reeser, my editor at Rizzoli, with his depth of knowledge and experience, allowed me to focus on the creative.

I thank Robb Rice for making the book design dance from the pages.

Special acknowledgments to Carol Boss, Charles Miers, Claudia Bauer, Darren Henault, Jesseca Salky, John Kreidler, Kimberly Giannelli, Kiran Karnani, Lamont Richardson, the Landon family, Lenny Lazzarino, the Levy family, the Mann family, Matthew Allard, Matt Grayson, Sage Backstrom, the Schad Family, Victoria Wellman, Dell Technologies, NVIDIA, Hahnemühle, and Leica Camera.

And, I extend my gratitude to the contributors who generously supported this project and its promotion: Reyana and Kamlesh Alwani, a friend of Steve Levy, the Wilson family, Lola Van Wagenen, Steven and Beena Levy, Alfred Moses and Fern Schad, Monte Lipman, Avery Lipman, and Paula Gottesman.

Mark Mann
New York, New York

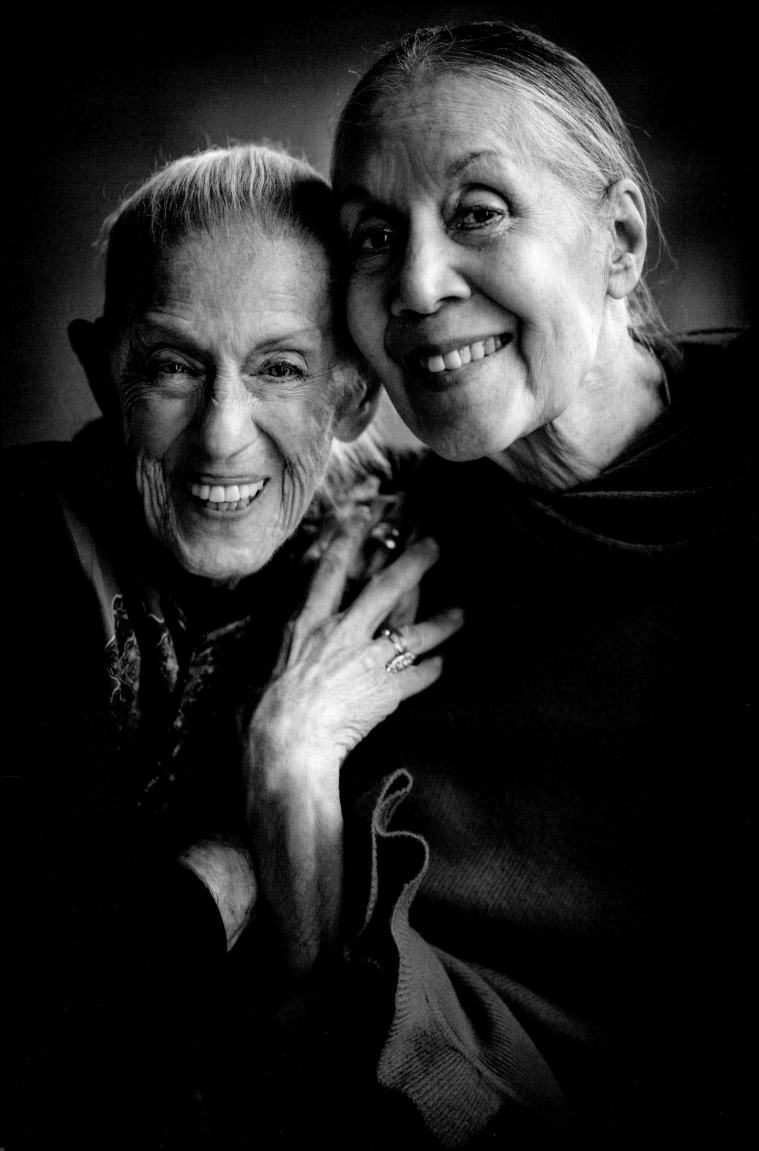

Page 2: Alexander Anderson
Page 236: Loni Landon
Page 239: Sondra Lee and Carmen de Lavallade

First published in the United States of America in 2023 by
Rizzoli International Publications, Inc.
300 Park Avenue South
New York, New York 10010
rizzoliusa.com

Publisher: Charles Miers
Senior Editor: Philip Reeser
Production Manager: Kaija Markoe
Design Coordinator: Olivia Russin
Copy Editor: Claudia Bauer
Proofreader: Sarah Stump
Managing Editor: Lynn Scrabis

Designer: Robb Rice

ISBN: 978-0-8478-9911-1
Library of Congress Control Number: 2022941813

2023 2024 2025 2026 / 10 9 8 7 6 5 4 3 2 1

Printed in China

Facebook.com/RizzoliNewYork
Twitter: @Rizzoli_Books
Instagram.com/RizzoliBooks
Pinterest.com/RizzoliBooks
Youtube.com/user/RizzoliNY
Issuu.com/Rizzoli